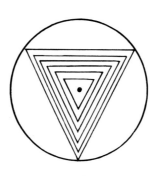

सर्वयन्त्रात्मिका

I bow to the Goddess who is 'the Soul of All Yantras'

Lalitāsahasranāma (205)

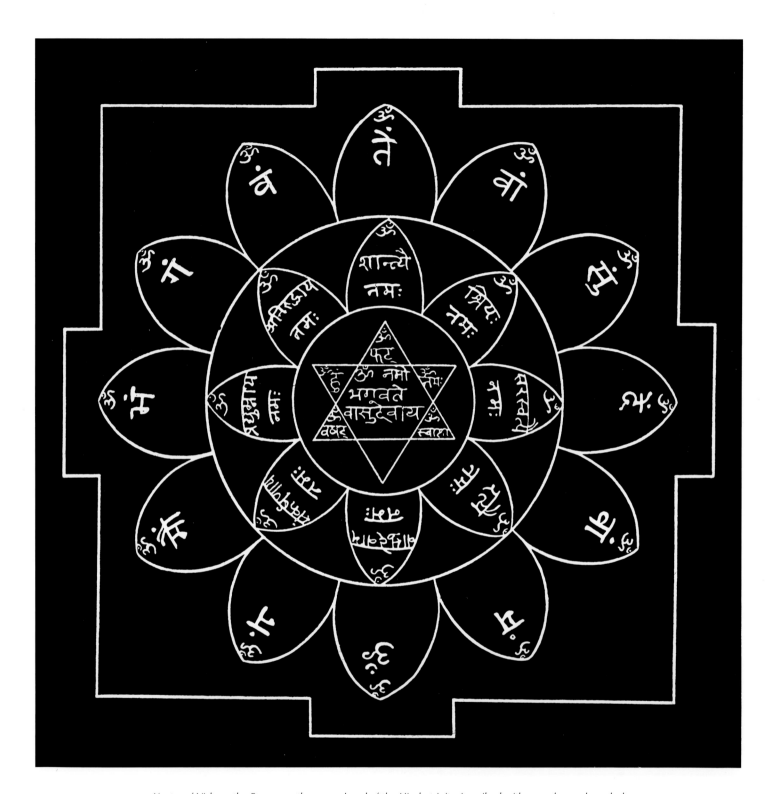

Yantra of Vishṇu, the Preserver, the second god of the Hindu trinity, inscribed with sacred sound-symbols

YANTRA

The Tantric Symbol
of Cosmic Unity

Madhu Khanna

Foreword by Ajit Mookerjee

INNER TRADITIONS
ROCHESTER, VERMONT

To Dr Manfred Wurr
on the tantric path

Inner Traditions
One Park Street
Rochester, Vermont 05767
www.InnerTraditions.com

This U.S. paperback published by Inner Traditions 2003
Copyright © 1979 Thames & Hudson Ltd, London

Library of Congress Cataloging-in-Publication Data
Khanna, Madhu.
 Yantra, the Tantric symbol of cosmic unity / Madhu Khanna.
 p. cm.
 Originally published: London: Thames & Hudson, 1979.
 Includes bibliographical references and index.
 ISBN-10: 089281132-3
 ISBN-13: 978-089281132-8
 1. Yantras. 2. Hindu symbolism. I. Title.

BL 1236.76.Y36K43 2003
294.5'37—dc21 2003051085

Printed and bound in Singapore

10 9 8 7 6 5 4 3 2

Contents

Foreword

The yantra is essentially a geometrical composition; but to understand its true nature our notions of geometry must yield to those of dynamics. The yantra, then, represents a particular configuration whose power increases in proportion to the abstraction and precision of the diagram.

Yantras vary according to their use. Individual deities have their own yantras accompanied by appropriate mantras (or sound-syllables): 'Yantra is ensouled by mantra,' the *Kulārṇava Tantra* says. When a sādhaka (aspirant) attains a high degree of spiritual progress he is initiated into the use of a particular yantra. The selection of the yantra with its appropriate mantra is a highly complex process, and the guru alone can guide the aspirant to his potent symbol. It arouses the inner life-force to its fullest, and its dedication to the deity is one with the process of its awakening. Its action can be seen as a physical, psychological and spiritual opening into comprehension of the mystery.

The study of Hindu yantras or power diagrams in this exhaustive analysis, the first of its kind, shows how each elementary geometrical form can generate a series of linear and multi-dimensional figures of the same shape, regardless of its original size. Common to such permutations are certain recurring linearities: the bindu, or point; the triangle; the square; and the circle. In the yantra, these function as 'thought-forms' that are so constructed that the aspirant understands by them particular patterns of force. To identify wholly with the configuration is to 'realize' or to release the inherent forces that each form denotes.

The principle behind this use of the yantra is basic to tantric perception. Each yantra makes visible the patterns of force that can be heard in the mantra sound-syllable, and each yantra reciprocally encloses its own unique power-pattern. Together, yantra-mantra may be said to *build form* (by the act of configuration), to *conserve form* (the configuration itself), and finally to *dissolve form* (as the aspirant comprehends its inner meaning and soars beyond it).

AJIT MOOKERJEE

Preface

The art that has evolved out of the practice of tantrism embraces a wide variety of imagery, of which the yantra, 'a geometrical diagram with abstract symbols', is one of the most vivid and central. In addition to the impact of its mathematical perfection, the yantra has a universal appeal on the level of archetypes. Similar forms reappear in almost all religions, operating as symbols of cosmic mysteries through which man rediscovers his primeval consciousness.

With the exception of G. Tucci's work on the theory and practice of maṇḍalas, there has not so far been a comprehensive analysis of the yantra. Its religious symbols have multiple meanings; the texts are often expressed in obscure language, and are susceptible to a variety of interpretations. The dot (bindu) at the centre of the yantra, for instance, can be viewed in several ways: as a tool for harnessing concentration, as a symbol for the source of cosmos, and as an emblem for the quintessential psychic unity of the male-female principles, when it implies metaphysical ideas of cosmic dualism. Similarly, each element of a yantra is a multivalent symbol.

This study examines the Hindu yantra from the interrelated aspects of its archetypal forms and sound associations, the deities and cosmological principles it embraces, the correspondences that are activated with its aid between man himself, the microcosm, and the macrocosm, through the internal yantras of the subtle body; and finally, the applications of yantras to temple plans and in practical magic.

Symbols such as the meditational yantra form part of the esoteric discipline of Indian tradition. Born of inner vision, they reveal truths that are timeless, and like great works of art, inspire man towards self-transcendence. If ignored or undocumented, the knowledge and spiritual achievements preserved in these complex symbols and formulae could be wiped out forever under the pressure of the contemporary world's upheavals.

This study has been completed with the aid of several people without whose personal help it would not have taken its present form. First, I owe a debt of gratitude to Dr Manfred Wurr and Wissenschaftlicher Verlag Altmann GmbH, Hamburg, for providing facilities for research in Germany and England. My gratitude is also due to Ajit Mookerjee for his helpful criticism and co-operation, and for lending a large number of yantra diagrams and three important illuminated manuscripts of yantra from his collection of tantra art. I wish to thank Mr Hans-Ulrich Rieker for reading through the manuscript and Mr Michael Paula for his co-operation. Last of all, I wish to record my gratitude to my parents, who have been a source of inspiration to me.

M.K.

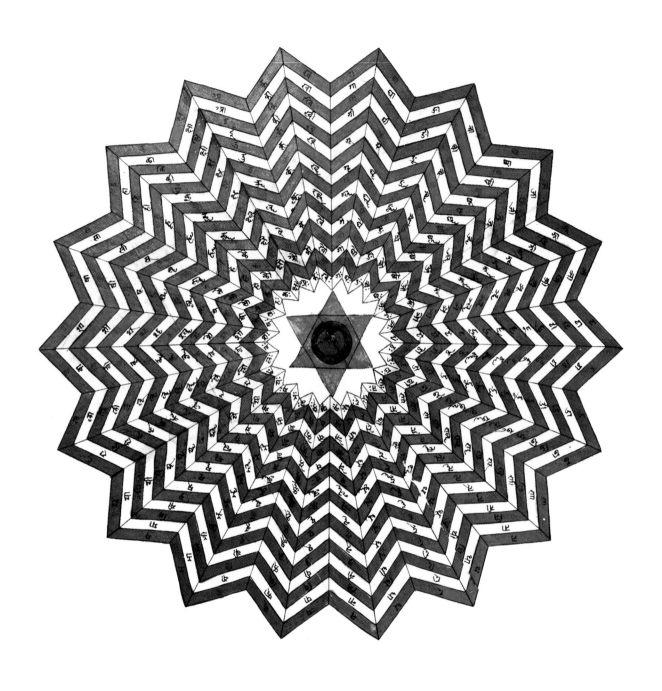

Yantra depicting the evolution and involution of the cosmos. The expanding and contracting currents of vibration symbolized by the Sanskrit letters form a web-like image, as the cosmos emanates and returns again to the primordial centre, the One. Rajasthan, c. 19th century, gouache on paper

1
Introduction

In the *Bṛhadāraṇyaka Upanishad* (2, 1, 19) there is the metaphor of a spider sitting at the centre of its web, issuing and reabsorbing its threads in concentric circles, all held at one point. This image occurs in several Upanishads since it points to the basis of the Indian world-view: unity in diversity. The spider's threads symmetrically expand into a visible circumference, and though there are divergent lines in between and varying distances to be spanned they can all be traced back to the central point of the web.

This apparently simple metaphor also condenses the essence of Indian thought: all existence is governed by a single principle, and the point of origin of the supreme consciousness is simultaneously an infinite reservoir of collective energy, from which everything issues and into which everything returns. This centre is the One, 'the potential All-point', which not only serves as a bridge but is Cosmic Unity underlying the physical diversity of the world. The metaphor also alludes to the Indian vision of the structure of the cosmos, which is conceived of as a 'holon', growing and expanding in concentric circles, and then contracting, dissolving into a single principle. The expansion can be atomic or infinite; no matter what their magnitude, the expansions and contractions are interconnected and integrated in the general framework supported by the centre.

The yantra is a potent and dynamic sacred symbol which reflects the same three metaphysical concepts embraced in the analogy of the spider. A geometrical figure gradually growing away from or towards its centre, in stages, until its expansion or contraction is complete, the yantra has around its centre several concentric figures 10, 11 which continue to expand or contract as precisely as a spider's web, not only as bridges between different planes, but also as symbols of unfolding or gathering energies. The figure's periphery is a square enclosure with four sacred doors opening towards the four cardinal directions. The concentric lines of the yantra define its volume and create a rhythmic unity, relating what they unite or divide to the centre, the point of integration. Like the spider in its web, the bindu (point) at the centre of the yantra is a centre of every creation, the radiating source of energy that generates all forms.

The central quest of Indian spirituality is to achieve total experience of the One. Man is a spiritual traveller whose main aim, in Indian tradition, is to intuit the unity of the One. The traveller, whether he is driven directly to the summit, whether he pauses for a while, whether he stumbles on the path or turns away, knows intuitively that all his movements inevitably lead him back to the starting point, the All-point, the origin and the end of all existence.

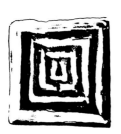

Kanudi coin (1st century AD) and seals from Mohenjo-daro (c. 2500 BC) with swastikas and square patterns

Awakening one's inner centre implies gathering one's self into a single creative point and integrating and balancing its expansion into a totality. To centre one's self is essentially a way towards inner awakening. The quest of this centre is the pivot around which yantra symbolism revolves.

The symbols of Indian art echo this fundamental truth and direct man's spiritual journey towards the goal of transmutation. Visual metaphors through which we move beyond our material order, they serve as cosmic cross-points by means of which our contact with nature at large can be expanded, to tap higher and more unified levels of experience. Whether these symbols are as monumental as Hindu temples or as small as coin-sized yantras, they mark a multitude of different stages on an individual's spiritual pilgrimage. They provide halting places, sites of rest and support where the seeker gains an awareness of the universe in its totality and discovers his inner identity with the single, immutable centre, as if the whole universe were condensed in him. Thus the symbols stimulate man to explore and reveal this centre which is a link between himself and the cosmos.

The use of abstract mystic symbols can be traced back to early Indian history. Among the artifacts excavated in the remains of the Harappan Culture (c. 3000 BC) are intaglio seals with designs that resemble yantras. A number of seals depict the swastika symbol while others are marked with a cross, a pattern of parallel lines intersecting into a grid-square or a composition of square-on-square. The seal designs, like yantras, are conceived on a cardinally orientated square. In subsequent periods the Vedic altars (c. 2000 BC), pregnant with cosmic symbolism, were conspicuously abstract in design (see Chapter 6). It was in tantrism (AD 700–1200, the tantric renaissance period) that the use of mystic symbols was fully revived.

Tantrism marked one of the most distinct and revolutionary phases of Indian religious history, synthesizing many heterodox elements. One of the ways in which tantric lore is distinguished from the non-tantric tradition is in its intensive use of sacred formulae and symbolism. Tantrism is basically a ritual-orientated system. Tantric sādhanā (ritual worship) requires the practice of yogic techniques and concentrated visualizations, and the linear compositions of the yantra are conceived precisely to meet the needs of such meditation. These mystic diagrams are ideally suited to a series of inner visualizations, growing and unfolding as links, marking stages of consciousness. Hence yantras were found to be an indispensable constituent of tantric sādhanā.[1] All sects and sub-sects of tantrism use abstract symbols[2] and yantras as part of their ritual initiation ceremony and daily worship, as means to attaining the adept's spiritual goal.

The literature of the Tantras is vast, and there are many texts[3] dealing exclusively with yantras. In addition, there are a number of commentaries in a few secular languages other than Sanskrit, such as Hindi, Bengali, Malayalam, Tamil and Assamese, in which yantras are discussed.

Yantras have survived in use, though the last remnants of their living tradition may still be found only in isolated areas in India. They have been transmitted through family groups, pupil-guru descents and esoteric tantric groups like the Nātha Saints of Bengal, Tamil Siddhāis in South India and the Kaulas in Kashmir. Their

ritual use and esoteric significance have been kept a closely guarded secret from the uninitiated, and their esoteric meaning and mystical associations are learned from a spiritual preceptor under strict discipline, who enforces a yogic regime.

Concept of the yantra

The Sanskrit word 'yantra' derives[4] from the root 'yam' meaning to sustain, hold or support the energy inherent in a particular element, object or concept. In its first meaning, 'yantra' may refer to any kind of mechanical contrivance which is harnessed to aid an enterprise. A yantra in this sense, therefore, is any sort of machine or instrument such as is used in architecture, astronomy, alchemy, chemistry, warfare or recreation. A Sanskrit text of the eleventh century AD, *Samaraṅganasūtradhāra*,[5] on the science of architecture, gives vivid descriptions of the making and operating of such mechanical yantras as a wooden flying bird, wooden aeroplanes meant to fly with hot mercury as fuel, male and female robot figures, etc. The vast observatories built in Delhi and Jaipur under the patronage of Jai Singh (1686–1734) are called Jantar-Mantar, as their massive structures are astronomical 'instruments' (yantras) for recording heavenly phenomena.

The meaning of the term yantra has been expanded to refer to religious enterprises, and has acquired a special theological significance. Mystic yantras are aids to and the chief instruments of meditative discipline. Basically a yantra used in this context and for this purpose is an abstract geometrical design intended as a 'tool' for meditation and increased awareness.

Form – function – power

Mystic yantras are an amalgam of three principles: the form principle (Ākriti-rūpa), the function-principle (Kriyā-rūpa), and the power-principle (Śakti-rūpa).[6]

They are, first of all, believed to reveal the inner basis of the forms and shapes abounding in the universe. Just as, whatever the outer structure, all matter is made of an intrinsic basic unity, the atom, so each aspect of the world can be seen in its structural form as a yantra. As the scientist sees the final picture of the world in the orderly, simple, atomic structures in which certain primal shapes appear as a harmonized 'whole', so the Indian shilpi-yogins (makers of ritual art) seek to identify the innermost structure of the universe by concentrating the variegated picture of world-appearances through intense yogic vision into simple form-equations. A yantra, then, can be considered an ultimate form-equation of a specific energy manifesting in the world. These simple form-equations are held to epitomize the real nature of the cosmos as abstracted from the concrete.

10, 11

In its widest application, Ākriti-rūpa refers to the inner or hidden form of structures, so that any structure, from an atom to a star, has its Ākriti-rūpa yantra. Thus a flower or a leaf has an outer structure which is immediately perceptible, but it also has an inner form, which generally consists of a skeletal framework in which all its linear forms intersect with a central axis or nucleus: all forms have a gross

structure and a 'subtle' inner structure, with a basic causal pattern (the inner form) for the external form.

77–80 Yantras function as revelatory symbols of cosmic truths and as instructional charts of the spiritual aspect of human experience. All the primal shapes of a yantra are psychological symbols corresponding to inner states of human consciousness, through which control and expansion of psychic forces are possible. It is for this reason that a yantra is said to embody a 'function-principle' (Kriyā-rūpa).

By constant reinforcement in ritual worship the apparently inert yantra-forms shake off their dormancy and act together as emblems of psychic power. In this case, the yantra is said to move beyond 'form' and 'function' and emerges as a 'power diagram' (Śakti-rūpa) endowed with a self-generating propensity to transform a mundane experience into a psychic one. It is at this point that the yantra is said to be 'revealed'. Although its outward meaning may be relatively easy to understand, the inner meaning that gives it its efficacy is difficult to grasp because its archetypal forms are basically concerned with the inner facts of psychic experience, gained through intuitive vision.

यन्त्रमित्याहुरेतस्मिन् देवः प्रीणाति पूजितः ॥८६॥

शरीरमिव जीवस्य दीपस्य स्नेहवत् प्रिये ।

As body is to the soul and oil is to the lamp, a yantra is to the deity
Kulārṇava Tantra (Chap. , v. 86)

Dwellings of the gods

Every yantra is a sacred enclosure (temenos), a 'dwelling'[7] or receptacle of Ishṭa-devatā (the chosen, tutelar, deity). A yantra is a substitute for an anthropomorphic image of the deity. Most Indian divinities, such as Kṛishṇa, Vishṇu, Durgā, and Kālī, in addition to their iconographic representations, have been assigned aniconic symbols in their specific yantras. A deity's yantra may bear no resemblance to the iconographic image (mūrti), whose proportions and human attributes are fixed by the traditional canon. The yantra is its 'trans-form' (parā-rūpa), its abstract translation. A yantra retains the suprasensible vitality of an image, expressing the sense and spirit of the original.

1 Sudarshana Chakra (Wheel of Vishṇu): yantra formed of Vishṇu's sixteen-armed icon inside his sacred weapon, the disc with the fiery circle, symbolizing his limitless power which destroys illusion. Rajasthan, c. 18th century. Gouache on paper

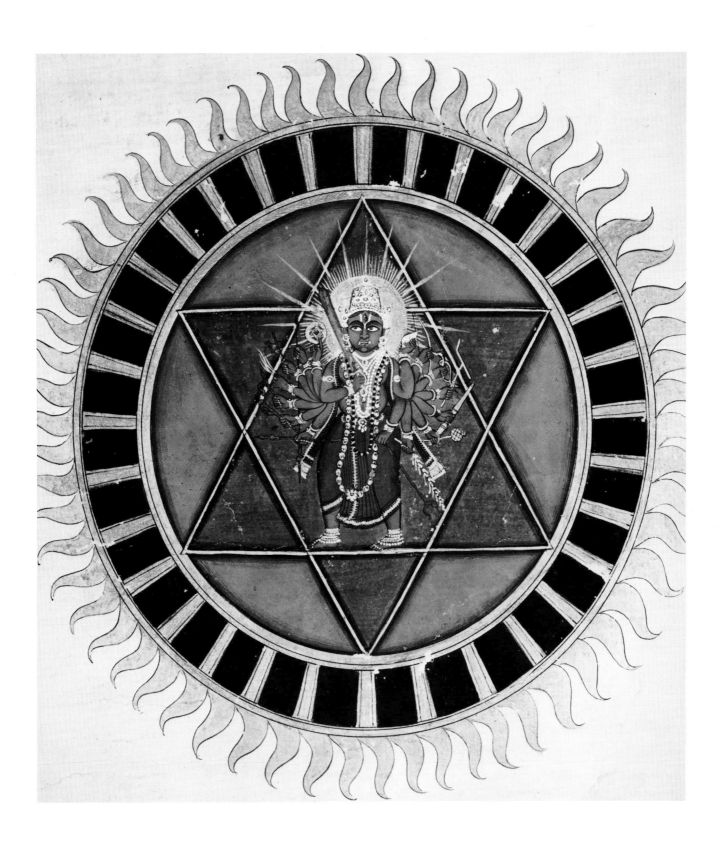

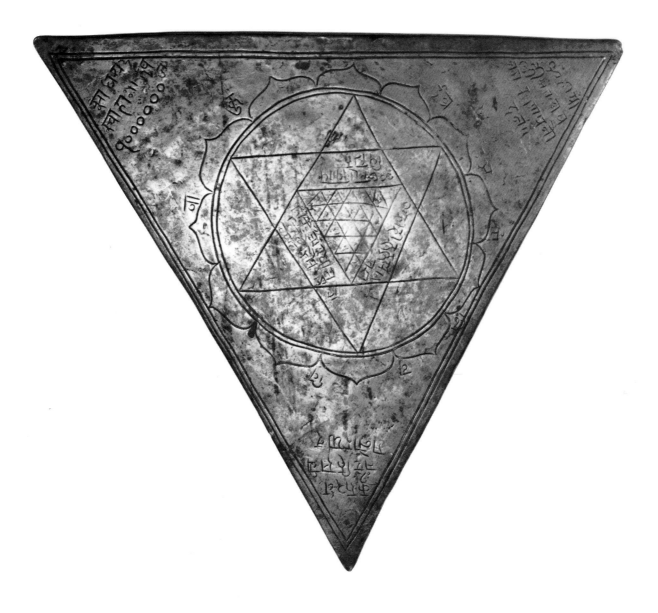

2. The primal triangle, emblem of cosmic energy as Śakti, the female principle, supporting the archetypal shapes of a Devī (goddess) yantra. South India, c. 18th century. Copper plate

3 Devī yantra based on the yoni-shaped plan of the ancient Vedic fire altars (yoni-kuṇḍa). The archetypal shapes of Vedic altars and their ritual practices have both survived in tantric worship. Rajasthan, c. 19th century. Ink on paper

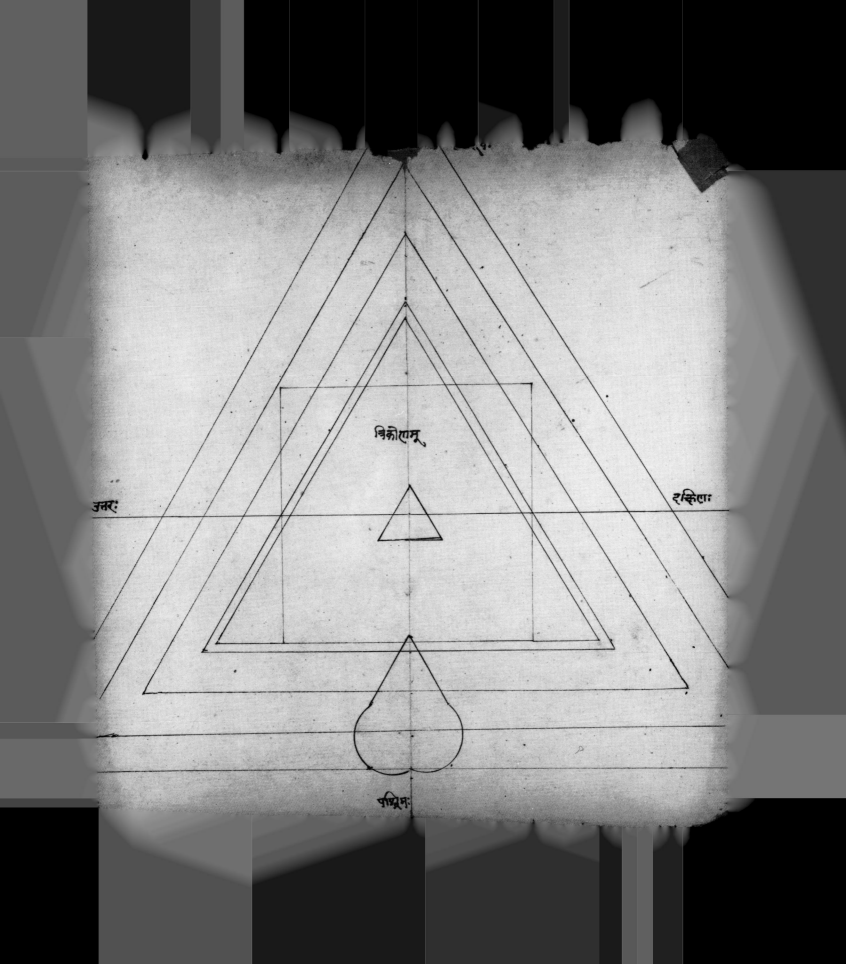

उत्तर: त्रिकोणम् दक्षिणः

पश्चिमः

4 Swastika Yantra employing the ancient solar symbol of auspiciousness, a primal symbolic form. Rajasthan, c. 19th century. Gouache on paper. Right, a swastika seal from Mohenjo-daro dating from c. 2500 BC

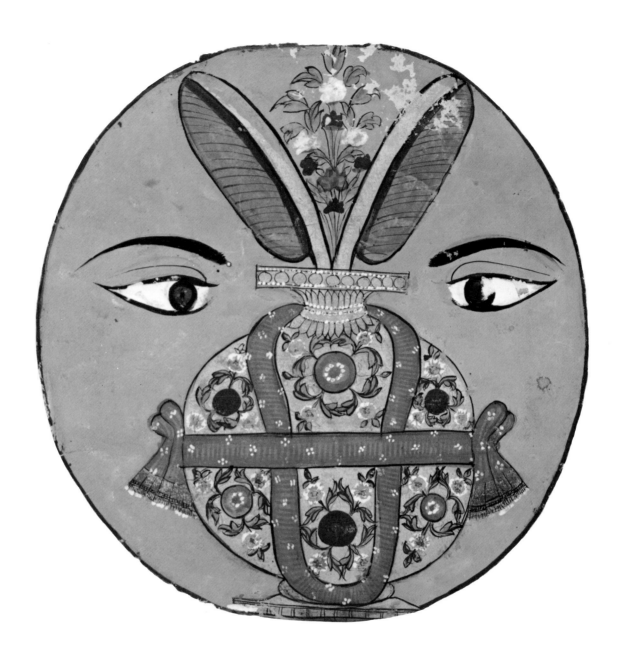

5 'Rise O Jar that art the Brahman itself, thou art the soul of the God and grantest all success' (*Mahānirvāṇa Tantra*, X, 156). The Maṅgala Ghata, the ceremonial water jar, sometimes substitutes for a yantra diagram during ritual worship. Rajasthan, *c*. 19th century. Gouache on paper

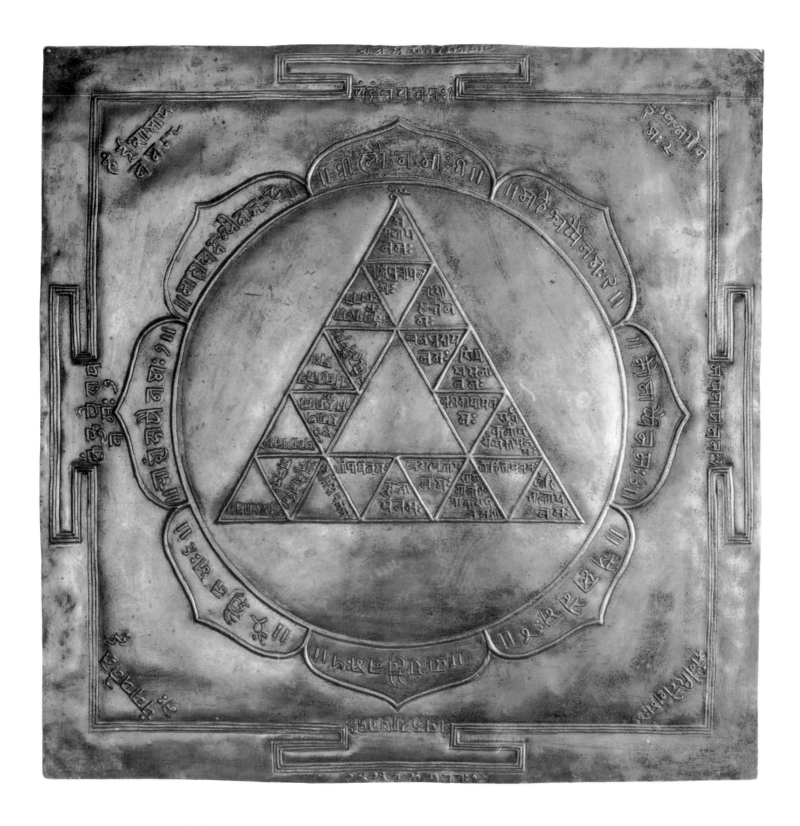

6. Maṅgala Yantra, worshipped for good fortune and success (maṅgala). The energy of the yantra's deity is expressed in the inscribed sound-syllables or mantras. Allahabad, 18/19th century. Copper plate

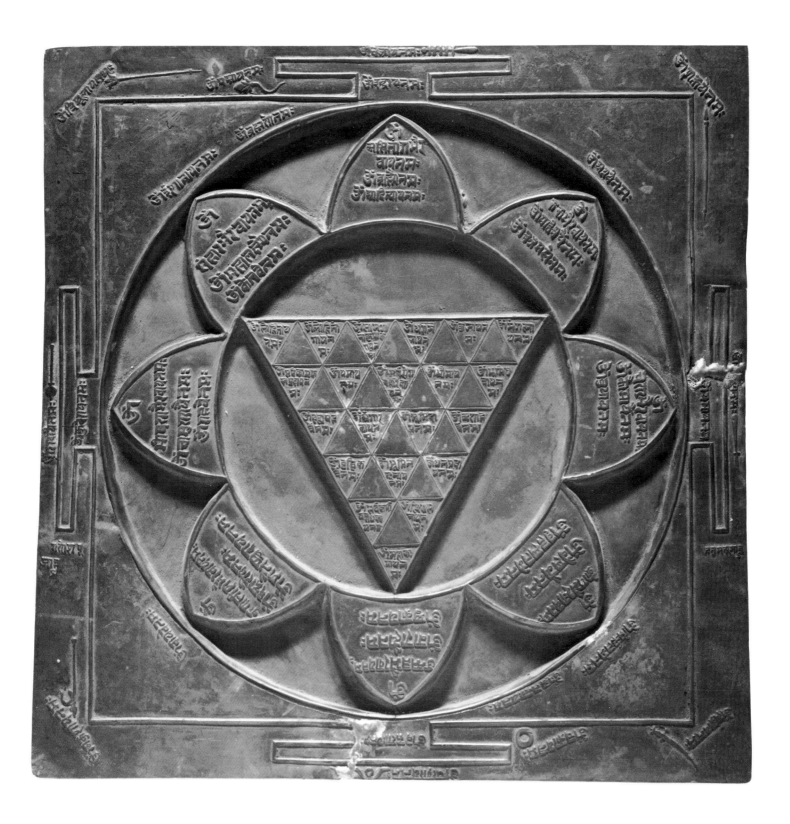

7 A vibration-pattern of the universe results and the yantra's static shape is made kinetic when the inscribed mantras are chanted in ritual worship. Rajasthan, c. 1700. Copper plate

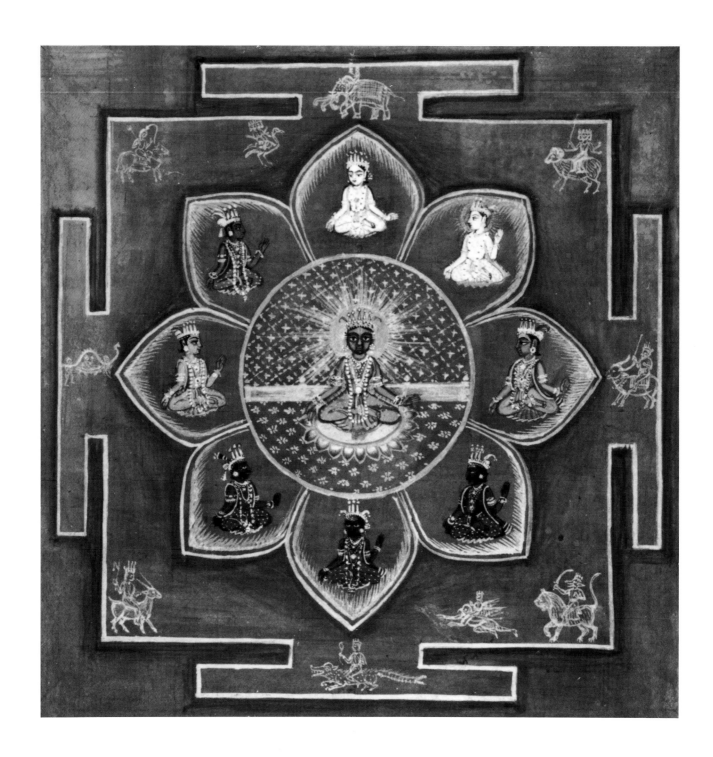

8 Sūrya (Sun) Yantra with images of the deities of the nine planets. A yantra is a celestial circle of the gods.
Every yantra's linear framework supports many clusters of deities, like sparks from the fiery nucleus of the
central deity. The outermost periphery is protected by guardian deities who forbid negative force to enter the
holy space. Seed mantras are often substituted for the images of these deities, or the appropriate deities may
be visualized in the spaces of the yantra by the sādhaka during meditation. *Sarvasiddānta-tattvacūḍāmaṇī*,
Punjab, *c*. 1839. Gouache on paper

Yantras have been described as 'symbolic extensions of the sacred pilgrim centres (pīṭha-sthāna)' – the most holy temples of the Supreme Goddess which are scattered throughout India – and as 'spatial digits' of the divine.[8] The origin of these pilgrimage centres is described in an Indian myth. Śiva wandered through India carrying the corpse of Satī (or Pārvatī, his spouse) in grief and madness, until Brahmā and Vishṇu became so anxious that Vishṇu, with successive throws of his disc, dismembered Satī, whose limbs fell to the earth at places all over India. These places became sacred centres of pilgrimage, temples saturated with holy power. Thus yantras should be seen, not as 'artworks' isolated from the religious tradition in which they developed and which sustains them, but as two-dimensional pīṭha-sthāna, or pilgrim temples, in which the movement from the profane to the sacred takes place. The yantras of devatās are 'revealed' images of transcendental reality.

The symbolic syntax of yantra imagery

By themselves, the constituent symbols of a yantra convey only partial meanings, and cannot carry the universe of meaning that a yantra as a whole denotes. The symbolic syntax of the yantra reveals a 'universe-pattern' of the totality of existence, in which hierarchical, apparently heterogeneous planes of existence form a synthesis. This synthesis 'allows a man to discover a certain unity of the world and at the same time become aware of his own destiny as an integral part of the world'.[9]

Broadly, the symbolic syntax of yantra can be divided into two specific dimensions: the cosmic and the psychic (that is, the macrocosmic and the microcosmic). The cosmic dimension can be further divided into the deity motif and the mantra element. Though the deity motif is the centre around which yantra symbolism revolves, it becomes fully meaningful only with awareness of the metaphysical principles and the laws and processes governing the cosmos which the particular divinities denote (see Chapter 3). For instance, the goddess Kālī represents the cosmic activities of creation and destruction, and the Kālī Yantra is not only the receptacle of Kālī but a symbolic projection of the metaphysical 'truths' which she personifies.

The second aspect of yantra syntax is the mantra element. Mantras, the Sanskrit syllables inscribed on yantras, are essentially 'thought-forms' representing divinities or cosmic powers, which exert their influence by means of sound-vibrations (see Chapter 2). It is put forward in the Tantras that the entire world is symbolized in mantra equations, as the mantra is essentially a projection of cosmic sound (Nāda = the principle of vibration born out of the conjunction of Śiva-Śakti, the Absolute Principle). Yantra and mantra are always found in conjunction. Sound is considered as important as form in yantra, if not more important, since form in its essence is sound condensed as matter.

The third aspect of yantra syntax is its psycho-cosmic symbolism. Despite its cosmic meanings a yantra is a reality lived. Because of the relationship that exists in the Tantras between the outer world (the macrocosm) and man's inner world (the

9

6, 7

67 microcosm), every symbol in a yantra is ambivalently resonant in inner-outer synthesis, and is associated with the subtle body and aspects of human consciousness (see Chapter 5). Thus, for instance, the bindu in a yantra is cosmic when viewed as the emblem of the Absolute Principle but psychological when it is related to the adept's spiritual centre. By aligning these two planes of awareness, the yantra translates psychic realities into cosmic terms and the cosmos into psychic planes.

Each of these dimensions of yantra syntax can be equated with all the others. Thus, the deity motif may be assumed in the mantra – in several instances the symbol of the deity is the seed sound (bīja-mantra) inscribed in the centre of the yantra (see Chapter 2); or a mantra may be related simultaneously to a deity (Chapter 3) and to body-cosmos parallels, or the human body with its cosmic identities may itself become an 'instrument' – a yantra – during the yogic process (Chapter 5).

Tantrism has evolved the most complex networks of these interactions, and if distinctions may be made between the syntactic dimensions, none can exist without the others since they are all mutually inclusive.

The symbolic syntax thus integrates all the dimensions of the tantric universe. It is based on the holistic view of life characteristic of Indian thought. In the ultimate sense, the separation of elements of whatever kind is illusory. The distinctions between psychic and cosmic, deities and mantras, are contingent. The fundamental aim of ritual and meditation on the yantra is to fuse all the dimensions into a state of oneness. Herein lies the symbolic unity of the yantra.

The complex nature of yantra syntax corrects the view of some scholars who have wrongly labelled all yantras 'magic' diagrams. Diagrams used for occult purposes form a separate category (see Chapter 8) which has evolved within the tradition, and the role of such yantras is peripheral in comparison with that of yantras for meditation.

Varieties and types

Yantras are most commonly drawn on paper, or engraved on metals or rock crystal, although any flat surface such as floors or walls may be used, especially for temporary yantras. Three-dimensional yantras may be on a small scale, or on the scale of architecture (see Chapter 7).

An inexhaustible number of fresh yantras may be made by rearranging the basic shapes and/or reshuffling the mantras. With each fresh mantra-combination a new yantra is created. Reciprocally, a particular yantra illustrating a specific religious idea may be composed in countless variations. Thus, for instance, one tantric text 34–46 describes how the sixteen yantras of the Moon Goddesses (Nityā-Śaktis) can be expanded into 9,216 variations simply by re-assigning their mantras.[10]

Yantras in one tradition may borrow elements from another, and their great abundance presupposes many levels of classification. Yantras exist in the Vedic,[11] Tantric and Buddhist traditions,[12] each of which has adapted the use of yantras to its

own specific metaphysical ideas. Vedic yantras are the oldest; Tantric yantras are the most numerous and varied; and Buddhist maṇḍalas (literally 'circle'), though they differ from yantras in being complex combinations of images within a rigorous linear framework, convey the same ideas, serve the same religious purposes, and have made a distinctive contribution to the yantra as a living form. Many yantras spring from Jaina sources[13] and embody speculative ideas of Jainism.

Yantras may be grouped according to their uses. Some 'architectural yantras' are used as prime analogues for the ground plans of temples (see Chapter 7). Others are employed in astrology.[14] Primarily, however, yantras are used in ritual worship (see Chapters 4, 5). There are yantras devoted to male deities, to female deities, conjointly to two deities, or to various aspects of a single female deity (see Chapter 3). Finally, some yantras are meant for occult purposes, and many of these are used as talismans (see Chapter 8). In addition there are several kinds of purely abstract designs of a symbolic kind, akin to yantras and maṇḍalas, drawn by women on the floors and walls of houses with rice-paste or powdered colours during festivals and other religious ceremonies. These auspicious signs are known as Ālipanā or Raṅgoli, and are found all over India.

Ālipanā, a sacred diagram drawn on floors with rice-paste during religious festivals

In Hindu tradition the pot-bellied earthenware or copper jar also serves as a yantra. Called the Maṅgala Ghata, decorated with auspicious signs and holding ritual ingredients, the pot is symbolically the vessel that holds the nectar of immortality. Its spherical shape is an apt analogy to the universe, and the water with which it is filled symbolizes the cosmic elemental forces. The worship of the pot as a complete yantra is very common in Bengal. When not used as a substitute for a geometrical yantra, it is generally placed before icons or in the centre of floor maṇḍalas as an auspicious symbol. In Tibetan tradition, the jar (Kumbha) is used to aid meditation, during which the aspirant visualizes the entire pantheon emerging from the cosmic waters symbolically contained in the jar. Such an image is also revered in Jain and tantric traditions.

5

No external symbol, however sophisticated, is a substitute for the body-yantra. With its physical and psychological planes, the human body is considered in tantrism to be one of the most powerful instruments of spiritual transformation: it represents the physical substratum of the divine, where the evolutionary unfolding of the being takes place, a repository of inexhaustible power which can be tapped in meditation (see Chapter 5). Only by mobilizing and awakening it from its slumber can one come to the fullest appreciation of its divine grace. 'The eternal essence is within, so what need is there to seek for outer means for liberation?'[15] The body is the sacred centre of all ritual, formula, offering, meditation, liturgy: 'Here [within the body] is the Ganges and the Jamunā, here are Prayāga and Benares, the Sun and the

Moon. Here are the sacred places; here the pīṭhas [pilgrimage centres] and the upa-pīṭhas – I have not seen a place of pilgrimage, an abode of bliss like my body.'[16]

66 Indeed, 'The yantra which is one's body is the best of all yantras.'[17]

Yantra as archetypal wholeness

Modern man, unaware of archaic mysteries, spontaneously draws or dreams maṇḍala/yantra-like patterns when he is achieving a fusion of opposite forces within his psyche. Jung's extensive researches have demonstrated that such a symbol is not 'manufactured' but discovered through primal inner sources. It springs from a universal human compulsion and embodies 'timeless' universal principles in archetypal language which is physically and spiritually not remote from life. This is evident in the impressive frequency with which similar archetypal forms appear in the various cultures of the world. Maṇḍala-like forms are to be found, for instance, in the crystalline patterns of Islamic art, in the sand-paintings of the Navaho Indians, in Celtic motifs and the circular dance-forms of the Sufi order. Hence yantras are not merely religious signs of a particular cult but constitute objective expression. They are primordial 'imprints' of consciousness – 'shapes of conception' that cut across all cultural barriers and are the heritage of all mankind.

In archaic societies man viewed himself as a part of nature and nature as part of himself. In possession of this vision of unity he created sacred symbols and used them for transpersonal experiences. Sacred symbols enabled him to see himself as part of a 'sacralized' cosmos, breathing and moving with a life in which all elements of existence were interlinked. For archaic man, the universe was pregnant with qualitative meaning. Modern man, on the other hand, has 'desacralized' the cosmos, developed a fragmented vision of the universe and lost his original unity with nature. The result of this 'quantification' is an alienation from within – a loss of subjective identity and of inner and outer force. Jung has said that man's most vital need is to discover his own reality through the cultivation of a symbolic life: 'Man is in need of a symbolic life. . . . But we have no symbolic life. . . . Have you got a corner somewhere in your houses where you perform the rites as you can see in India?'[18]

Symbols like the yantra are transformers of our psychic energy – such symbols alone allow us to discover a 'missing part of the whole man' that makes life joyful, radiant and infinitely meaningful.

9 'As body is to the soul . . . a yantra is to deity.' Yantras are the sacred enclosures of divinities and indeed are inseparable from them. At the top is the yantra of the goddess Bhuvaneśvarī, who rules the three spheres of the earth, atmosphere and the heavens as space; below left, the Viśvayoni Chakra with icons of Śiva-Śakti, the male and female principles, over a triangle representing the cosmic womb (viśvayoni). Below right, Śiva appears as white point (bindu) and Śakti as red point within the primal triangle, symbolizing the unity of male and female principles. Nepal, c. 1761. Gouache on paper

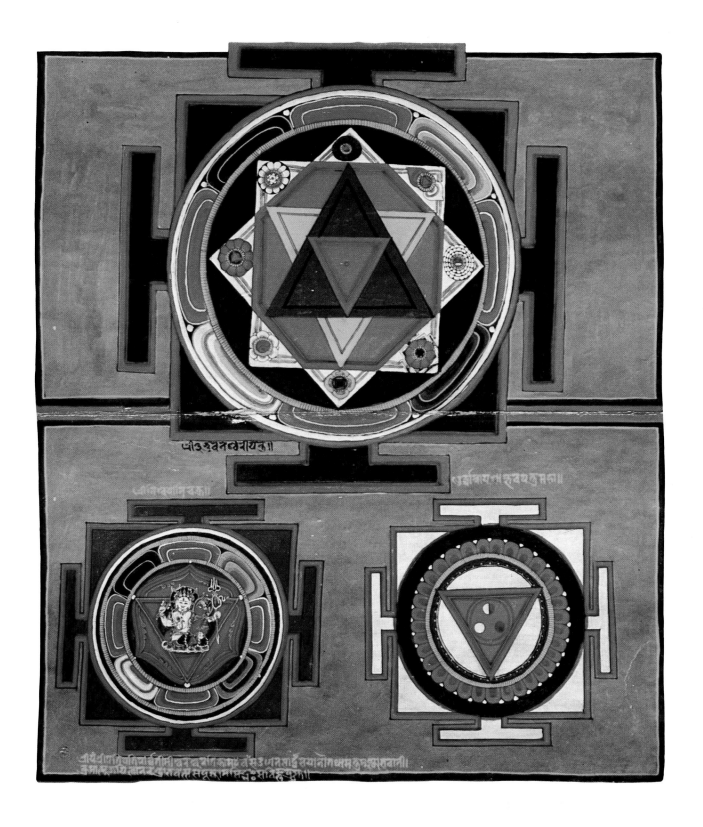

श्रीश्मशानायन्त्रं॥

श्रीगुह्यषोडशीयन्त्रं॥

श्रीश्रीराधाधर्मयन्त्रं॥

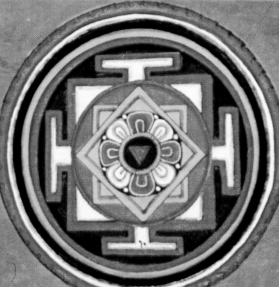

श्रीप्रकृतियन्त्रं॥

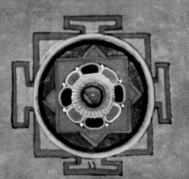

श्रीशाण्डाक्ष्यायन्त्रं॥

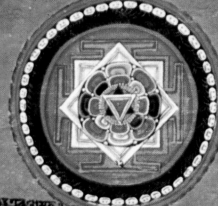

श्रीश्रीकृष्णयन्त्रं॥

श्रीश्रीगणेश्वरीयन्त्रं॥

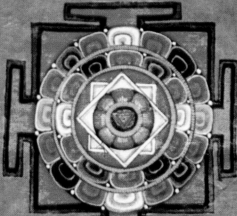

श्रीप्रकृतिकाशयन्त्रं॥

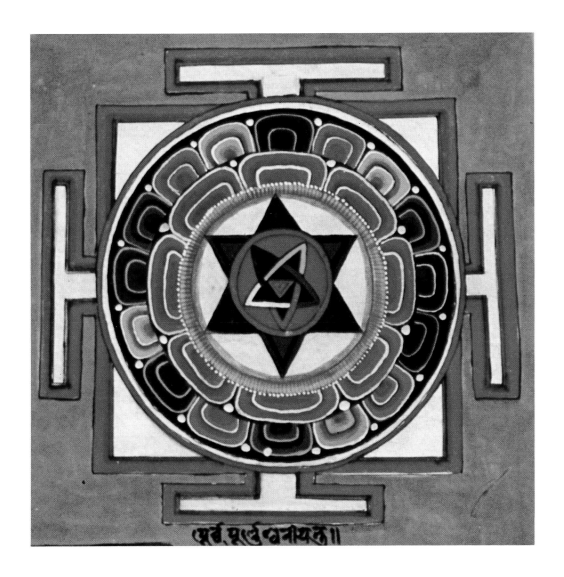

10, 11 Yantras as images of the cosmos in pristine wholeness. The various geometrical configurations of which they are composed include T-shaped portals, squares, lotus petals, circles and triangles – but all are centred on the mystic point, the bindu. The yantra of the goddess Pūrneśvarī, above, is an archetypal image of the deity who embodies the balance of cosmic forces maintained by the primordial centre. Nepal, c. 1761. Gouache on paper

12 The Nava-yoni Chakra floating in the cosmic waters, signifying the creation of the universe by the union of the male and female principles, represented by interpenetrating upward and downward pointing triangles. The nine inscribed triangles indicate the nine (nava) cosmic wombs (yoni). Nepal, c. 1761. Gouache on paper

2
Archetypal Space and Sacred Sound

In every civilization there are consecrated sites and sacred places that are heavy with spiritual significance. Temples, caves, sanctuaries, or features such as rocks serve as vital points of contact and centres of accumulated energy. Such places, once consecrated according to traditional canon, acquire sanctity, and their 'enclosures' separate the archetypal sacred space from its surroundings. The two areas, the world within the enclosure and the world without, also stand for the psychological separation of man from his habitual concerns. The wall or fence or 'magic circle' – whatever form the enclosure takes – stands between the visible and the invisible and recalls the ritual separation of two distinct realities; the one that is sacred in which the divinity manifests itself and the other that is profane, the realm of mundane existence.

Once consecrated, even an insignificant stone will acquire uniqueness and spiritual significance. In India, one often comes across such objects where a sacred enclosure is marked: a simple stone daubed with vermilion is laid under a tree, or a sacred syllable or the name of a deity may be scribbled on the wall. Such images 'speak', 'move' and 'breathe' with life since they impart in a mysterious way a sense of primal reality. To a seeker who searches for meaning in such sites or images, the past participates in the present in that they preserve countless archetypal associations. Such a response necessarily puts out of balance all the notions of linear time of modern man, for whom the past is merely a dead sequence of events. The archetypal images, therefore, call for a new way of seeing through the sharpening of the innate faculties by which they were originally preserved. All such images, whether large or small, abstract or figurative, simple or sophisticated, re-create a celestial prototype and recapitulate the symbolism of the centre where the divine manifests itself, thus investing them with a spiritual value which is held to be ultimately real. The yantra enclosures follow a similar principle and accord with ancient intuitions.

In the *Yajur Veda* (23, 60–61), a passage describing a conversation between a devotee and the priest who performs the fire oblation summarizes this concept. The seeker questions:

> Who knows this world's central point? Who knows the heavens, the earth, the wide air between them?
> Who knows the birthplace of the mighty Sūrya [sun]?
> I ask thee of the earth's extremest limit, where is the centre of the world, I ask thee?

He is answered by the priest:

> I know the centre of the world about us. I know heaven, earth, and wide air between them.
> I know the birthplace of the mighty Sūrya . . .
> This altar is the earth's extremest limit; this sacrifice of ours is the world's centre.

Thus, although made of fragments of brick and mortar, the plinth of the fire altar is transformed into a cosmic entity and a spiritual centre, and the altar begins to exist in mystical 'time' and 'space' quite distinct from the profane. In the same way, the archetypal space of the yantra becomes a sacred entity recognized by the sādhaka (aspirant).

In our ordinary perceptions we view space as an amorphous entity which is related to us in units of measurement. For us space is essentially quantitative; we understand it in terms of dimension, volume and distance. For the adept who uses yantras in yogic meditation, on the other hand, space enclosed within the bounded figure is purely qualitative; space is absolute void and unity is a 'sacrament' by means of which he communicates with a force that stands for life itself.

The yantra is an archetypal unit, and in the making of every new yantra the archetypal activity and the divine revelations repeat themselves. Each yantra's consecrated place acts as a dwelling for the gods, a space where movement from the level of profane existence to the level of profound realities is made possible. Symbol and meaning blend so closely that they are one reality, indistinguishable from one another. The yantra of the goddess Kālī, for instance, is not merely her symbol but an indispensable complement of Kālī herself, her total substance experienced through meditation on the 'metaphysical' spaces of her yantra. We not only perceive the yantra being 'of Kālī', but 'understand' it as being one with the spirit of the goddess. It is said, therefore, that the wise 'know no difference between the goddess [Maheśi] and the yantra'.[1]

Every yantra creates a power-field, a cosmicized circuit (kshetra) in which the powers of the sacred are invoked. The lines and planes localized within the yantra, though distinct from all the spaces that surround its outer circuit, are an expression of a transcendental reality. Stretching from star to star the ultimate substratum of all forms is space. Empty space is in itself a primordial substance and shares in the nature of divinity. Without it, the primordial substance whose abode is the whole universe would remain without support. Absolute void is defined by Indian philosophers as a limitless sea of undifferentiated continuum which is an ever-present entity not detachable from the relative, thus making all division of space illusory. So the spaces within a yantra, however minute, can be symbolically brought to 'presence' and expressed as being as immense as the spaces within the solar system. Although in the abstract this is the immutable principle on which the space concept of yantras functions, on the level of human experience we are led to locate the sacred by creating spatial divisions. The act of bounding the figure, 'fencing' its four quarters, defining its spatial orientations, delimiting the sacred territory of the yantra, is an act of asserting where sacred space begins to manifest.

26

Grammar of archetypal space: from the centre to the periphery

The optical focus of the yantra is always its centre. As the point of intersection, the centre is a supremely creative nucleus from which the etheric force-lines (setu) radiate outwards in concentric circuits and dissolve in the outer circumference (nemi). The nucleus of the yantra is the place of the epiphany of the divine (pīṭha-sthāna). Its central cosmic zone is the inner focus of all the outwardly directed circuits and lines.

In the sacred centre an epiphany may be represented in anthropomorphic form or as an emblem; or the spot may be marked by the mantric seed-syllables of the deity, such as Oṃ, Hrīṃg, Śrīṃg, Krīṃg. In some instances, especially in the important yantras such as the Śrī Yantra and Kālī Yantra, the mantra or devatā image at the centre is replaced by one of the most abstract of all symbols: the mathematically extensionless dot, the bindu. 1, 33 15 62

In the Tantras the bindu has been given several interpretations. As an ultimate figure beyond which energy cannot be condensed, the bindu is an appropriate symbol of the first principle, the One. Therefore, the bindu is a 'Whole', or 'Full' (pūrṇa), the undifferentiated, all-embracing reservoir of the infinite. With these associations, the bindu symbol is viewed in cosmological terms as the creative matrix of the universe, the 'world-seed' (viśva-bīja), the point of origin and return of cosmogonical processes. Metaphysically, the bindu represents the unity of the static (male, Śiva) and the kinetic (female, Śakti) cosmic principles, which expand to create the infinite universe of matter and spirit.

In meditation, as we shall see, the bindu is the region of the absolute where the ultimate union of the aspirant with the divine takes place. The centre of the bindu is the *sanctum sanctorum*, the abode of supra-mundane bliss (sarva-ānandamaya), and the ultimate goal of the sādhanā (worship), Being-Awareness-Bliss (Sat-Cit-Ānanda). Paradoxically, this last metaphysical point of integration with the totality, the absolute void (Śūnya), is also the first cause of the universe. The bindu thus symbolically functions in two dimensions, one in time, in existence, as a source and fount of all life, and the other in a sphere beyond all time, in 'timelessness'. Viewed subjectively, from the point of view of the sādhaka, the bindu corresponds to the energy centre of the subtle or psychic body which is visualized as located in the forehead (see p. 120 *ff*). In yantra meditation the central point of the yantra and the abstract centre of the aspirant are brought together by mental concentration.

Thus the bindu conveys a variety of concepts. There is a cosmological bindu which functions as the root matrix of creation; the psychological bindu which mirrors the sādhaka's own spiritual centre; the metaphysical bindu which expresses the union of male and female principles; tantrikas have even evolved the concept of the physiological bindu, which is concentrated as human semen.

The 'root' forms from which yantras are constructed, the triangle, circle and square, are considered essentially 'primordial' since visually they cannot be reduced further to orderly closed shapes.

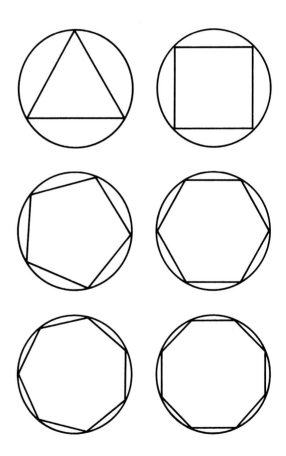

Archetypal shapes based on the division of a circle, after equations in the mathematical treatise Gaṇita Kaumudi (AD 1356)

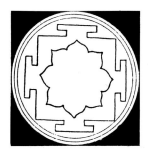

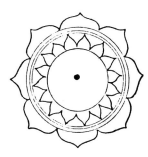

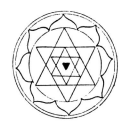

Lotuses as symbols of unfolding energies

The rhythm of creation is crystallized in the primal symbol of cosmic location, the triangle. The primary sign of sacred enclosure, since space cannot be bounded by fewer than three lines, the triangle is thus conceived as the first symbolic form to emerge from the cataclysmic chaos preceding creation. In this aspect it is known as the root matrix of nature (mūla-trikoṇa: mūla = root, trikoṇa = triangle). The inverted triangle is also the symbol of creative-genetrix feminine power (Śakti), whose kinetic dynamism gives impetus to the inert force in existence. It is the female emblem (yoni-maṇḍala) of the śakti-principle. With these two associations, the inverted triangle is the first enclosure surrounding the infinitesimal nucleus of most yantras devoted to goddesses, and is the emblem of the great goddess Kālī. The triangle with apex upwards denotes the male principle (Purusha) and is the emblem of Śiva. Its numerical equivalent is 3.

Whereas the bindu is the gathering-up of forces, the circle represents the cyclical forces, the contraction and expansion of astronomical revolutions, and the round of cosmic rhythms. Within this image lies the notion that time has no beginning and no end. The farthest region of space and the innermost nucleus of an atomic structure are bound by the constant flow of life and the rhythmic energy of creation. The circle may also be considered, in its concentrated form, as a bindu, or in galactic proportions as the expanding universe; its numerical counterpart is the zero.[2]

These three fundamental shapes, the point, triangle and circle, appear in intricate combinations and permutations, and may be related in several ways. Most frequent are the diagrams formed by interpenetration of two triangles to form a star-hexagon: the upward pointing 'male' and the downward pointing 'female' generate the concept of the fusion of polarities, the male and female, spirit and matter, the static and the kinetic in a perfect state of unity. The numerical equivalent of this figure is 6. Similarly, the aṣṭakoṇa (a figure with eight angles) results from the superimposition of square on square; its allusion is to the number 8, a sign of infinity and associated with the eight directions of space and the endless cycle of time. The star-pentagon illustrates the total organization of space into the numerical order of 5. The symbolic references of this figure are to the creative and destructive power of Śiva in his fivefold aspect (as one of the chief divinities of the Hindu trinity, Śiva has been represented in innumerable forms; in his fivefold aspect his epithets include: Conqueror of Death, Mṛityunjaya; an embodiment of knowledge, Dakshiṇa-mūrti; Lord of Lust, Kāmeṣvara; the Being of Life, Prāṇamaya-mūrti,; the Lord of the Elements, Bhūtesha).

The lotus blossom is one of the principle archetypal symbols used in yantras. Generally centred on the axis with its geometrically abstract petals pointing towards the circumference, it is the appropriate image to illustrate the unfolding of power or the divine essence.

In ancient Indian cosmology, the lotus was associated with creation myths, and is a type of physical prop to the universe. It is, for example, often depicted as springing from Vishṇu's navel, supporting and giving birth to Brahmā, the first god of the Indian trinity. From its pericarp the rest of the created world issues. Since the earliest times, the lotus has always been a symbol of the citadel of the heart, the seat of the

Self. Yogis believe that there are actual spiritual centres within us whose essential nature and luminosity can be experienced during meditation; these spiritual centres are often represented symbolically as lotuses. The *Chāndogya Upanishad* (VIII, I, 1–3) states:

> Within the city of Brahman, which is the body, there is the heart, and within the heart there is a little house. This house has a shape of a lotus, and within it dwells that which is to be sought after, inquired about, and realized.
>
> What, then, is that which dwells within this house, this lotus of the heart? . . .
>
> Even so large as the universe outside is the universe within the lotus of the heart. Within it are heaven and earth, the sun, the moon, the lightning and all the stars. Whatever is in macrocosm is in this microcosm . . .
>
> Though old age comes to the body, the lotus of the heart does not grow old. It does not die with the death of the body. The lotus of the heart, where Brahman resides with all his glory – that, and not the body, is the true city of Brahman.

Thus the true city of the Supreme Principle is the heart, or central core of the individual, symbolized by the lotus which remains untouched by the banal reality of every-day living; from the tantric point of view, the lotus is the pure Self revealed in meditation, the spiritual state in its fullness.

Because of its associations with progression, development and the life-expanding quality of prāna (breath, or the vital force of nature), the lotus represents the 'out-petalling' of the soul-flower in the process of spiritual realization. The aspirant's lotus-field (padma-kshetra) is formed of the energy-centres of his subtle body, and their 'opening-up' implies the state of complete repose when the purpose of yogic meditation is attained.

The square is the fundamental format of most yantras. It is the substratum, the receptacle and base of the manifest world. The square denotes the terrestrial world which must be transcended. Its prosaic regularity is contained by the compass points of the four cardinal directions, and its numerical equivalent is 4.

Four is a symbol of the world extended into four directions, uniting in its horizontal and vertical directions pairs of opposites, and representing the totality of space. The square is the form of order and perfection, the 'support' of the yantra figure.

Each of these figures – circle, square, triangle, lotus – may function as a complete yantra or be combined with several linear circuits. Each primal symbol has a range of meanings, according to its context and the plane of consciousness on which it functions.

At the periphery of the figure are four T-shaped portals, placed at the four cardinal directions and known as cosmic doors because it is through them that the aspirant symbolically enters the cosmic force-field. Pointers directing towards the interior of a yantra, the portals are an initiatory threshold which simultaneously opposes the phenomenal and embraces the noumenal.

The portals, with their extended gates, are the earthly plane of existence (bhūgraha) or the region of materiality, and signify the lowest point of the ascent towards perfection. In effect, they represent the earthly passage between the external and 'material' and the internal, sacred space of the yantra. The frontiers

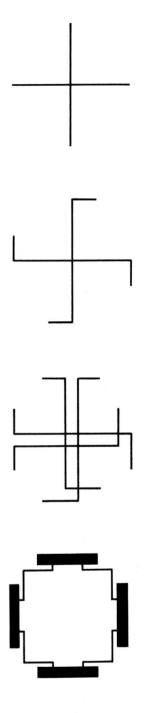

The cross extended into a double swastika, indicating that the Supreme Principle can be reached by both 'right-hand' and 'left-hand' paths. In the fully formed square enclosure of the yantra the gates open out at all four sides and are invitations towards the sacred centre

which are related to the directions and determinants of space have their own complex iconographic deities who forbid negative forces to enter. The deities of the spheres, Lokapālas, who preside over the T-shaped portals and square enclosure of the yantra, may be four, eight or ten in number, corresponding to the four regents of space, the intermediary directions, the nadir and the zenith. In yantras devoted to goddesses, a group of auxiliary Śaktis or the eight Bhairavas (epithets of Śiva) flank the doors. Where the yantras are completely closed circuits, as in the Sarvatobhadra (square grid) form, each of the outer squares (pada) is presided over by a guardian divinity of one of the four quarters, sometimes represented by emblems, such as the trident, goad, noose, etc. In all types of yantra, however, the basic function of these divinities is the same: to protect the sacred precinct from negative or disintegrating forces.

Sacred sound

Inseparable from yantras are the subtle vibrations which help to intensify their power. These sound elements are often represented by letters inscribed on the yantra, and in principle all yantras are associated with mystic combinations of Sanskrit letters.* The inner dynamics of the yantra can never be understood in isolation from the system of sound dynamics, as the two combine to make up the complete 'definition' of the divine. The yantra-mantra complex is basically an equation that unites space (ākāśa), which in its gross form appears as shapes, and vibrations, which in their finite forms occur as the spoken or written word.

Essentially, then, a mystic sound combination composed of Sanskrit letters, a simple mantra consists of 'atomic' monosyllabic sounds such as Krīṃ, Hrīṃ, Śrīṃ, Aiṃ, and more complex mantras are composed of a sequence of such syllables. Almost all yantras have some form of mantra, either simple or complex, inscribed on them. The centre of the yantra is generally inscribed with the most important syllable of the mantra associated with it, while other mantric letters are arranged in the spaces formed by the intersection of lines, either around the circle or on the lotus petals or on the outer square band (bhūpura) of the yantra. Certain important yantras may contain all the vowels and consonants of the Sanskrit alphabet in their spaces, whereas others will be inscribed with whole mantric verses associated with the particular devatā (tutelar deity) the yantra represents.

The infinite diversity of the universe as represented by the deities is manifest most explicitly in the iconographic image, more abstractly as the yantra and most subtly by the mantra. The mantra projects through vibrations the subtle anatomy either of the devatā (from which it is inseparable) or of the forces of the universe. The mantric energy condensed in the letters is seen as vested with a spiritual power beyond human comprehension. Pronounced correctly, joined, and with the correct rhythm, accent, intonation and mental attitude, a mantra becomes the 'soul of the yantra' (Kulārṇava Tantra), and a vitalizing force within the mind of the seeker.

A common mistake is to view mantras in conceptual terms, splitting hairs over the meaning of the vocables. Mantras are not to be regarded as parts of speech, or

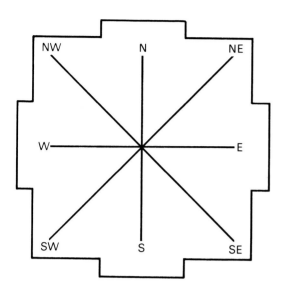

The eight compass points locating the divinities of the eight regents of space who guard and protect the microcosmic universe of the yantra

Śrīṃ, seed mantra of the goddess Lakshmī, the Śakti of plenitude and fortune

*For note on Sanskrit pronunciation, see p. 170.

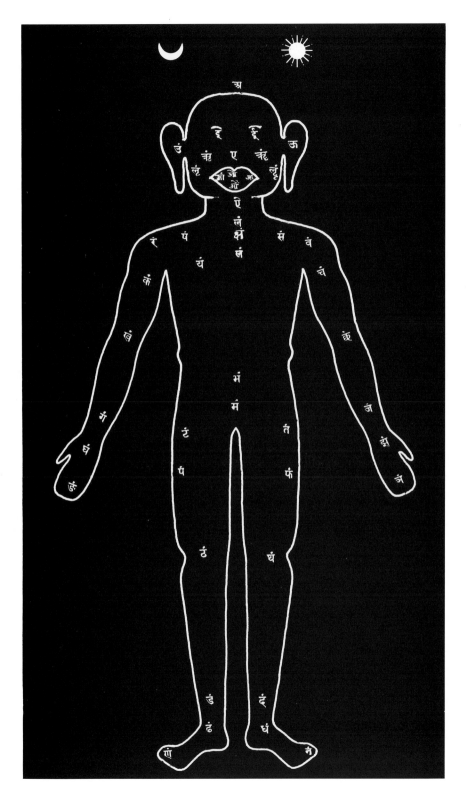

The Sanskrit alphabet, symbol of cosmic sound, related to the parts of the subtle body and energized in a ritual known as Aṅga-nyāsa. After the Sanskrit work Tārārahasya (v. 138–40)

elements of grammar. They are non-discursive symbols articulating the ineffable in terms of resonating wavicles of sound vibrations. The concentrated symbol of the metric mantra and the compact whole of the yantra coincide to arouse appropriate psychic states in the sādhaka.

33

To be efficacious, a mantra must be transmitted by a guru to the disciple. It should be distinguished from the Kavaca ('cuirass' – a protective formula), the yāmala (a mantra based on a text), and the dhāraṇī (a mnemonic formula containing a mantra).[3]

The image of the world as a web of sound is a constant theme of the Tantras. The *Sāradātilaka Tantra*[4] describes the visionary world-tree (lipi-taru) as composed of an intricate mesh of Sanskrit letters which are the spreading resonances of cosmic energy. The entire physical universe, composed of the five elements (earth, water, fire, air, ether), is represented by a set of sound combinations on the various parts of the world-tree. Its seed is the self-creating original principle; its tap roots are cosmic 'location' and vibration (bindu and nāda) that spring from the eternal male and female principles; its branches are composed of letters that denote the earth element; its leaves that spread over the three worlds are made up of letters that stand for the water element; its shoots, bright 'as gems', are made up of the letter combinations that denote the element fire; the flowers of the tree are represented by the letters of the air element and the fruits of the tree by the letters representing ether. The *Sāradātilaka Tantra* also divides the Sanskrit letters into five classes, each of which represents one of the five elements. Virtually every aspect of the physical world, including the solar system with its planets and stars, is symbolically represented by mantric equations.

The *Tantrasāra*[5] divides the Sanskrit letters into combinations of two, three and four units, and equates these letter-combinations with the twelve zodiacal signs (Rāśi-chakra).

Man is included in the system of vibrations and in some Tantras[6] each letter is said to have an effect on a corresponding level in the human body. In a ritual known as the Mātṛikā-nyāsa, the ritual projection of the letters is achieved by touching various parts of the body while reciting mantras with the vivifying nasal sound, m; the aspirant seeks to transpose the sound powers of the Mātṛikā Śakti into his subtle body. In a similar ritual the alphabetical conjunctions represent aspects of the physical universe (macrocosm) and affinities are struck with the human body (microcosm).

The doctrine of the primacy and eternality of sound, which underlies the theory of mantra, has a very ancient history and is upheld most zealously by the Trika school of Kashmiri Śaivism, which was influenced greatly by tantric thought. This school links the phenomenon of the pronounced sound as mantra with the highest metaphysical principle of their system – the Mātṛikā Śakti, the Primordial Energy, which is latent within the letters of the mantras or mystic syllables. Speech as it is expressed in vocables is looked upon not only as being generated by physical organs and breath but as being supremely conscious in itself. Ultimately all letters are seen as the reflection of the universal energy divinized in the concept of Mātṛikā Śakti.

Articulated speech and the alphabets are the 'little mātṛkās', or finite prototypes of the primordial Mātṛkā Śakti. It is perhaps for this reason that the letters of the Sanskrit alphabet, called the Mātṛkā, are also known as akshara or 'imperishable', because they share the immutable and eternal quality of their source. The Mātṛkā Śakti emanates as speech on two different levels: in its 'eternal' aspect as mantra and in its finite aspect as ordinary language.

The mantras are also intimately associated with the theory of the eternal word, Sphoṭavāda, expounded by the philosophers of Sanskrit grammar, who traced the germ of speech or words back to divine source (an imperishable unit of speech: Sphoṭa, also known as Vāk, or Praṇava or Śabda-Brahman), thus raising the formalism of grammatical speculation to the dignity of a theological discourse. The basis of everything, they held, is the word: 'It is the word-element from which all the universe takes its birth, retains its life, and becomes capable of mutual social behaviour.'[7] All transitory words that can be seen and heard are held to derive from a subtle form of sound (madhyamā) in which sound exists as a thought-force; beyond this is another level of sound (pashyanti) in which sound exists as a concept or idea in its germinal state, like 'the seed of a tree before sprouting'; ultimately, sound is generated by Parā, the first stage of vibration, where it exists as 'unstruck' or silent sound.

Thus any letter inscribed on a yantra can be traced back to its metaphysical sources; it then ceases to be a method of conveying meaning and becomes a fragment of sacred sound, the parallel of archetypal space, which has the power to tap the inert energies of the yantra.

Particular sound-syllables are especially linked to yantras. The sound-syllable Oṃ represents the fundamental thought-form of all-pervading reality. With its associations with the universe in all its manifestations, Oṃ is a complete alphabetical yantra in its own right and can be equated with the creative point, the bindu.

A number of syllables, such as Hrīṃ, Krīṃ, Aung, Phaṭ, which are frequently inscribed in or otherwise associated with yantras, are the primary mantras (mūla-mantra) of the divinity. They are called seed mantras (bīja-mantras) as they contain the quintessence of the powers of the divinity and complement the 'root' forms of the yantra. These basic mantras are omnipotent formulae, instinct with the power of the divinity: 'Verily, the body of the deity arises from its basic seed mantra' (Yāmala Tantra). They are generally inscribed in the centre of the yantra, and are substitutes for an anthropomorphic image as its 'indestructible prototype'.

In ritual and meditation with yantras, the seed mantras are pronounced from the diaphragm, then from the throat, rolled round the mouth and finally closed off with a nasal sound, m. Although the seed mantras are composed of single syllables, each sound is a further symbol of either an attribute or the complex nature of divinity. Thus, for instance, the seed mantra of the goddess Bhuvaneśvarī, the Lady of the Three Spheres, consists of four sounds, H-R-Ī-M: H = Śiva, R = Prakṛti or nature, Ī = Māyā or creative play, M = dispeller of sorrow. Thus the mantra represents the whole nature of the goddess whose worship grants boons and dispels sorrows.

Hrīṃ, seed mantra of the goddess Tripurā-Sundarī, denoting the unity of the male and female principles. It is also the primal vibration of the goddess Bhuvaneśvarī who presides over the three spheres

Krīṃ, seed mantra of the goddess Kālī, representing her power of creation and dissolution

Like yantras, mantras can be categorized according to classes and purposes, and in principle are matched to particular yantras. Mantras which induce a trance-state, for instance, are associated with yantras which are used for enlightenment; protective mantras are paired with yantras which are defences against malignant powers, and so on. So intimate is this relationship that mantra and yantra are parallel to each other and in some cases may be interchangeable. A letter may assume the form of a diagram and manifest as a 'static' mantra-yantra; conversely, the yantra may be aroused into vibrating rhythm and function as a mantra.

When a particular letter functions as a yantra it is given an abstract geometrical figuration. A characteristic graphic representation of the sacred monosyllable Oṃ in its yantra form appears in the Orissan manuscript *Sayantra Sūnya-Saṃhitā*, where it is split into five constituent parts, starting from the bindu and proceeding to curves having an element of the spiral. These five graphic forms correspond to the complete unfolding of the basic principles of the universe in its fivefold aspects, such as the five elements, five subtle essences (tanmātras), five deities, five seed mantras, etc.

In addition to the seed mantras, there are a number of complex mantras composed of several seed-syllables. Their number, mode and purpose, with their yantras, are mentioned in several tantric texts.

The structure of certain mantras is based on the esoteric symbolism of numbers. The mantra devoted to Śiva, for instance, is composed of five letters (pañcākshara) - Na/maḥ Śi/vā/ya. In religious practice and mythology Śiva combines in himself five aspects of the universe. His eternal energy is conceived of as evident in five

	Devatā	Seed mantra	Element	Subtle element	Vital air in the subtle body
●	Sudarśana	Pliṃ	ether	sound	Udāna
‿	Siṃhāsana	Dhliṃ	air	touch	Vyāna
ↄ	Jagannātha	Kliṃ	fire	sight	Samāna
৪	Subhadrā	Sliṃ	water	taste	Apāna
�‿	Balbhadra	Hliṃ	earth	smell	Prāṇa

Oṃkāra Yantra, a graphic representation of the primordial seed sound Oṃ, symbolizing the whole cosmos. The letter Oṃ is split up into five shapes to represent the entire universe, resolved into five cosmic principles. After the Orissan palm-leaf Ms. Sayantra Sūnya-Saṃhitā

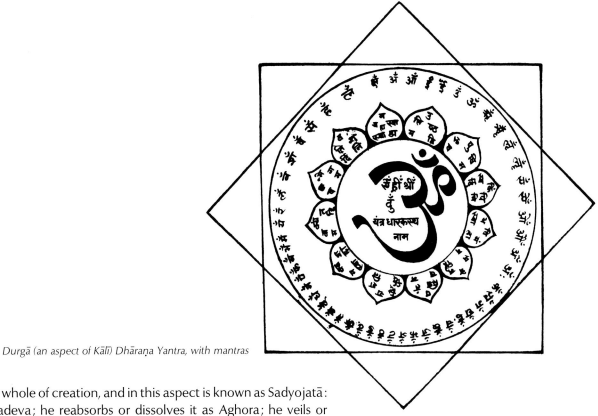

Durgā (an aspect of Kālī) Dhāraṇa Yantra, with mantras

activities: he enfolds the whole of creation, and in this aspect is known as Sadyojatā: he preserves it as Vāmadeva; he reabsorbs or dissolves it as Aghora; he veils or conceals the world of phenomena in his Tatpurusha aspect; finally, as Iśāna, he grants boons and bestows on his devotees grace which leads towards final liberation. These five aspects are correlated with important and fundamental sets of five psycho-cosmic principles such as the five elements, the five senses and five quarters (the four regents of space + zenith). This is one of the reasons why the pentagon is associated with Śiva (see p. 32 above). The five syllables of the Śiva mantra are an attempt to illustrate his immanence in his five aspects, and when his mantra is inscribed in the yantra, it symbolically recapitulates the fivefold Śaivite tenets. Similarly, the mantra devoted to the second god of the Hindu trinity, Vishṇu, has twelve syllables – Oṃ/ Na/mo Bha/ga/va/te/ Vā/su/de/vā/ya; as does that of the sun god Sūrya, associated with the twelve zodiacal signs.

The Gāyatrī Mantra

One of the most important longer mantras, commanding great respect since Vedic times, is the Gāyatrī Mantra. This reads: Oṃ bhur bhuvah swaḥ tat savitur vareṇyam, bhargo, devasya dhimahi, dhiyo yo naḥ pracodayāt, Oṃ – 'May we meditate on the effulgent Light [or Power] of he who is worshipful and who has given birth to all worlds. May he direct the rays of our intelligence towards the path of good.'[8] The tantric version of the Gāyatrī Mantra in the *Śrīvidyārṇava Tantra*,[9] given in

the table below, illustrates how each of the syllables of the expanded mantra is linked with a deity, a colour, a bodily mechanism and a cosmic principle. The mantra is inscribed in a circular fashion in the Gāyatrī Yantra, symbolically integrating a whole mantra-picture of the universe with the yantra form.

Mantra syllable	Colour	Śakti (goddess)	Cosmic principle (micro-macrocosm)
Tat	yellow	Prahlādini	earth
Sa/	pink	Pradhā	water
vi/	red	Nityā	fire
tuḥ	blue	Viśvabhadra	air
va/	fiery	Vilāsini	ether
re/	white	Prabhāvati	smell
ni/	white	Jayā	taste
yam	white	Sāntā	sight
Bha/	black	Kāntā	touch
rgo	red	Durgā	sound
De/	red on lotus	Saraswati	speech
va/	white	Viśvamāyā	hands
sya	golden-yellow	Visāleśā	genitals
Dhi/	white	Vyāpini	anus
ma/	pink	Vimalā	feet
hi	conch-white	Tamopahāriṇi	ears
Dhi/	cream	Sūkṣma	mouth
yo	red	Viśvayoni	eyes
Yo	red	Jayāvahā	tongue
Naḥ/	colour of the rising sun	Padmālayā	nose
Pra/	colour of blue lotus	Parā	mind (manas)
co/	yellow	Śobhā	ego-sense (ahaṃkāra)
da/	white	Bhadrarūpā	The first causal principle of the world (mahat)
yāt	white, red, black	Trimurti	Three qualities of material nature: sattva, rajas, tamas (i.e. radiance, activity, inertia)

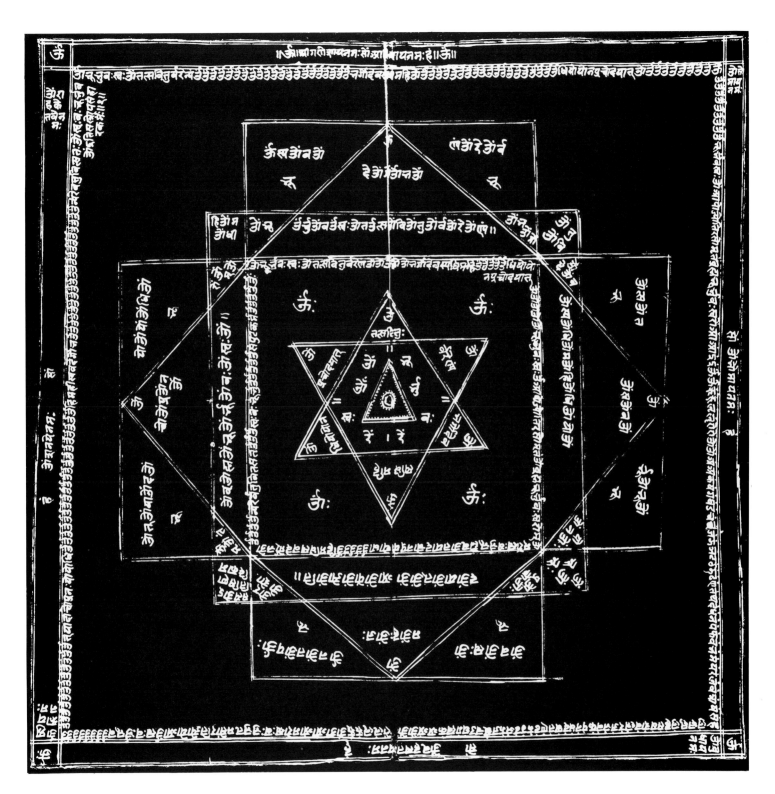

The Gāyatrī Yantra inscribed with the Gāyatrī Mantra. Rajasthan, c. 19th century. Ink and colour on paper

41

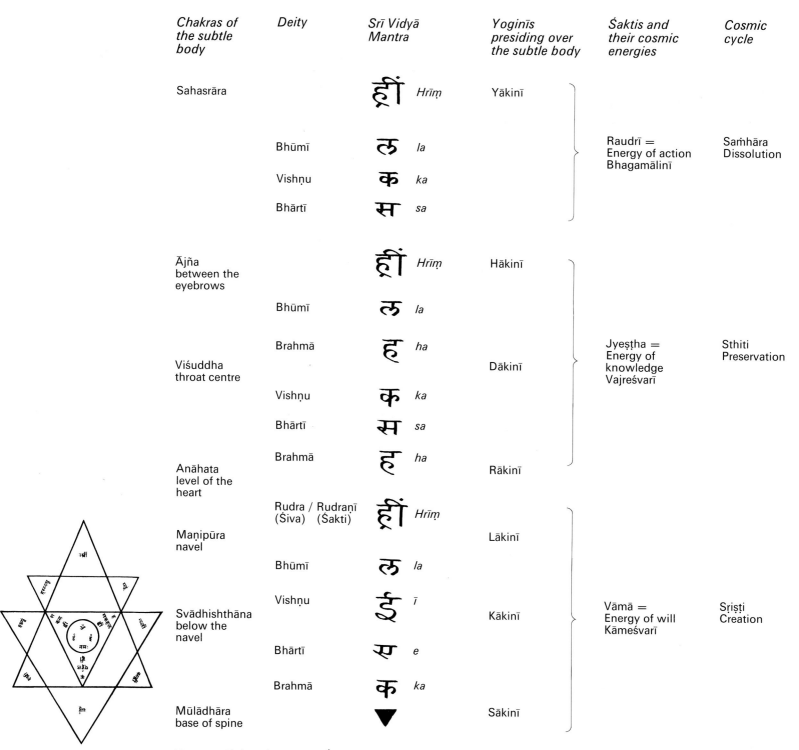

Chakras of the subtle body	Deity	Śrī Vidyā Mantra	Yoginīs presiding over the subtle body	Śaktis and their cosmic energies	Cosmic cycle
Sahasrāra		ह्रीं Hrīṃ	Yākinī		
	Bhūmī	ल la		Raudrī = Energy of action Bhagamālinī	Saṃhāra Dissolution
	Vishnu	क ka			
	Bhārtī	स sa			
Ājña between the eyebrows		ह्रीं Hrīṃ	Hākinī		
	Bhūmī	ल la			
	Brahmā	ह ha		Jyeṣṭha = Energy of knowledge Vajreśvarī	Sthiti Preservation
Viśuddha throat centre			Dākinī		
	Vishnu	क ka			
	Bhārtī	स sa			
	Brahmā	ह ha			
Anāhata level of the heart			Rākinī		
Maṇipūra navel	Rudra / Rudraṇī (Śiva) (Śakti)	ह्रीं Hrīṃ	Lākinī		
	Bhūmī	ल la			
	Vishnu	ई ī		Vāmā = Energy of will Kāmeśvarī	Sṛṣṭi Creation
Svādhishthāna below the navel			Kākinī		
	Bhārtī	स e			
	Brahmā	क ka			
Mūlādhāra base of spine		▼	Sākinī		

Nava-yoni Chakra. The yantra for Śrī Vidyā worship, composed of interpenetrating triangles to symbolize the imperishable unity of Śiva/Śakti. The 15 seed syllables inscribed around the circle represent all the hierarchies and planes of the cosmos, and illustrate the mutual interrelationship of microcosm and macrocosm. The 15 syllables are divided into three groups. The first has 5 seed vibrations: ka = primordial desire, e = causal womb, ī = substance of generative force, la = Śiva, and Hrīṃ = seed syllable of the goddess Tripurā-Sundarī, invoked in the yantra. The second group consists of 6 seed syllables: ha = Śiva, sa = Prakṛti, ka = force of nature as primordial desire, ha = Śiva aspect, la = cosmic ether, plus the seed mantra Hrīṃ. The third group consists of 4 syllables: sa, ka, la, Hrīṃ, and represents the unity in duality of the male and female principles. The aspirant may internalize this complex symbolism by concentrating on the esoteric essence of each of the syllables, and so intuit his unity with the cosmos. After the tantric work Varivasyā-Rahasya

The reason the sound vibrations of the Gāyatrī Mantra are divided into twenty-four syllables is probably to correspond with the twenty-four cosmic principles, technically called tattvas, of the traditional Sāṁkhya system of Indian thought (see p. 74). These principles, from the point of view of creation, represent the entire static and kinetic universe; from the point of view of man, they embody the whole psycho-physical and spiritual self.

The Śrī Vidyā Mantra

A highly esoteric mantra is the Śrī Vidyā Mantra which is discussed in the *Varivasyā-Rahasya*, a tantric text devoted to the supreme goddess Tripura-Sundarī who, in her knowledge aspect, is known as Śrī Vidyā. The cosmic vision of the tantras can be considered either exoteric or esoteric; these two viewpoints give two sides of a single doctrine. The former looks at the exterior, the literal, and is easily comprehensible; when tantric deities are in their exoteric sense, for example, they are comprehended by the senses in their image form. But from the subtle, or esoteric, point of view the deities are expressed in a group of vibrations like the mantra of Śrī Vidyā. Esotericism being more subtle and interior, Śrī Vidyā sādhanā (ritual practice) is confined to 'secret circles' in which the individual teaching is by oral transmission from the preceptor according to the disciple's level of spiritual awareness. The Śrī Vidyā Mantra consists of fifteen seed-vibrations which are partial aspects of the supreme goddess and are believed to hold the force of Enlightenment. This mantra may be worshipped in the Śrī Yantra (see p. 109), or in the Yantra of Nine Triangles (Nava-yoni Chakra, see opposite), in which case the fifteen esoteric syllables are divided into three principal groups and are inscribed in the primal triangle around the bindu.

62
12

It is held by Śrī Vidyā practitioners that one syllable of the fifteen is in the nature of Pure Consciousness (Cit). This secret syllable is generally not recorded in the texts. When uttered by the guru with the correct instruction it can bring about the aspirant's direct comprehension of the highly esoteric properties of the yantra-mantra complex. Like the Gāyatrī Mantra, above, the Śrī Vidyā Mantra has a precise psycho-cosmic symbolism.

The combinations of letters inscribed on the yantras must be logically congruent with the structure of the Sanskrit language. Certain important yantras, such as the Śrī Yantra, have all the Sanskrit vowels and consonants inscribed in their angles or on the lotus petals. According to tantra, the first Sanskrit letter, A, represents Śiva. When the letter A is aspirated and pronounced from deep in the throat, it sounds Ha, the letter symbol of Śakti as well as the last letter of the Sanskrit alphabet. The combination of the two letters A and Ha embraces the entire range of the Sanskrit alphabet and epitomizes the whole of creation in its subtle aspect as sound.

As related to yantras, then, mantras serve two main purposes. They stand for the deity whose mantra is inscribed on the yantra, and they are used extensively during worship and meditation with yantras, chanted and intoned during ritual (see pp.

102–5). Ritual mantras may take the form of complete verses, repeated combinations of the seed syllables (japa) or single letters which serve in some cases as 'reminders' of ideas of the qualities either of the deities or of the universe.

Finally, the mantra and the yantra form a complex dialectic of form and sound. Although the yantra and the mantra are two distinct principles and operate on two distinct levels, they are mutually influential and complementary: every yantra can be reduced to certain frequencies of vibration (mantra) and every sequence of vibrations can be grouped into particles of matter to form an appropriate geometrical shape (yantra). The yantra and the mantra are meant to substitute for each other and operate on a principle of modern science similar to the conservation of energy into matter and matter into energy. A yantra in its 'root' vibration may be considered as a seed mantra of the divinity and allowed to exist only in the mind as a thought-force, or the nucleus of the seed mantra may be exteriorized, expanded and localized as harmonic lines. In other words, it is possible to 'see' sound as form and 'hear' pattern as sound.

Recent research in cymatics (the study of the interrelationship of wave-forms and matter) has shown remarkable results: 'The Hindu sacred syllable Oṃ, when correctly uttered into the tonoscope, apparently produces the circle 'O', which is then filled in with concentric squares and triangles, finally producing, when the last traces of the 'm' have died away, a "yantra".'[10] Such complex energy transformations lend support to the conclusion that yantra and mantra, in the ultimate sense, are one and the same.

Yantra and mantra thus present the union of archetypal space and sacred sound. Both are aids to inward illumination which tap the senses of sight and sound in order to transcend the phenomenal. Each is inseparable from the other, with mantra the 'soul' and yantra the 'body' of subtle sound.

65

13 Yantra of the goddess Chāmuṇḍā (a form of the great goddess Kālī) inscribed with sacred syllables or mantras. Here the seed mantras Oṃ, Hrīṃ and Klīṃ are related to each part of the yantra, intensifying the diagram's energy and vitalizing its static shapes when they are meditated upon or chanted during worship. Rajasthan, 19th century. Ink and colour on paper

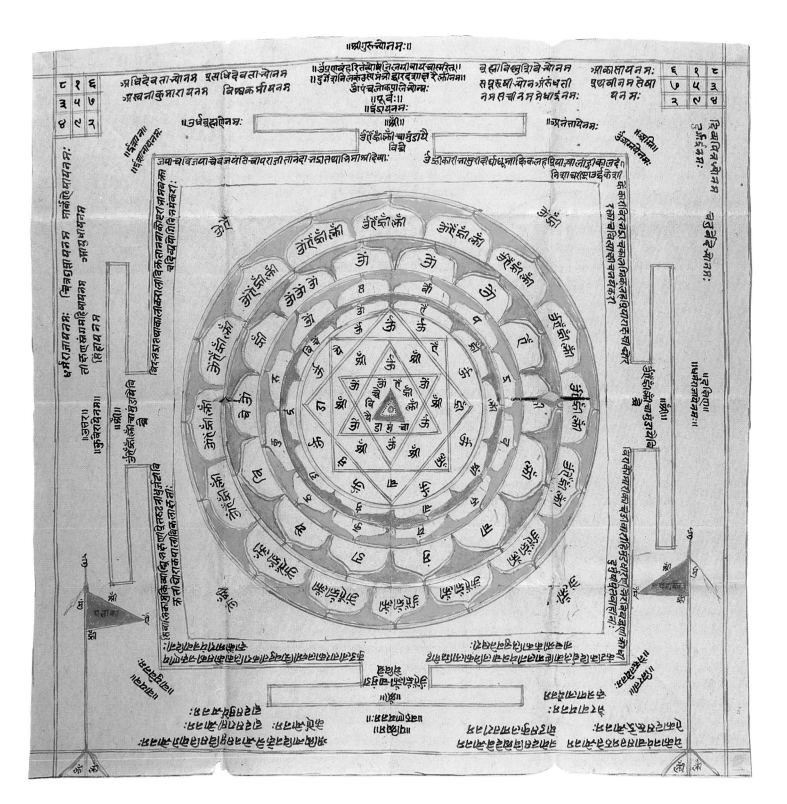

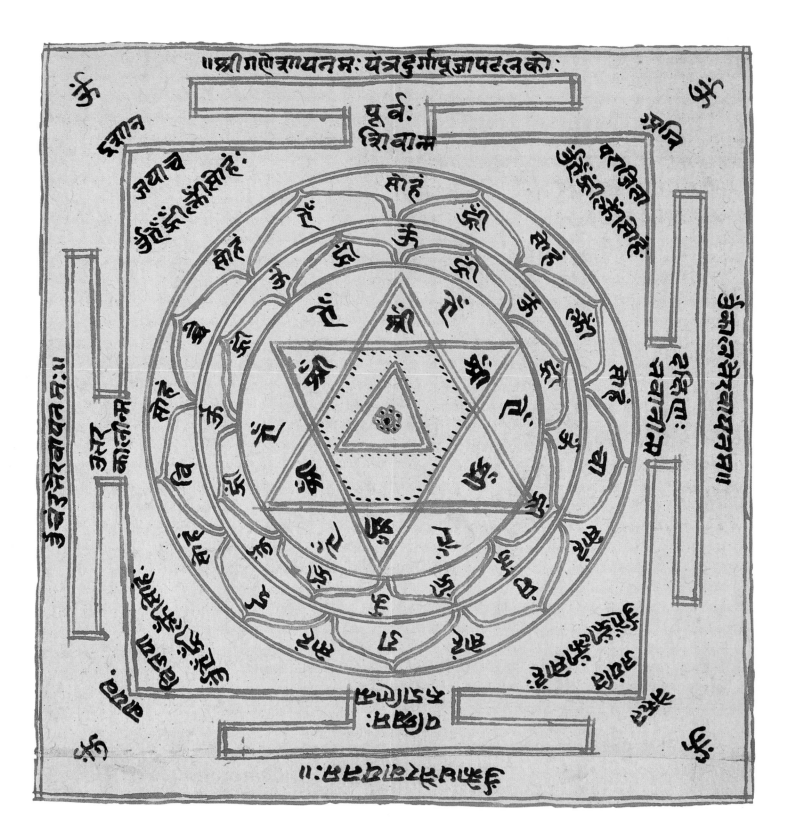

14 Yantra and seed mantras of the goddess Durgā, an aspect of Kālī, representing the dissolution of the dark forces of nature and triumph over evil. Rajasthan, 19th century. Ink and colour on paper

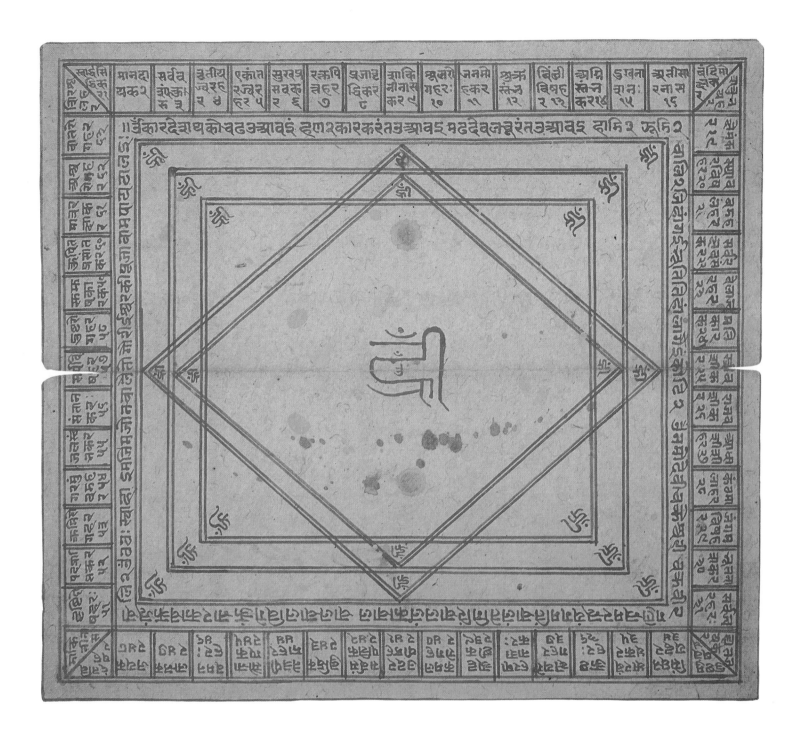

15 Yantra with the syllables Oṃ Hrīṃ inscribed in the centre and at the cardinal directions. This mantra is the symbol of the tantric goddess Lalitā, denoting her creative play (Māyā) which gives rise to the manifested world. Rajasthan, 19th century. Ink and colour on paper

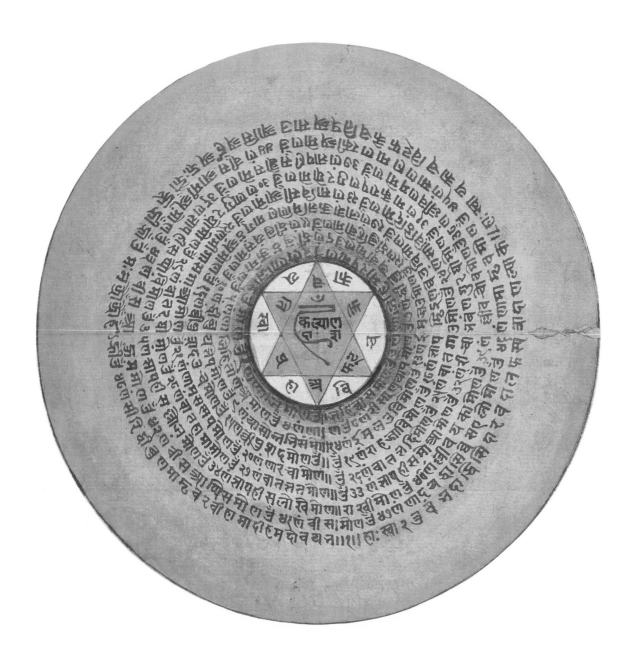

16 Kalyāṇa Chakra, the 'Wheel of Fortune'. The mystic syllables radiating from the centre are grouped in a cryptic manner in order to conceal the yantra's esoteric significance from the uninitiated. Rajasthan, c. 19th century. Ink and colour on paper

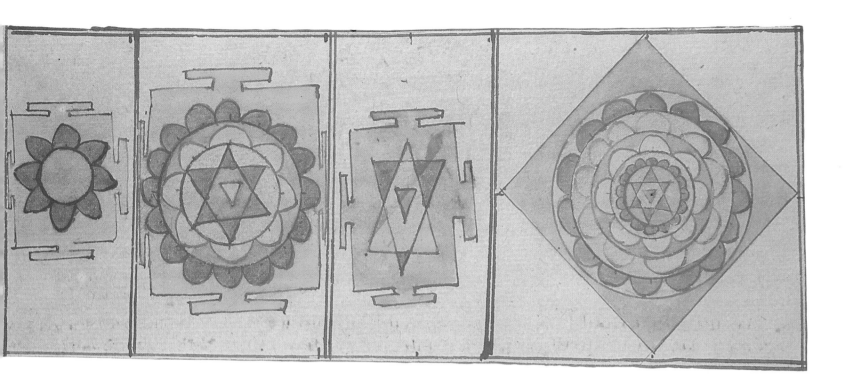

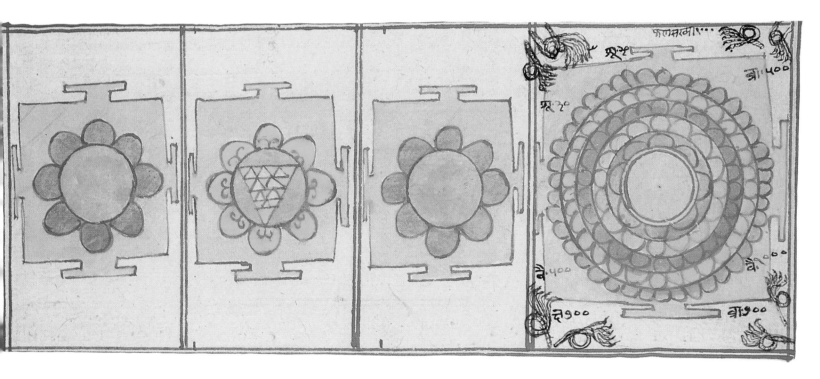

17, 18 All tantric deities have their corresponding yantra forms. Top, from left to right: yantra of Annapurṇā, a form of Durgā, and three yantras of Mahāvidyā Bagalā-mukhī; above, from left to right: two yantras of Sūrya, the Sun God; one of Śiva; and one of another aspect of Śiva, Mṛtunjaya, the Conqueror of Death. *Mantramahodadhi*, Rajasthan, *c.* 18th century. Gouache on paper

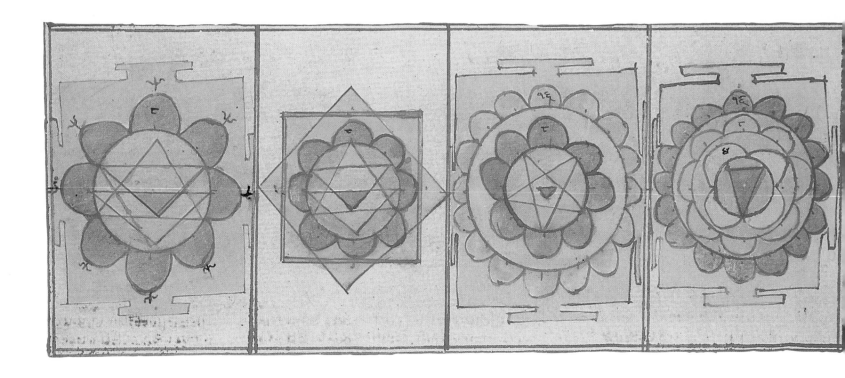

19 Ceremonial yantras of the partial aspects of the feminine or kinetic principle, which is considered by tantrikas to be the highest principle of the cosmos. Left, three yantras of the Supreme Energy as a young maiden, Bālā; right, an Annapurṇā Yantra devoted to the goddess as the giver of food and plenty. *Mantramahodadhi*, Rajasthan, *c.* 18th century. Gouache on paper

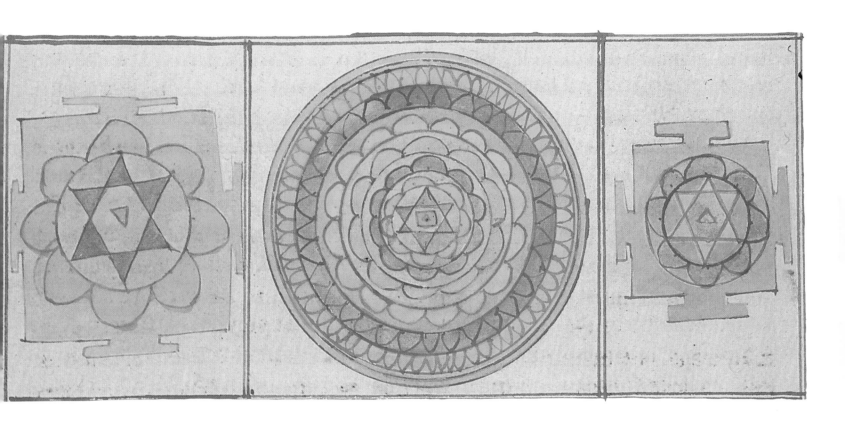

20 Yantras of deities are essentially aids to concentrated visualization and contemplation. The imagery of the cosmic 'whole' allows the worshipper to discover his own inner wholeness. Three yantras of the goddess Tārā draw the sādhaka's vision to the mystic centre. *Mantramahodadhi*, Rajasthan, *c.* 18th century. Gouache on paper

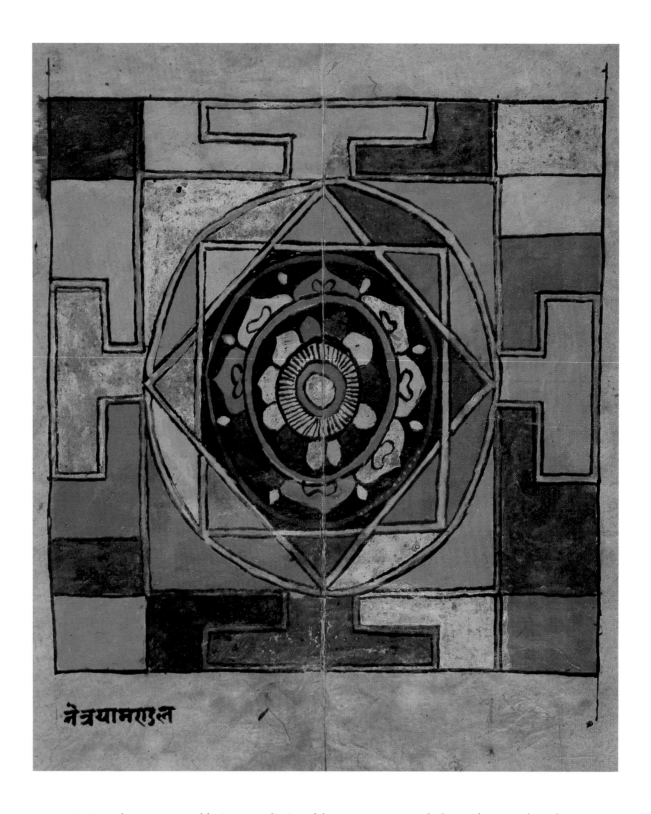

नेत्रयामएत

21 Yantra from a series used for inner visualization of the cosmic processes which provide a metaphysical basis for their symbolism, leading to the experience of man-cosmos unity. Nepal, c. 18th century. Gouache on board

3
Metaphysics of Yantra

Considered as being essentially guides to human enlightenment, yantras express a comprehensive vision of reality, illuminating for the sādhaka the nature and mystery of the cosmos. The framework of metaphysical teachings within which yantra symbolism evolved is a 'transcription' of the main principles of Indian thought, some of the oldest systematized speculations on man and nature.

One of the principal symbolic components of the yantra is the deities inscribed or depicted within its linear framework. So varied and numerous are the possible deity projections that the whole pattern of the yantra may be considered as a complex rubric of divine manifestations. These deities are expressions of conscious principles, relating the aspects of the manifested universe; and, as we shall see in the following chapters, they are equally symbols of the phases and forces of the human mind and personality.

Tantra has absorbed the whole corpus of earlier traditions and evolved its own cosmic vision, giving specific tantric interpretations to the traditional Hindu deities. Accordingly tantric Śaiva yantras project the manifold nature of Śiva; Vaishṇava yantras depict Vishṇu in his divine incarnations, with his qualities and characteristics; and yantras devoted to goddesses are the summary of the attributes and emanations of the Female Creative Power (Śakti). The surrounding deities of yantras – there may be as few as three or as many as one hundred in a single yantra – are technically known as Āvaraṇa Devatās (deities who shadow or veil the principal archetype). According to *Kāmakalāvilāsa* (v.35), in goddess yantras they are like a 'patch of cloud' which hides the luminous effulgence of the Primordial Goddess placed at the centre of the yantra whose radiance is like the sun. The Āvaraṇa Devatās are like the limbs of the primordial Śakti in her transformation in her yantra.

The Principle of Energy

A fuller understanding of the metaphysical basis of yantra must begin with consideration of the tantric doctrine of Śakti. Śakti is the immense power inherent in the universe. Everything that moves and breathes is a manifestation of Śakti and has its basic consciousness, power and action. Śakti is a creative mystery that displays itself in different spheres in different ways. To the physicist Śakti implies the inherent active force of matter; to the psychologist Śakti displays itself through the external stimulus that acts on the mind; to the mystic the spiritual experience of unity is Śakti. The entire edifice of science may be seen as being related to the notion of Śakti, with matter, energy, sound – all the main constituents of physical science –

displaying a power that is their essential nature. Everything in life possesses a force to transform, to become, to be, to expand its inherent nature and grow as it were from within, which is Śakti.

For tantra this Śakti is both transcendent (abstract) and immanent (concrete). If a synthesis of all active and potential forces were possible, there would still be an inexhaustible and untapped reservoir of this force. Śakti is therefore seen as creating, maintaining and absorbing every aspect of life and plane of existence. Although the Sanskrit word śakti is feminine, the concept refers to a cosmic principle that transcends finite explanations in terms of gender: Śakti, *Mahākāla Saṃhitā* states, 'is neither female nor male nor neuter. It is inconceivable, immeasurable Power, the Being of all which exists, Void of all duality, attainable in illumination.'[1]

The highest personification of the Supreme Energy Principle is expressed iconographically as feminine in the Tantras. Though neutral in her ultimate aspect, theologically Śakti is contemplated as a goddess, or Devī, under the names of Kālī, Tārā, Durgā, Pārvatī, Lakshmī, etc.

In early Indian history the vision of the sacred as feminine received little attention. Vedic theology was male-oriented, and goddesses were assigned peripheral roles: they appear as consorts to male gods and as subservient to male power. By the beginning of the tantric renaissance (AD 700–1300), however, the female reappeared with greater importance and began to share the grandeur of the gods. Eventually, goddesses exercised so great an influence in Hindu mythology that they overshadowed the previously male-dominated theology and became 'total' symbols of divine power.

The female principle as an emblem of kinetic or potential energy as well as the chief symbol of the Absolute Reality (Brahman) has since dominated the whole range of tantric thought.[2] In the *Devī Upanishad* (1–3) the Supreme Goddess explains her true nature, that transcends all empiric existence and represents all the attributes and functions of the Hindu trinity:

> Great Goddess, who art Thou?
> She replied: I am essentially Brahman [the Absolute].
> From me has proceeded the world comprising Prakṛiti [material substance]
> and Purusha [cosmic consciousness], the Void and the Plenum.
> I am [all forms of] bliss and non-bliss.
>
> Knowledge and ignorance are Myself.
> I am the five elements and also what is different from them, the pañchabhūtas
> [five gross elements] and tanmātras [five subtle elements].
>
> I am the entire world.
> I am the Veda as well as what is different from it.
> I am unknown; I am born
> Below and above and around am I.

The origin of the goddess has been described in several ancient texts.[3] A Hindu legend explains that in a battle to overthow negative forces, the denizens of heaven, Brahmā, Vishṇu and Śiva, emitted a flood of their energy in all directions which condensed into the form of a woman. This is how Śakti, having emerged from

a miraculous amalgamation of the energy of the gods, concentrates all the powers of the gods in her person.

Around this central feminine principle, a complex and varied feminine theology has been developed in the Tantras. Innumerable goddesses were named, each representing one of the manifold aspects of the principal feminine divinity, and many have been given their symbolic identity in yantras. A substantial number of yantras of female divinities are described in some of the important tantric texts.[4] Several tantric texts[5] deal exclusively with specific goddesses and give elaborate descriptions of yantra, mantra, mode of worship, etc. Thus just as there is a representational iconography of feminine theology, there is, parallel to it, a symbolic, abstract, repertoire of Śakti yantras.

The theology of Śakti as feminine branched off into two major streams, the schools of the goddess Kālī (Kālī-kula) and the goddess Śrī, whose worship is known as Śrī Vidyā.[6] Both schools developed their own specific auxiliary deities around their central goddesses and also devised yantras which illustrate some of the dominant philosophical concepts of their respective systems of thought.

Yantra of Primordial Energy: Kālī

Kālī, one of the most awe-inspiring goddesses of the Hindu pantheon, gained an extraordinary popularity in tantra and is the object of fervent devotion in tantric forms of worship. Perhaps her great popularity in tantric ritual is explained by the fact that she is the embodiment of certain key metaphysical principles of the tantric tradition. Reigning supreme among goddesses in the Tantras, Kālī is a power-symbol displaying the original unity of the transcendental in her feminine form. Although her prehistory has been traced to Vedic origins and non-Aryan sources,[7] Kālī makes her 'official' first appearance in the *Mārkaṇḍeya Purāṇa*,[8] where she is said to have been born from the brow of Durgā in a battle between gods and demons. In this context, Kālī is considered as the terrible form of the great goddess Durgā, another consort-Śakti of Śiva, who was so called to commemorate her victory over the buffalo-demon Mahisha. Kālī's gory image and symbolically fierce appearance have been the subject of extensive descriptions in several tantric works. The *Karpurādistotra*, a short devotional hymn, describes an awe-inspiring vision of the goddess: Kālī is dark of skin, garbed in space (naked), with dishevelled hair; blood trickles from her mouth; in one hand she waves a sword and with the other holds a skull; her waist is girdled with severed heads. Kālī's favourite place of repose is a cremation ground littered with corpses.

The terror-drenched iconographic imagery of Kālī as the annihilating power of Time and the Energies of creation and dissolution is condensed in her yantra for worship into the bindu, a circle, an eight-petalled lotus and 'three pentagons' (actually five inverted concentric triangles).[9] 26

In her yantra form, Kālī appears in the central dot, or bindu, as a conscious source or womb of the world. She is the energy aspect of material nature, whose inexhaustible kinetic quality is possessed by and unites with the Absolute for the

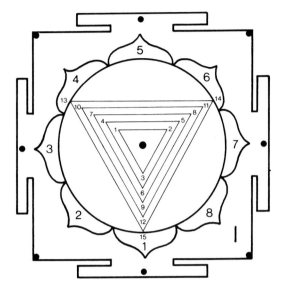

Āvaraṇa (surrounding) deities invoked in the Kālī Yantra. In the 15 angles of the triangle: 1 Kālī, 2 Kapālinī, 3 Kulla, 4 Kurukulla, 5 Virodhinī, 6 Vipracittā, 7 Ugrā, 8 Ugraprabhā, 9 Diptā, 10 Nīlā, 11 Ghanā, 12 Balākā, 13 Mātrā, 14 Mudrā, 15 Mitā. In the 8 lotus petals: 1 Brahmī; 2 Indrāṇī; 3 Māheśvarī; 4 Cāmuṇḍā; 5 Kaumārī; 6 Aprājitā; 7 Vārāhī; 8 Nārsimhī; and the traditional deities of the eight regents of space. After the tantric work Kālī Tantra

sake of creation. Her primordial explosive will to create is contrasted with Purusha, the male principle, not as 'matter' to 'spirit' but as male to female. The bindu shows her non-separability and non-difference from the Supreme Male Principle, Śiva.

As the Supreme Generative Energy, Kālī is the material, instrumental and efficient cause of material nature, and in this aspect she is represented as Prakṛiti, symbolized by the lotus-form of the yantra. Her creative urge impels material force (Prakṛiti) to diversify into an infinite number of grosser forms. The eight petals of the lotus denote the eight elements of Prakṛiti – earth, water, fire, air, ether, mind (manas), intellect (buddhi), ego-sense (ahaṃkāra) – of which the phenomenal world is held to be composed and which are none other than herself. Kālī's creative function as Prakṛiti associates her with the active power of time. She is the Mistress of Time who weaves the warp and woof of countless aeons from age to age. She represents the cyclic time-consciousness of nature that transcends the short span of individual destiny. Worlds emanate from her womb like bubbles from an ocean. Without her pulsating Prakṛiti-function, the whole of existence lies inert and unmoving as a corpse. Just as she is the creator, so she is the preserver, of the infinite cyclic order of time. Her ceaseless mother-aspect sustains life, while she simultaneously carries on her cataclysmic functions of creation and dissolution.

Prakṛiti in her phenomenal aspect is associated with the concept of Māyā – represented in the circle of the yantra. The word māyā has two connotations. Positively, it is the spontaneous, inexplicable power of the divine; Kālī is Mahā-māyā and the world is an effortless creation of her divine reflex. But in relation to created matter, the māyā-created world is viewed negatively as an all-pervasive veil, or delusion and ignorance. Māyā is that which intoxicates man and deludes him into taking the fleeting and shifting appearance of the world for reality. The lesson of Māyā is that man must apprehend the true nature of the world, the inner meaning of its secret forces operating beyond the flux of appearances. The circle of the Kālī Yantra symbolically indicates that the veils of Māyā which confine man to the 'circle' of life need to be pierced in order that he shall 'see' reality.

The fifteen corners of the five concentric inverted triangles of the Kālī Yantra represent the Avayavas, the 'aspects' or psychophysical states: the five organs of knowledge (jñāendriya); the five organs of action (karmendriya); the five vital airs (prāṇa); i.e. they relate to the body, the senses, and the receptive functions. The *Karpurādistotra* states that the symbols of the Kālī Yantra are to be taken into the body of the worshipper, while the famous tantrika poet-saint Rāmprasād (1718–75), in his hymn written in adoration of his patron goddess Kālī, bids the worshipper to 'Fashion Her image with the stuff of mind and set it on the lotus throne of your heart.' The Kālī Yantra is both an 'object' existing in the external world, and a 'subject' to be interiorized in the human body. Kālī is both a cosmic reality and a psychic fact.

Śakti-clusters

The role of the Supreme Śakti can be compared with the role of the sun in the solar system: like the sun, the Supreme Goddess is the source of countless 'energies',

female deities who are principally her emanations, or her partial archetypal images. The concept of Śakti emanations is similar to the doctrine of the incarnations of Vishṇu in Hindu tradition, but the notions of emanations and avatārs should not be confused. The immense array of Śakti transformations developed separate personifications and are classified in descending order. Certain goddesses are the complete manifestation (purṇaśakti) of the supreme female principle; some are her partial emanations (amśa-rūpiṇī); some are fractions of her power (kalā-rūpiṇī); the last group – mortal women are included here – constitute the 'parts of the parts of fractions' of the Supreme Goddess (kalāmśa-rūpiṇī). These manifestations may be worshipped individually or collectively in a 'circle' of goddesses. The innumerable Śaktis appearing in yantras are obviously ordered and generally form clusters like galaxies, which 'orbit' together. In principle, a particular divinity is assigned to a specific group, moves with it and is worshipped in the centre (pīṭha-sthāna) of the yantra; like the sun, she commands the luminous sphere of her Śakti-cluster, who are disposed on the inner circuits of the yantra, on the lotus petals and within the square band. Each of these Śaktis is a power emblem, poised to transform the baser aspects of material existence into the radiance of being. All these divinities have their roots in Śiva's 'consort', who is held to be the source of the 'entire female mythological system'.[10]

Daśa-Mahāvidyās: the Śakti-cluster of the 'Ten Great Wisdoms'

The 'knowledge' aspect of Kālī is represented by a Śakti-cluster of goddesses who are known as the Daśa-Mahāvidyās, the Ten Great or 'Transcendent' Wisdoms. The *Devībhāgavata Purāṇa* explains the mythical origin of these goddesses, essentially goddess transformations of Kālī. In a feud between Śiva and Sati (his consort Pārvatī), the goddess transformed herself into her terrible aspect as Kālī. Seeing her horrific image, Śiva tried to flee from the scene, whereupon Kālī in all her magnificence 'filled' the four quarters, in the ten directions, with her ten energies or major forms, which are to her what sparks are to fire.

The myth symbolically alludes to the notion that the ten energies encompass the whole knowledge of the universe. Together, they are the expression of the cycles of life, and the summary of all planes of existence. These feminine embodiments of knowledge constitute the power of wisdom that rouses the aspirant from the illusion of existence, and awakens dormant qualities of mind towards conscious awareness and perfect wisdom. In their yantra forms they are a cluster of varying degrees of concentration and are aspected either as divine, heroic, terrifying, demonic or peaceful, or as embodiments and consummations of human perfection. In a particularly tantric connotation their contrasting aspects, the horrific and beneficent, constitute two opposite principles. They inspire and shock, flower and fade, simultaneously, since the polarity of the divine nature is perfectly acceptable within the tantric system. In their 'knowledge' aspect their greatest boon is that they represent forces that are related to the powers of time, of death, of the continuous

Yantra devoted to the Śakti-cluster of 64 Yoginīs, tantric deities representing the cycle of time. Each inverted triangle is the sacred seat of the Devī

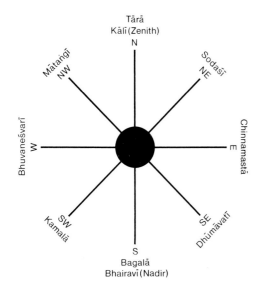

Tārā
Kālī (Zenith)
N

Mātaṅgī
NW

Ṣoḍaśī
NE

Bhuvaneśvarī
W

Chinnamastā
E

SW
Kamalā

SE
Dhūmāvatī

S
Bagalā
Bhairavī (Nadir)

Śakti-cluster of the ten Mahāvidyās and their association with the regents of space, indicating that they contain the knowledge of the whole cosmos, encompassing all

flux in life which is a constant reminder that life is a passing phenomenon, continuously devouring and being devoured. To a mind that is sunk in the mire of worldly illusion, the power of time appears as fearful. But for the aspirant, the confrontation of the brevity of existence symbolized by the fearful aspect of the goddess generates conscious introspection and renewed spiritual impetus.

There are specific Tantras devoted to each of the ten Mahāvidyās,[11] each named after a goddess and explaining her nature, yantra, mode of ritual, and the benefits that are gained from her ritual. Two main centres of the Daśa-Mahāvidyā worship are Bengal and Mithila in Bihar state, eastern India. In Mithila, when a child is born the local priest assigns one of the ten Mahāvidyās as his chosen deity (Ishṭa-devatā) and the individual generally adheres throughout his life to the worship of the deity in either a yantra or image form.

Each of the goddesses has a specific cosmic function. The first Mahāvidyā is Kālī herself. As we have seen in discussing her yantra, Kālī is the Śakti of Kāla, or the transcendent power of Time; she is the embodiment of the time-force of the universe and is therefore the primordial evolutionary principle. Her seed mantra is Krīṃ.

Time-movement presupposes change and transformation, so the second Mahāvidyā, Tārā, symbolizes the power of aspiration, spiritual ascent, the potential that is actualized through the process of transformation. Her yantra is an eight-petalled lotus in a circle, with an inverted triangle, the first pattern of cosmic location significantly representative of the goddess's fundamental urge, the pure desire to create. Her seed mantra is Oṃ.

The third Mahāvidyā, Ṣoḍaśī, represents the power of perfection and sustenance. Her name means 'sixteen', a number associated with perfection and totality (see pp. 65–6). Ṣoḍaśī is the full cycle of creation, when the entire universe, like a flower, is in full bloom, a quality that is represented in her yantra with its nine 'cosmic wombs'. She is one of the goddesses of this group who is worshipped widely in her own right. She is the chief deity of the Śrī Vidyā form of worship (see pp. 42–3) and is invoked either in the great Śrī Yantra or in her own yantra, the Nava-yoni Chakra. Her seed mantras are Aiṃ, Klīṃ, Sauḥ.

The fourth goddess-transformation is the Lady of the Spheres, Bhuvaneśvarī, who illumines the universe with her radiance and beauty. She appears in her yantra seated on a star hexagon which is associated with the transcendent immensity of the two (male and female) principles as one. With the colour of the rising sun and moon as her diadem, her anthropomorphic image placed in the centre of the yantra is surrounded by two rings of eight- and sixteen-petalled lotuses. Whereas Kālī is supreme as time-consciousness of the universe, Bhuvaneśvarī is the chief projection of space-consciousness, a quality recalled in part of her name (Bhu = space, and also support). The supporter of all existence, she is, therefore, extension, expansion and infinite space in which everything is contained, and is also the ruler of the three spheres, earth, atmosphere and the heavens as space. Her seed mantra is Hrīṃ.

The fifth Mahāvidyā, Chinnamastā, symbolizes the end of existence or the consummation of the ever-burning, ever-devouring life-cycle that precedes and

33

The yantra cluster of the ten Mahāvidyās (from the top, clockwise): Mahāvidyā Kālī, Tārā, Ṣoḍaśī, Bhuvaneśvarī, Chinnamastā, Tripurā Bhairavī, Dhūmāvatī, Bagalā-mukhī, Mātaṅgī, Kamalā. A variant after the tantric manual Śākta-pramodaḥ

influences resurrection. She is shown decapitated, holding her head in her left hand, while drinking streams of blood-nectar flowing from her own severed neck. In her yantra, the destructive aspect of her image is implied symbolically by triangles and circles. Her seed mantra is Huṃ. 22 23

Tripurā Bhairavī, the sixth manifestation, is the embodiment of the power of destruction and is constantly dissolving the world by her incessant active (rājasika) tendency. Her yantra is a hexagon placed within a circle of lotuses, and her seed mantra is Hsraiṃ, Hsklriṃ, Hssrauh. All existence is permeated by the two opposing forces of growth and decay; all that exists is subject to dissolution from the very first moment of its being. The annihilating power of time is represented in the yantra of this goddess by the nine triangles which symbolize the disintegrating planes of existence.

The omnipotently destructive Tripurā Bhairavī is followed by the ash-coloured Mahāvidyā Dhūmāvatī, the embodiment of ultimate destruction. Her all-powerful destructive tendency, with which she reduces the world to ashes, is recalled in her name, the 'Smoky One'. Dhūmāvatī is the night of cosmic slumber, a state of existence when everything in the universe lies inert, unused and 'dead'. She is conceived as a 'widow' and therefore without a male consort. She symbolizes

ignorance and darkness veiled within itself; her outward manifestations in the world are despair, dread, poverty, hunger and misfortune. Dhūmāvatī's yantra is a hexagon within an eight-petalled lotus and her seed mantra is Dhum.

The eighth manifestation of Kālī is the crane-headed goddess Bagalā-mukhī who represents the unconscious tendencies in man that lead him towards illusion, though her power immobilizes and stifles all movements and actions. By her force fire turns cold and anger is appeased. She is propitiated to suspend activities of nature. Her yantra is like Dhūmāvatī's apart from an additional triangle within the hexagon. Her seed mantra is Hlrīṃ.

The ninth Mahāvidyā, Mātaṅgī, represents the power of domination, dispels evil and dispenses justice. Her yantra, again, is like Dhūmāvatī's and is differentiated by her seed mantra.

The tenth Mahāvidyā, the lotus-coloured Kamalā, is like a flower blossoming in everything and represents a state of reconstituted unity. She is the embodiment of all that is desirable and therefore reveals herself in good fortune. Everything joyful is associated with her. The yantra of this Mahāvidyā, too, is a hexagon placed within a circle of lotuses, and is differentiated by her seed mantra, Śrīṃ.

The ten Mahāvidyās can broadly be grouped as belonging to descending or ascending planes of reality. Starting from the nadir of creation, there are the Mahāvidyās associated with the darker forces of life which are invoked through their yantras for occult or magical purposes, while those at the zenith of creation and dominated by the effulgence of the pure state of being are invoked for spiritual knowledge of the highest order. All the aspects of goddess-transformations bring liberation, although some may bring the aspirant to the shores of knowledge, others to the summit.

In the tantric tradition, especially among Śāktas (worshippers of the Female Principle), these deities are looked upon with great veneration because they hold the key to the psychic transformation of the seeker. The ten goddesses act as an impulse of intelligence. Their gory associations are meant to horrify and shock. They strip reality bare in order that the seeker may confront the truth of transience. There is, however, another revelation of the Tantras which is brought out boldly through this Śakti-cluster: that life and its manifold processes are not an inert, even, state of oneness; what justifies existence is variety, contradiction, change and multiplicity. Tantrism shows a preference for a dynamic concept of cosmic unity which implies a harmony of all differentiations and paradoxes. The Śakti-cluster of the Mahāvidyās as a whole reflects this dynamic unity of existence in which all aspects of life, the darkest, the purest, the most forceful and the inert, have been combined to form a whole. The ultimate consummation for the sādhaka lies in his absorbing this vision of unity in diversity.

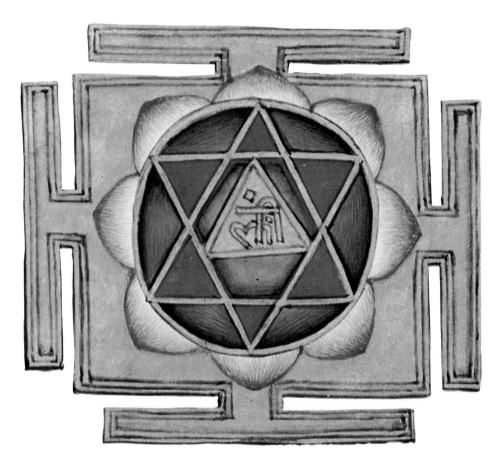

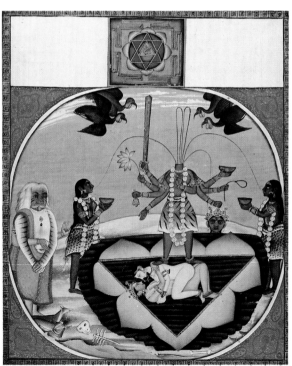

22, 23 Mahāvidyā Chinnamastā, fifth transformation of the great goddess Kālī, in iconic and yantra forms. The Devī with her two Śaktis (female energies) whom she nourishes represent the triad of cosmic phases – creation, preservation, and dissolution – triple and cyclical functions symbolized equally by the triangles and circle of the yantra. Rajasthan, c. 18th century. Gouache on paper

24, 25 Contemporary image of the great goddess Kālī, first in the cluster of ten goddesses known as Mahāvidyās, and the primal Śakti, symbolizing the triple cosmic phases of creation, preservation and dissolution – that is, embracing the totality of existence. Below, Kālī's presence is invoked during ritual worship by Śrī Satyanand Giri, a tantric guru of Kalighat, Calcutta

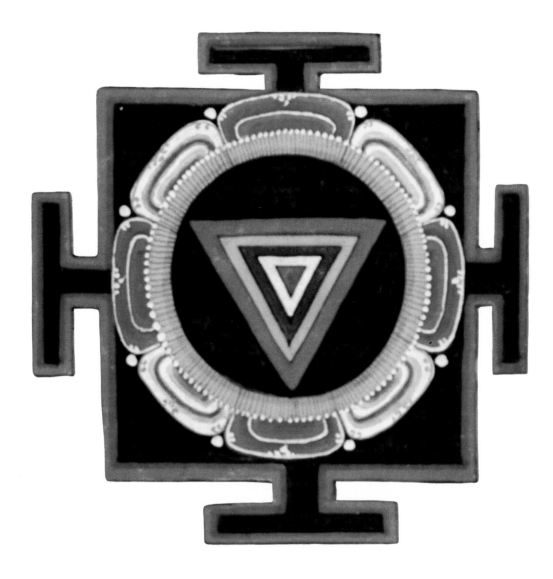

26 Kālī Yantra, an image of the cosmic functions of the Supreme Energy. Nepal, c. 1761. Gouache on paper

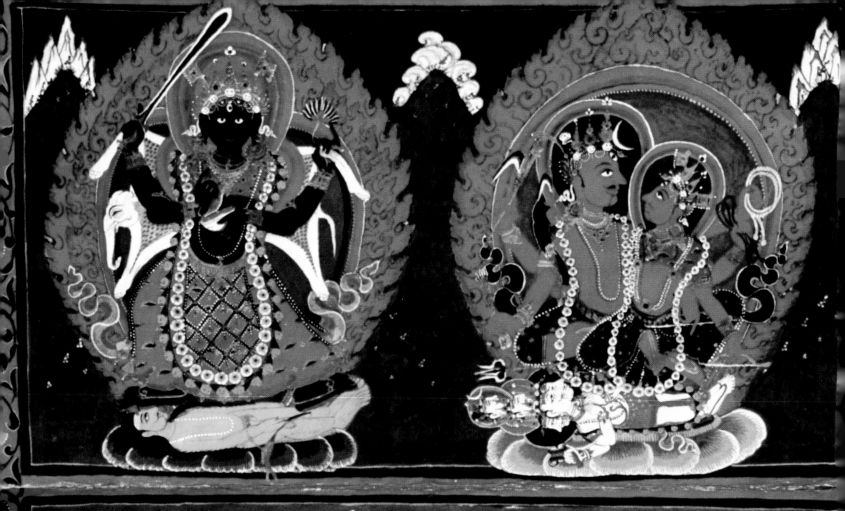

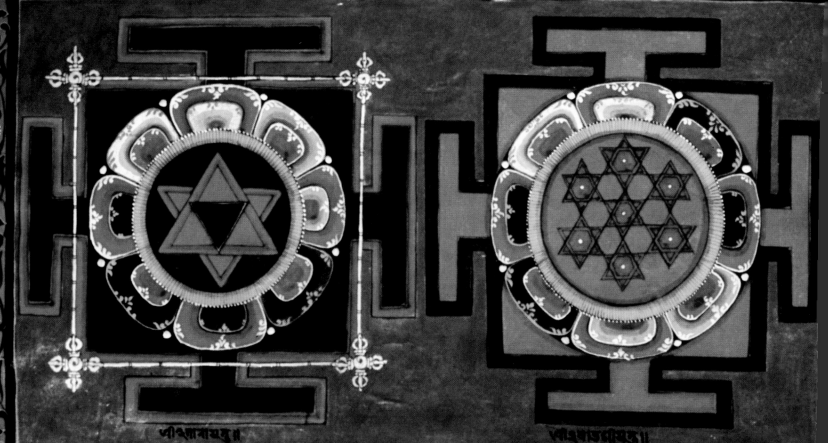

श्रीकालायन्त्र॥ श्रीषोडशीयन्त्र॥

Cosmic Time: the Nityā Śaktis

The Supreme Energy is personified as Cosmic Time in the great goddess Ādyā Nityā Lalitā (Ādyā = primordial, Nityā = eternal), who divides herself sixteenfold and is to be contemplated as sixteen Nityā Śaktis. These Śaktis' descriptions, with their meditations and yantras, occur in the *Tantrarāja Tantra*.[12] The Nityā Śaktis partake of the luminous nature of the moon in the bright half of the month, and their esoteric symbolism is based on the mathematical enumeration and multiplication of the number 16 which has mystical associations in Indian tradition. The imagery of the sixteen moon digits (or Kalās = fractions) is drawn from the cycle of the moon which waxes, wanes, disappears and is 'reborn', a symbol of recurrence, fecundity and abundance. Just as in the bright half of the lunar month the moon appears to evolve gradually in fractions until its fifteen parts vanish and merge in the 'whole', or full moon, though its actual unity remains unchanged, so the fifteen minor Nityā Śaktis (also known as Kalās) are partial emanations of their principal archetype, the Ādyā Nityā. Each digit of the moon has been given a special name and an attribute, and each Śakti personifies a phase of the moon and has been assigned a special yantra, mantra and auxiliary divinity in which her 'presence' is worshipped for the fulfilment of worldly joys.

34–46

The number 16 is arrived at by multiplying the three qualities (guṇas) of material nature (sattva or mind, rajas or energy, and tamas or inertia) by the five elements (earth, water, fire, air, ether): $3 \times 5 = 15$, and adding the Nityās' single transcendent source, the Ādyā Nityā. Together, the Śaktis and their sixteen yantras form a unity embracing the manifold nature of the universe and typifying all that the universe holds.

The 'totality' of the lunar phase may also be represented iconographically, as the sixteen-armed image of the Supreme Goddess, or as a body maṇḍala consisting of the worship of sixteen virgins (Kumārī pūjā), in which sixteen girls aged from one to sixteen are worshipped in turn, starting from the first day of the new moon.

The most significant application of the sixteen yantras of the Nityā Śaktis and their associated mantras is to provide a model of cosmic time. India does not think in terms of historical time, but has developed the conception of cyclical time through the doctrine of 'yuga' or ages. A complete cosmic cycle consists of four successive ages of varying length, in the ratios 4:3:2:1. The 16 yantras of the Nityā Śaktis are multiplied by reshuffling the 36 Sanskrit consonants (their mantras) according to prescribed rules to give the key number of yantras, 576, which multiplied by 3,000, also prescribed by the Tantras,[13] gives the duration of the first and longest age, Satya-yuga, i.e. 1,728,000 solar years. The second age, Tretā-yuga, is thus 1,290,000 solar years; the third, Dvāpara-yuga, consists of 864,000 years; and the fourth, the present age, Kalī-yuga, consists of 432,000 years. Time flows through the ages like an endless river, never exhausting itself. Each age has its period of zenith and decline. The four ages are succeeded by a state of universal cataclysm when everything 'bursts into flame', and then the universe will evolve again *ad infinitum*. Thus the microcosmic unity of a single moon phase is repeated on a cosmic time scale.

27 Śiva as Kāmeśvara (top left), the personification of primordial desire, and Śiva with his Śakti, Kāmeśvarī (top right). The cosmic pair represent the primordial male and female principles, and the corresponding energy patterns are shown below. Nepal. *c.* 1761. Gouache on paper

*Moon phases representing the Śakti-cluster of Nityā
Śaktis. Beginning from the dark night: Kāmeśvarī Nityā,
Bhagamālinī Nityā, Nityāklinna Nityā, Bheruṇḍā Nityā,
Vahnivāsinī Nityā, Mahāvajreśvarī Nityā, Dūtī Nityā,
Tvaritā Nityā, Kulasundarī Nityā, Nityā-Nityā, Nilapatakā
Nityā, Vijayā Nityā, Sarvamaṅgalā Nityā, Jvālāmālinī Nityā,
Chitrā Nityā, and Ādyā Nityā representing the full moon.*

The circle of the Nityā Śaktis is a reservoir of delight, for they embody all those aspects of life that make existence a celebration of the spirit. They combine the all-beneficent aspects of the divine. As partial manifestations of transcendent completeness, they are representative of life-affirming qualities and the primal founts of power to bestow worldly joys. Thus worship of their yantras grants boons, dispels fear and brings enjoyment to the worshipper. Esoterically, their yantras may be used for higher meditation, but exoterically they are employed as wish-fulfilment charts. Thus the first Nityā Śakti, Ādyā Nityā, is all-beneficent; Kāmeśvarī is the fulfiller of desires; Bhagamālinī charms and incites; Nityāklinna grants fortune and supernatural powers (siddhis); Bheruṇḍā frees from evil influences; Vahnivāsinī (the fire-dweller) can make one master of the forces of nature and in the three worlds; Mahāvajreśvarī (the embodiment of mercy) destroys cruelty; Dūtī (the chief saviour of the devotees) destroys fear, bestows prosperity and the objects of one's desires; Tvaritā grants beauty and fame and expands the faculties of learning: Kulasundarī bestows all esoteric knowledge; Nityā-Nityā is beneficent: Nilapatakā bestows mastery over evil forces in nature; Vijayā stands for conquests and prosperity; Sarvamaṅgalā is totally beneficent; Jvālāmālinī bestows propitious esoteric knowledge of one's previous births; Chitrā grants the objects of one's desires.

Though it is true that, since the female principle gained popularity in the tantric pantheon, an immense number of yantras have been assigned to the various aspects of Śakti, nevertheless within the goddess's kinetic and pulsating nature is a point of stillness which can only be fulfilled by a counter-principle, her exact opposite, represented by Śiva.

Cosmic biunity: Śiva-Śakti

In the essentially dualistic cosmic vision of tantrism the kinetic verve of the primordial female energy (Śakti) is supported by an indispensable correlative principle, Śiva (Purusha) or the male principle. Śiva is identified with cosmic consciousness and as the static substratum to all phenomena. Complementary and 'opposite' to the inert Śiva is Śakti, whose essential nature is to be active, creative, mobile, and to pulsate with the rhythm of life. Śiva is the silent seer of all phenomena, the innermost focal point of the subjective self (consciousness or cosmic spirit) and Śakti is the phenomenon itself (matter or nature = Prakṛiti). The whole universe lies extended between these two opposite yet complementary principles, and all creation is held to be a result of the creative play (līlā) between them. In our own sphere of existence these two cosmic principles appear as opposed (male/female, static/dynamic, plus/minus), but in conceptual terms their contrariety is the basis of syntheses – unity is the foundation of duality – and their quiescence is in fact a perfectly balanced tension.

Though the universe is an expansion of the mystic combination in the Śiva-Śakti equation and though the two principles are diametrically opposed they are 'essentially' identical. Their mutual dependency is so great that they remain inseparable, since each requires the other in order to manifest its total nature. The *Śaiva Purāṇa* (4, 4) emphatically states: 'Just as moonbeams cannot be separated from the moon nor the rays from the sun so Śakti cannot be distinguished from Śiva.' So close is their interrelation that there can be no Śiva without Śakti and no Śakti without Śiva. This cosmic biunity is paralleled as 'psychic biunity' in the human male and female, and suggests that there is necessarily feminine in every man and masculine in every woman, as partial illuminations of a whole.

In yantra the chief emblems of these two principles are the liṅga, the phallic object, representing the Śiva principle, and the yoni, the vulva, denoting Śakti. The combined liṅga-yoni has been the object of veneration of the various sects of Hinduism – Śaivaites, Śāktas and Tantrikas – who worship it as the principal symbol of divine biunity.

In this context liṅga and yoni should not be interpreted as references to the physical male and female sex-organs or to human sexual intercourse, nor is the liṅga to be regarded as part of Śiva's body: it signifies the static principle whose visible form has also been given a shape of an egg (aṇḍa-rūpa Brahman) and characterizes the essential being of Śiva in the 'attributeless' (nishkala) aspect. It is the cosmogonical emblem of his substance.[14] Similarly, the yoni does not refer to the individual female vulva, but through the emblem to the sum-total of the creative womb, the kinetic field of creation that impels static forces towards movement, change and expansion. The emblems, therefore, point to archetypal principles and operate above the level of mundane consciousness.

In Hindu myth, however, the liṅga is taken as a sexual symbol paradoxically fulfilling a cosmic function, and the myth of the origin of liṅga-worship, from the ancient *Mahābhārata*, is described in terms of a cure for Śiva's unabated sexual desire:

The sages cursed Śiva's liṅga to fall to the earth, and it burnt everything before it like fire. Never still, it went to the netherworld and to heaven and everywhere on earth. All creatures were troubled, and the sages went in desperation to Brahmā who said to them, 'As long as the liṅga is not still there will be nothing auspicious in the universe. You must propitiate Devī so that she will take the form of the yoni, and then the liṅga will be still.' They honoured Śiva, and he appeared and said, 'If my liṅga is held in the yoni, then all will be well. Only Pārvatī can hold the liṅga and then it will become calm.'[15] They propitiated him and thus liṅga-worship was established.

Śiva's phallus and Pārvatī's yoni are presented as sexual emblems but on the deeper, non-mythological level they represent the non-separability of antithetical principles which cannot be at rest when disunited. Their 'synthesis' restores balance, changing a state of chaos and disequilibrium caused by their separation to perfect continuity and equilibrium.

This polarity is represented figuratively in the icons of Śakti sitting upright on the body of the inert Śiva, 'not to destroy him', as Agehananda points out, but to symbolize for the devotee the basis of its cosmosophy: '"Śiva without Śakti" is a corpse'.[16] In other words, Śakti, kinetic energy, is the instrument to arouse the slumbering Śiva beneath her. Again representing unity in duality, Śiva is sometimes shown as Ardhanārīśwara, the half-female and half-male deity, in which the right half is depicted as female and the left half as male.

This cardinal doctrine of cosmic biunity is expressed in many yantras dedicated to the Śiva-Śakti principle. Such yantras are often constructed as a network of squares, with liṅga-yoni emblems within their geometrical framework. The colours of the rhythmically arranged patterns of identical squares are themselves used to exemplify the contrasts of dynamism and become a way of expressing the dualistic principle.

In Hinduism, time and space are considered cyclical and self-perpetuating. All existence issued from a single source and ultimately returns to its point of origin. Thus it can be abstractly viewed not as a linear motion in a single direction but as forming a curve. Planets and constellations move in orbits to trace expanding and contracting spheres. These curvilinear cosmic images are the basis for the roundness of the Śiva-liṅga (though in the Śaiva yantras the 'curve' is 'squared' and adapted into a geometrical framework).

The geometricized Śiva-liṅga in most yantras lies embedded in the yoni-shaped pedestal (yoni-pīṭha): embraced by Śiva, Śakti manifests her creative powers, becomes the flow of evolution and blossoms into infinity. As the force of nature, she withdraws and creates the universe in her womb-like vessel. The pedestal-yoni, therefore, is given the elongated shape of a sacrificial vessel into which 'flow' the pervasive forces of Śakti.

The polarity principle appears in yantra symbolism in a variety of forms. One of the most important is the bindu, in which the tension between the opposites is resolved. In the bindu the empirical and the transcendent merge into an indistinguishable unity. Expanded emblems of duality as male and female (considering the bindu as the contracted emblem) are a pair of interpenetrating triangles which form a star hexagon; or a figure formed by splitting the bindu into

Liṅga and yoni pedestal, detail from the grid-square type of Śaiva yantra, showing the imperishable unity of the male and female principles (see also pls. 70, 73–4)

two dots, one male and the other female. In linear form, the dualism is expressed as two intersecting lines. The *Kālikā Purāṇa* explains this image in describing the Tripurā Yantra: 'The line that begins from the north-eastern region is called Śakti; [the one] going from the south-western region to the north-western region and then reaching the north-eastern region is called Śambhu [Śiva]; one should cause the Śambhu to intersect with the Śakti.'[17]

The concept of dualism permeates tantric symbolism. Even Sanskrit letters, which are inscribed on the yantras, are divided into male and female. Every consonant is articulated with a vowel, and the *Jñanārnava Tantra*[18] divides the symbolic properties of the Sanskrit alphabet into two: the vowels embody the feminine energy and the consonants the male principle. If it were not for the force and dynamism of Śakti represented by the vowels, all the letters (consonants as Śiva) would be inert as a corpse. Hence, for example, the 'force' of the mantric sound rooted in this conjunction of opposites. Only by the union of Śiva-Śakti can speech be articulated expressively.

Conversely, in another text the Sanskrit consonants are referred to as yoni (Śakti) because they cause the formation of compound words known as bīja (seeds) with the vowels (Śiva).[19] For instance, in Krīṃ, the seed syllable of the goddess Kālī, two of the four sounds (K = Kālī, R = Śiva) denote the union of the two principles.

Since these two principles are inseparable and indispensable to the continuum of existence, Śākta yantras (yantras devoted to goddesses) implicitly express the 'Śiva element'. (In tantric philosophy the female principle, in addition to her own attributes, possesses all the attributes of Śiva.) Conversely, Śaiva yantras with their liṅga-yoni motifs are considered to possess an inherent Śakti nature.

In the yantras devoted to Śakti-clusters, the goddesses as a group denote the dual principles. In the sixteen yantras of the cluster of Nityā Śaktis, who constitute the moon-phases, the *Kāmakalāvilāsa* (v. 17) states that 'the 15 Nityās represent the 15 lunar days and the lunar days are the union of Śiva-Śakti'.

Tantric symbolism employs several images to illustrate the integration of the dual principles in the physiology of the subtle body. This duality is 'vertical' inasmuch as Śakti (energy) lies in latent form as Devī Kuṇḍalinī at the base of the spine, and Śiva in the highest spiritual centre, the Sahasrāra Chakra at the crown of the head, and 'horizontal' in the two psychic nerves in the subtle body: Iḍā, the lunar or female channel, on the left side of the body, and Piṅgalā, the solar or male channel, on the right side. The subtle body thus appears as an amalgam of paradoxical energies. From this theory follows the entire discipline of tantric sādhanā, which consists in unifying these opposite forces. The vital energies circulating in Iḍā and Piṅgalā are unified in the central Sushumṇā nerve; the union of Kuṇḍalinī Śakti with Śiva takes place in the chakras at their various levels in the subtle body, until their final union in the highest centre, the Sahasrāra Chakra.

One of the most striking representations of Śiva-Śakti biunity, and at the same time, the most spectacular abstraction of yogic vision, is the Śrī Yantra.

Biunity expressed in the subtle body, through the two psychic channels, Iḍā (female) on the left and Piṅgalā (male) on the right

Cosmogenesis: the Śrī Yantra

47, 62 The Śrī Yantra, considered the greatest of all yantras, displays the splendour of Śiva-Śakti in their manifestation in order to create the root principles of life (tattvas). A graphic synthesis of the abstruse cosmological and metaphysical theory of Śaiva-Śākta, the Śrī Yantra is to be read as a chart of the evolution of the cosmic scheme, exposing step by step the theory of creation and its categories. It also demonstrates how the passage from formlessness to form takes place, as the antagonistic principles of life emanate and differentiate themselves from the original wholeness of Śiva-Śakti. The Śrī Yantra marks each phase of cosmic evolution and articulates every descending level of the creative process.

One of the earliest surviving specimens of the Śrī Yantra is preserved in the religious institution Śrīngarī Maṭha, established by the philosopher-saint Śaṅkara in the eighth century AD, although its imagery is far older. The hymn from the *Atharva Veda*[20] (c. 1200 BC) contains a description of a yantra-like figure composed, like the Śrī Yantra, of nine geometrical permutations.

The Śrī Yantra is one of the chief instruments of instruction of the Śrī Vidyā form of worship, which consists essentially in the use of an esoteric fifteen-syllable mantra representing the supreme divine power manifested as a form of the universe (see Chapter 2, p. 42). The Śrī Vidyā was the chief form of worship of a number of famous sages,[21] and has survived among all sects of tantrism.

The Śrī Yantra (also known as Śrī Chakra, chakra = circle) is a 'neutral' circuit of world-creation. In itself it is not limited by being either male or female but embraces both principles in a totality. The Śiva-Śakti equation contains the constant tendency towards fusion of the two principles. They cannot be divided because their apparent duality implies a third principle: unity which subsumes the two. It is precisely this all-embracing unity which transcends duality that is structurally reproduced in the enigmatic but harmonious arrangement of the triangles in the Śrī Yantra. Hence the Śrī Yantra is a representation of macrocosmic, impersonal, absolute reality which is neither male nor female nor neuter, but is pure existence with all its qualities and categories, and is ultimately qualityless. The Śrī Yantra represents all 'parts' of the whole: everything that has name and form as well as super-empirical completeness – in other words, everything given to experience as well as transcendent infinite fullness. This universality is testified to by the numerous different symbolic references to the Śrī Yantra in the tantric texts.[22]

The metaphysical basis of all yantras is the theory of the thirty-six cosmic principles (tattvas) which owe their origin to the synthesis of Śiva/Śakti. It will be found helpful to understanding of the symbolism of the Śrī Yantra if the yantra (p. 73) and the table of the scheme of tattvas (p. 74) are viewed side by side.

Cosmic evolution takes place in stages. Originating from primordial stillness, the cosmos expands and evolves through several graduations and attributes, only to return to its pristine 'wholeness'. The pre-creative stage of evolution is a state of total void, the purest principle of creation, Śiva. The beginning of creation is an omnipotent all-pervading cosmic principle (Parama Śiva or Saṁvit) in embrace with

Śakti (his potential power). Everything we know, feel and hear is latent in this primordial consciousness. This Being is empty (śūnya) of any objective content. The only knowledge this Being-Consciousness has is the cosmic concept of Self (the Universal Ego or 'I', in Sanskrit aham) as a self-ignited incandescent light (prakāśikā-svabhāva). The Self's awareness is of a dynamic indwelling essence manifesting infinite power and freedom (svatantra; other Sanskrit terms for the same manifestation are māyā, śakti, vimarśa). This Being is neither male, female nor 'it', and is above and beyond all divisions. There is neither any anti-force nor any external power to act as a counter-entity. There is only the One without a second, and all phases of creation are part of this pure vision.

This reality is reflected in the primal symbol of the cosmos: the bindu which rests in the centre of the Śrī Yantra: 'When the mass of the sun-rays of Supreme Śiva is reflected in the pure vimarśa (Śakti) mirror, the Mahābindu appears on the wall of Consciousness illumined by his reflected rays' (Kāmakalāvilāsa, v.4). In the pre-creative stage, Śiva, in his absolute state called Saṁvit, is a clear mirror who in his inexhaustible freedom reflects the universe as a mirror reflects an image. Just as a mirror cannot be separated from the image, neither can Śiva be separated from the universe he reflects. In contrast to Śiva as the luminosity of cosmic consciousness, Śakti is the immense power (vimarśa) that causes the reflection of the universe which shines forth as a radiant seed-point (Mahā bindu).

Thus, the point which is the first form to emerge on the surface of the void (represented in the centre of the Śrī Yantra) is wholly transcendent, the germinal state of the world when material power is still very pure. It projects a level of creation on which all the combined energies of the universe lie dormant, a realm of infinite possibility.

The appearance of the bindu is the gathering-up of centripetal tendencies which will unfold during successive phases of evolution. Just as the seed of a tree is not a 'manifested' tree yet holds the essence of a tree, so the bindu holds a universe not yet differentiated from the original monad. Philosophically (in terms of the Śaiva-Śākta theory of creation) it is Śiva's consciousness of 'I' when it begins to be limited and negated by his power to create (Śakti). Therefore the limitless 'contracts' into a point. The experience of location, illustrated by the contraction of infinite space (ākāśa) into the bindu which appears upon the clear mirror-like consciousness of Supreme Śiva, is in itself a negation of Śiva's limitlessness.

The creative urge of the Supreme is set in action under the irresistible force of self-regeneration. The bindu expands. Cosmic evolution is moved into expansion by a splitting of original unity into two, and the pristine homogeneity of the point is modified: 'the two Bindus, white and red, are Śiva and Śakti, who, in their secret mutual enjoyment, are now expanding and now contracting [in the manifestation of the universe]. They are the cause of creation of lettered sound [vāk] and meaning [artha], now entering, now separating' (Kāmakalāvilāsa, v.6).

In yantra symbolism this process of world creation is called visarga-maṇḍala (visarga = emission, outflow). The two bindus are represented in Sanskrit script by the aspirate H. When pronounced with an outflow of breath, H is analogous to the

Metaphysics of evolution	Yantra symbol	Description
1 The universe in its unmanifested form, in the void ↓	●	Mahā bindu, the great seed point
	Unity	
2 Śiva's potential power, Śakti, activizes the quiescent state		The splitting of the bindu by the force of cosmic desire
3 Modification of original unity in the two principles Śiva/Śakti, the two in ONE.	● ●	Bindu splits. Visarga-maṇḍala
4 Transformation of original unity	▽	Mūla-trikoṇa, the root triangle as the cosmic womb, representing cosmic triads
	Duality	
5 Expansion, doubling and development, by the integration of the male and female principles		Śiva (prakāśa) and Śakti (vimarśa) dividing to create the root principles of life. A stage of creation which begins to give rise to psychical tattvas (kañchukas) which obscure our perception of original wholeness
	Multiplicity	
6 Creation of tattvas, cosmic categories, by external projection that gives rise to the world of diversity		Mūla-prakṛti, primordial nature, projecting its 24 gross tattvas of the material universe. The five Śakti triangles (left) represent all the fivefold categories, such as the five elements, five organs of action and five sense organs The four Śiva triangles representing individual consciousness that is obscured by the creative play of Māyā Śakti
	Nāda or Cosmic Sound, symbol of Śiva Bindu, symbol of Śakti	↑ Involution, or process of return to Unity

72

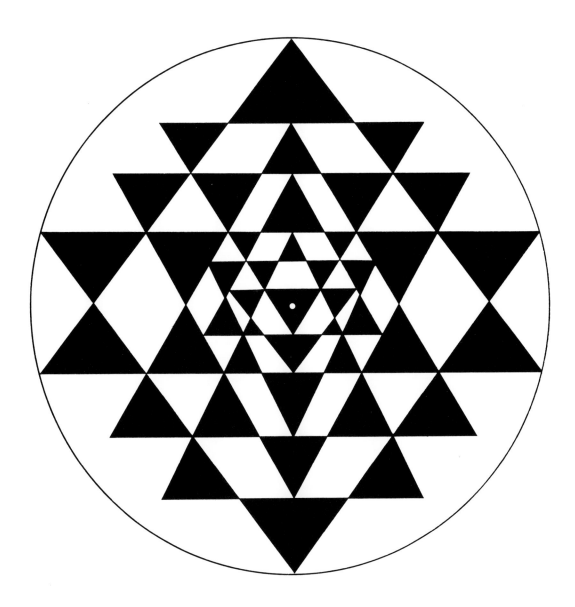

quasi-biological emission (visarga) of the cosmos. But at this stage the 'pair' is still structurally indivisible: even though two, it forms a single unit.

The intense impulse of procreation in which Śiva-Śakti join to produce the bindu, the primordial seed of the universe, has sometimes been equated with the human sexual impulse. The 'sexual' aspect of Śiva-Śakti should not be over-emphasized, and in the creative act we must not see a divine coupling, but the unfolding of cosmic principles that produce two forces, matter and anti-matter, changeless Śiva (Cit Saṁvit) and changing power (Cit Śakti) full of light (prakāśa) and power (vimarśa), and giving rise to sound (nāda) and material force (mūla-prakṛiti, or kalā). It is a gross misconception to view the Śrī Yantra as an erotic symbol.

The fully created cosmos (sṛiṣṭi) arising from the union of male and female principles, in which the world of multiplicity is held by the unity of the primordial bindu at the centre. Each triangle of this yantra has its presiding deity. Many epithets of the Supreme Energy, such as Ādyā Nityā, Ṣoḍaśī, Lalitā, and Tripurā-Sundarī, are invoked as the central divinity in this yantra, known as the Śrī Yantra

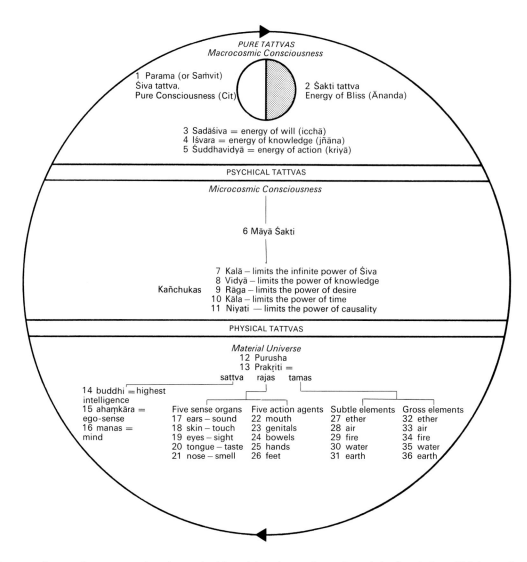

PURE TATTVAS
Macrocosmic Consciousness

1 Parama (or Saṁvit)
Śiva tattva,
Pure Consciousness (Cit)

2 Śakti tattva
Energy of Bliss (Ānanda)

3 Sadāśiva = energy of will (icchā)
4 Iśvara = energy of knowledge (jñāna)
5 Śuddhavidyā = energy of action (kriyā)

PSYCHICAL TATTVAS

Microcosmic Consciousness

6 Māyā Śakti

7 Kalā – limits the infinite power of Śiva
8 Vidyā – limits the power of knowledge
Kañchukas 9 Rāga – limits the power of desire
10 Kāla – limits the power of time
11 Niyati — limits the power of causality

PHYSICAL TATTVAS

Material Universe
12 Purusha
13 Prakṛiti =
sattva rajas tamas

14 buddhi = highest
intelligence
15 ahaṃkāra =
ego-sense
16 manas =
mind

Five sense organs	Five action agents	Subtle elements	Gross elements
17 ears – sound	22 mouth	27 ether	32 ether
18 skin – touch	23 genitals	28 air	33 air
19 eyes – sight	24 bowels	29 fire	34 fire
20 tongue – taste	25 hands	30 water	35 water
21 nose – smell	26 feet	31 earth	36 earth

The tattva diagram above summarizes the tantric vision of the scheme of cosmic evolution/involution which forms the metaphysical basis of the symbolism of the Śrī Yantra.

The universe is composed of 36 cosmic principles (tattvas) unfolding from primal unity, called Parama Śiva (or Saṁvit). The first two of the 5 pure or subtle tattvas consist of Śiva as Consciousness in union with his Śakti or Energy of Bliss (graphically represented in the yantra as the bindu). The following 3 pure tattvas are Śiva/Śakti's threefold energies: of will (= Sadāśiva); of knowledge (= Iśvara); and of action (= Śuddhavidyā) which are the prime movers of cosmic evolution (symbolized in the three points of the primordial triangle). At this stage, there is no experience of division or diversity. Everything is merged in the unity of Śiva/Śakti.

The next unfolding is the stage of psychical tattvas which go to make up the human soul. The original unity of Śiva/Śakti begins to modify itself towards differentiation. This development implies limitation of the limitless pure tattvas. Māyā Śakti, the first tattva of the psychical stage, obscures the primordial unity of the earlier stage by means of 5 tattvas which are each a type of limitation (the kañchukas): The omnipresence of Śiva/Śakti is limited by the kañchuka of kalā (part or fraction) which gives rise to the notion of individuality; the omniscience of Śiva/Śakti is limited by the kañchuka of vidyā (knowledge) and gives rise to our ignorance of reality; the wholeness of Śiva-Śakti is limited by the kañchuka of rāga (attachment, desire) and gives rise to discontent; the eternality of Śiva/Śakti is limited by the kañchuka of kāla (time) and gives rise to mortality; the omnipotence of Śiva/Śakti is restricted by the kañchuka of Niyati (fate, predestination) and conditions us to the round of life. Like a husk that envelops a seed, these six psychical limitations veil and obscure our perception of reality.

Up to this stage of creation, everything is harnessed in unity. Now evolution bifurcates into subject and object, when all division and opposites appear. At the next level, Śiva tattva transforms as Purusha tattva, or the Primordial Male Principle. Purusha retains his absolute substance but appears limited under the spell of Māyā. In contrast to Purusha who represents every sentient person – the innermost focal point of the subjective self, limited by conditions imposed by creation – the

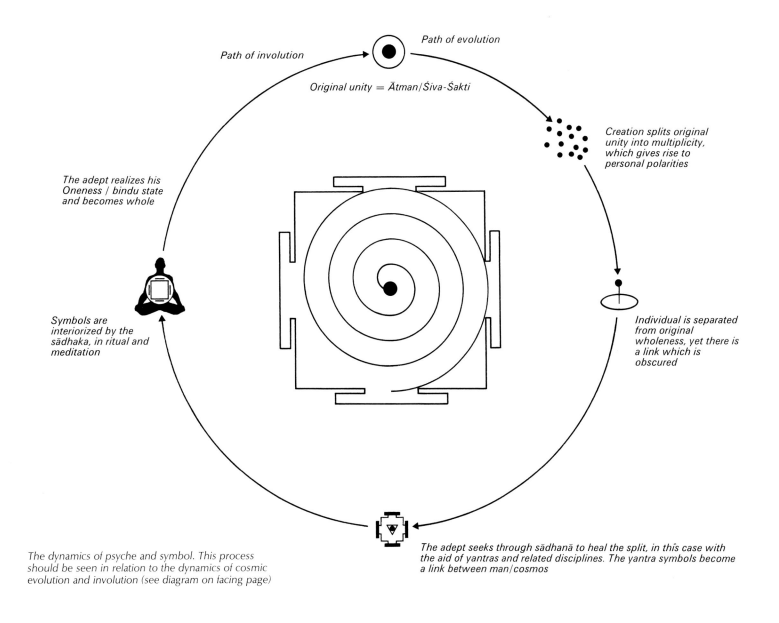

Path of involution Path of evolution

Original unity = Ātman/Śiva-Śakti

Creation splits original unity into multiplicity, which gives rise to personal polarities

The adept realizes his Oneness / bindu state and becomes whole

Individual is separated from original wholeness, yet there is a link which is obscured

Symbols are interiorized by the sādhaka, in ritual and meditation

The adept seeks through sādhanā to heal the split, in this case with the aid of yantras and related disciplines. The yantra symbols become a link between man/cosmos

The dynamics of psyche and symbol. This process should be seen in relation to the dynamics of cosmic evolution and involution (see diagram on facing page)

Prakṛiti tattva, the Female Principle, is the embodiment of the kinetic quality and constitutes the objective manifestations of nature. Prakṛiti, consisting of three guṇas: sattva (quality of radiance, intelligence), rajas (kinetic quality), and tamas (inertia), differentiates into a state of buddhi, or highest intelligence, and ahaṃkāra, a state of consciousness of self (aham = ego).

The homogeneity of pure creation is torn asunder in this stage, when matter dominates spirit and gives rise to the world of multiplicity. The gross categories of nature are grouped in clusters of 5 tattvas: the 5 sense organs, the 5 action agents, the 5 subtle and the 5 gross elements, which together constitute the objective universe, whereas the mind (manas), the receiving agent of impressions, is the 'subject'. The fivefoldness of material nature provides the basis of the symbolism of the Kālī Yantra and the 5 Śakti triangles of the Śrī Yantra, and constitutes the world of matter.

Evolution is not an end in itself. Everything evolves only to return again to source. At the end of the cosmic cycle all these categories will be withdrawn once more into the primordial unity of the pure tattvas. It follows that there is fundamental identity between man, cosmos and yantra symbol

From the union of the two bindus issues the primary sound-principle (nādātmikā śakti). The Sanskrit letters that are inscribed in a spiral on the yantra, beginning from the outer rim of the figure and ending at the bindu, are the gross aspects of cosmic sound springing from the interaction of Śiva/Śakti. The two bindus are thus related to the entire Sanskrit alphabet, whose first and last letters, A and H, contain the entire range of sound between them, just as the two bindus in conjunction contain the seed of the universe. In this respect the letters represent the subtle energies of all the elements: 'ether, air, fire, water and earth. The modification of these five elements or of their representative figures constitutes the whole universe, macrocosm and microcosm'.[23]

With further expansion and contraction of energies there emerges the primordial cosmic womb, and the bindu rests in the first form of cosmic location, the downward-pointing triangle in the centre of the Śrī Yantra. In this phase Śiva and Śakti tattvas have fully evolved into distinct categories, but are still yoked by the unity of the primordial triangle (Kāma-Kalā). This phase is marked by Śakti's awareness of her threefold characteristics: her creative will (icchā) which is the prime cause of all creation; her inexhaustible power of discrimination, or knowledge (jñāna) which gives rise to multiplicity; and her power of action and movement (kriyā). Śakti's threefold activity is described in the *Mālinīvijayottara Tantra* (II, 6–8):

> O Devī, she is called Śakti, inherent in the sustainer of the world, assumes the desire nature [icchātva] of Him who desires to create. Hear now how she attains multiplicity, though one. That by which a thing is known for creation to be 'this' and not otherwise goes by the name of Jñāna Śakti in this world. When the idea is born 'let this thing be thus' the power making it so is at that moment Kriyā Śakti.

These threefold aspects of Śakti have been philosophically related (*Kāmakalāvilāsa*, v.22) to the triad of basic attributes that make up the world. They are seen in three theistic expressions of Śakti and the three phases of cosmic sound:

Goddess (Śakti)	Aspect of Śakti	Sound manifestation	Cosmic phases
Vāmā	volition (icchā)	subtle sound (pashyanti)	creation
Jyenṣṭhā	knowledge (jñāna)	intermediate sound (madhyamā)	preservation
Raudrī	action (kriyā)	articulated sound (vaikharī)	dissolution

These primary categories, symbolized by the triangle, effect transformation only in the self-experiencing of Śiva/Śakti; they are not extra-mental and therefore do not bring about any element of difference in the supreme unity. At this stage of creation, the spirit still asserts itself over material nature, and the three aspects of Śakti constitute her self-experiencing creative funtion in her circumscribed universe. Philosophically, this stage corresponds to the pure creation of the Śiva tattvas (cf. table p. 74). It is only in the next phase that the primordial homogeneity of Śiva/Śakti is divided by manifestation.

After the initial crystallization of primordial energy, the subtle principles of matter and spirit begin to make their appearance, and the whole process of creation alters course, as matter begins to dominate spirit. At this stage original unity splits into two streams, into subject and object in which all divisions and opposites appear. This phase of the Śrī Yantra is indicated by the interaction of nine triangles.

The triangles of the Śrī Yantra are called nine cosmic wombs (Nava-yoni) and parallel nine categories of nature in the macrocosm. The triangles are in two sets: the four upward-pointing (known as Śrikanthas) emanate from the Śiva principle and denote the individual soul (Jīva) and its vital energies; the five downward-pointing represent Śakti principles and from them emanate the material elements of the macrocosm – earth, water, fire, air, ether – their five corresponding subtle states (tanmātras) and all the human organs which react to the impressions of the senses. These are the organs which facilitate action (mouth, hands, feet, bowels, genitals) and sense experiences (ears, skin, eyes, tongue, nose). The two sets of triangles are superimposed to show the imperishable unity of Śiva-Śakti. So united, they form the creative cosmic field represented by forty-three smaller triangles, each presided over by a goddess, within the rings of lotus petals and the outer square fence. Metaphysically this stage constitutes the evolution of all the elements of nature: 'O Supreme One, the whole Cosmos is a Śrī chakra formed of the twenty-five Tattvas – five elements plus five Tanmātras plus ten Indriyas plus Mind plus Māyā, Śuddha-vidyā, Maheśa [Śiva], and Sadāśiva.'[24]

Cosmic order

According to Indian evolutionary theory, the cosmos is to be viewed as a continuum. Whatever is born will develop, age, and dissolve again into the primordial reality that gave it birth. Like a circle, the cosmic order presents an interrupted continuity. Hence, there never was a 'first', nor will there ever be a 'last' cosmos, nor will there ever be a period at which the universe will have reached a static phase of total disintegration or total integration.

There are three phases of the cosmic process: creation, preservation, and dissolution, a vision which Hindu iconography represents in the unified image of the Hindu trinity formed by the three major deities, Brahmā, the creator, Vishṇu, the protector, and Śiva, the destroyer.

The structural synthesis of the Śrī Yantra illustrates the Indian view of cosmic time as a triad, with three phases of universal becoming. To match this, the goddess Tripurā presiding over the yantra has three aspects: the young one (Trividha-Bālā), the beautiful one (Tripurā-Sundarī), and the 'terrible' one (Tripurā-Bhairavī). Each of the three periods of cosmic time assimilates another triad, producing numerical association to the order of nine. Hence the symbolism and basic structure of the Śrī Yantra always revolve around a ninefold division which is basically an expansion of three. From its outermost periphery, the square, to the bindu, the Śrī Yantra has nine circuits, each with its own name and presiding devatā. These nine circuits are divided into three groups of three circuits to denote the three phases of the cosmic

cycle. These three major divisions which make up the nine circuits can be viewed philosophically as successive phases of creation, preservation, and dissolution. The following equation of circuits of the Śrī Yantra and cosmic phases is based on the *Tantrarāja Tantra* (Chap. V):

First phase: CREATION

1 The square	creation-creation	unity
2 The circle of 16 lotus petals	creation-preservation	duality
3 The circle of 8 lotus petals	creation-dissolution	duality

Second phase: PRESERVATION

4 The 14-angled chakra	preservation-creation	duality
5 The 10-angled chakra	preservation-preservation	unity
6 The 10-angled chakra	preservation-dissolution	duality

Third phase: DISSOLUTION

7 The 8-angled chakra	dissolution-creation	duality
8 The primary triangle	dissolution-preservation	duality
9 The bindu	dissolution-dissolution	unity

In the cosmic cycle no phase is absolute in itself but each is a synthesis of opposite principles, with the apparent disequilibrium neutralized by the principle of unity. In the first phase, for example, creation is seen as a vast cosmic activity in which certain forms of life are evolving, others are simultaneously vanishing, while some are static (preserved). In the second and third phases the same principle asserts itself, for while preservation or dissolution dominates, certain forms of life simultaneously evolve, are preserved and dissolve. Thus each phase of the cosmic cycle is a dynamic whole, and while the Whole contains all the parts, all the parts assimilate the Whole.

The enigmatic nature of these divisions should not surprise us. They demonstrate the core-nature of Śakta philosophy which sees every aspect of life as a spectrum of paradoxes and its resolution. No element of nature, no process of life, can ever be complete in itself. It must embrace an opposite to manifest itself, and resolve its tension and contradictions by a third principle: unity. From this dimension, each phase of the cosmic cycle is complete in itself and retains its cyclical continuity.

The association of the number 9 with 3 appears in Indian thought to be an inescapable necessity, since it is based on the symbolic association of the structure of cosmic time. The Whole (consisting of three phases of cosmic cycle) is threefold. It

denotes two opposites and its resolution, a neutral. Every part in creation must also be of the nature of the Whole (viz., threefold). Therefore each of the three parts of the Whole (creation, preservation and dissolution) is necessarily split into triads, bringing the numerical order of 9. This concept of the Whole is embodied in the nine circuits of the Śrī Yantra, and the nine Śiva-Śakti triangles, which are an expansion of the unity of 3 of the primordial triangle.

The web of Māyā

The conception of hierarchical planes of existence occupies a central place in tantric thought. The cosmic categories and principles of the universe known as tattvas which Śiva-Śakti project in their infinite expansion to create the world are organized as a pyramid of which they are the apex. Starting from pure unity (Śiva), the world is a continuous unfolding, and the lower we go down the ladder of creation the greater the differentiation and the more numerous the cosmic categories become – until a state is reached, according to Śaiva-Śākta theory, when the process must reverse, and involute back to the very beginning. In other words the series of categories that are created during evolution must reverse their downward flow and move upwards
 become the essence which gave them birth – multiplicity must once again become unity. This spiritual descent and ascent, which applies to everything in existence, is charted in the Śrī Yantra.

The vision of man found in the Tantras corresponds to the tantric vision of the cosmos. The tantric scheme of the universe is divided into three levels or kinds of tattvas: the spiritual or pure, the psychical and the physical. These three categories are regarded by Śaiva and Śākta Tantras as making up the circuit of life, and as exemplifying man's entire being of matter and spirit:

Cosmos	Man
Pure or spiritual tattvas (Śiva-Śakti)	Ātman or Self
Psychical tattva (Māyā Śakti)	mind (organs of intelligence)
Physical tattva (Prakṛiti)	body (organs of sense and action)

As primal cosmic unity first divides into two, so our consciousness emerging from the precreative to the post-birth state divides into two parts: one who as a silent seer observes in detachment (the Ātman), the other who as the phenomenal ego yields to the creative play of life. These two basic levels of consciousness are radically different but co-extensive. The Ātman, the eternal point of consciousness in which the male and female principles (Śiva-Śakti) meet as equals, is pure unity. The phenomenal ego, the first form which consciousness assumes when it splits from its original unity, is composed of organs of mind, senses and action yielding to constant change and impulses.

The Ātman has no boundaries, no limitation. It retains its wholeness and purity throughout eternity. It is 'total'. Under the spell of the creative play of the Supreme Energy (Māyā Śakti), man mistakes the phenomenal ego for reality and identifies it

with Ātman. The phenomenal ego shatters our perception of our inner wholeness, and makes us see life as an accumulation of disjointed images. The real self lies hidden, veiled by the limiting factors (kañchukas) which like sheaths hide the luminosity of Ātman and obscure from us our inner unity with the cosmos. The purpose of the tantric quest and the goal of ritual and meditation (Chapters 4 and 5) is the gradual realization of the real self, so that the play of the phenomenal ego yields to the inner wholeness of Ātman, as the sādhaka retraces his steps from the outward-directed world of multiplicity to the inward focus of unity.

Return to the centre

Involution is a compulsion into the spiritual. It implies moving against the current of life. In subjective terms it means thirsting for a higher state of consciousness, suppressing the 'lower' by ascending the ladder of multiplicity into unity, a spiritual itinerary which takes the form of a return to the state of cosmic foetalization, the *a priori* state before experience begins. Such a return shifts the centre of the personality from a fragmented awareness of his ego-centric consciousness to cosmo-centric wholeness, and brings about the union of the individual and cosmic consciousness (Śiva-Śakti). It means a death of the profane self, the perishable phenomenal ego, and a rebirth to an eternal, deathless state of being. The entire discipline of yantra-ritual and meditation is directed towards this single goal, a return to the Supreme Centre. The yantra makes the process of involution conscious to the adept.

The hierarchical planes of the cosmos are depicted in the yantra as successive concentric figures, 'ascending' from the periphery to the centre, or in pyramidal yantras, from lower levels to higher, and up to the summit. The journey from periphery to centre is known as the involution mode, or the 'dissolving' way (laya-krama). (Conversely, the interpretation of yantras as symbols of cosmogony is outwards from the bindu, and is known as the evolution mode, or sṛiṣṭi-krama.)

A yantra thus maps the road of eternal return, and the way to inner wholeness. Escaping from the web of Māyā, the adept gradually rediscovers his eternal being through the yantra's symbols. When he has internalized all the symbols of the cosmos and his body 'becomes the yantra', the adept is no longer alienated from the truth that the symbol illustrates, but is transformed into the truth he seeks.

28 Śrī Chakra-patra. Yantra of Vishṇu as Hari-Nārāyaṇa with his consort Lakshmī. The inscription on the yantra states that it was given by a king named Varadarājaya to his daughter the princess at her marriage, for her worship to ensure her welfare and protection. The symbols repeated many times around the centre square represent the nine planets. Symbolically these serve to protect the cosmic energy of the deities invoked in the centre. Tamil Nadu, c. 16th century. Copper plate, 38 × 38 in.

29, 30 Kṛishṇa, eighth incarnation of Vishṇu and chief divinity of Hindu devotionalism, in his iconic and yantra forms. As the Supreme Being and eternal lover, Kṛishṇa attracts the human soul to its ultimate surrender. In his yantra the seed mantra Klīṃ symbolizes his eternal aspect of love. Orissa, 18th century. Bronze

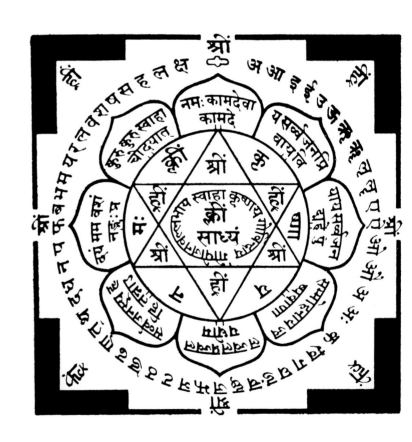

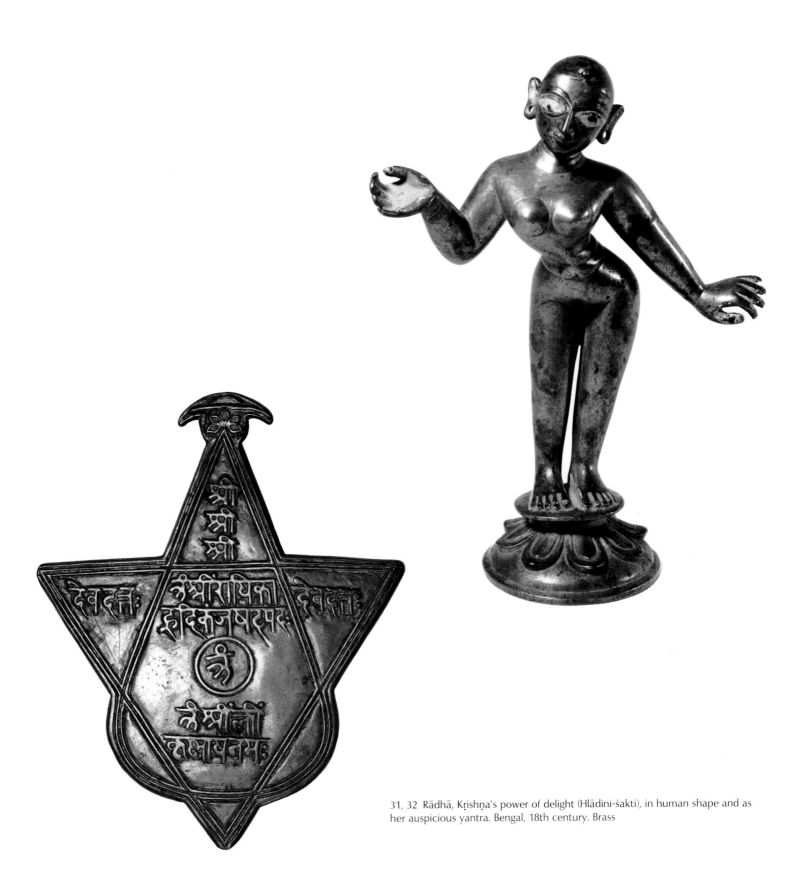

31, 32 Rādhā, Kṛishṇa's power of delight (Hlādini-śakti), in human shape and as her auspicious yantra. Bengal, 18th century. Brass

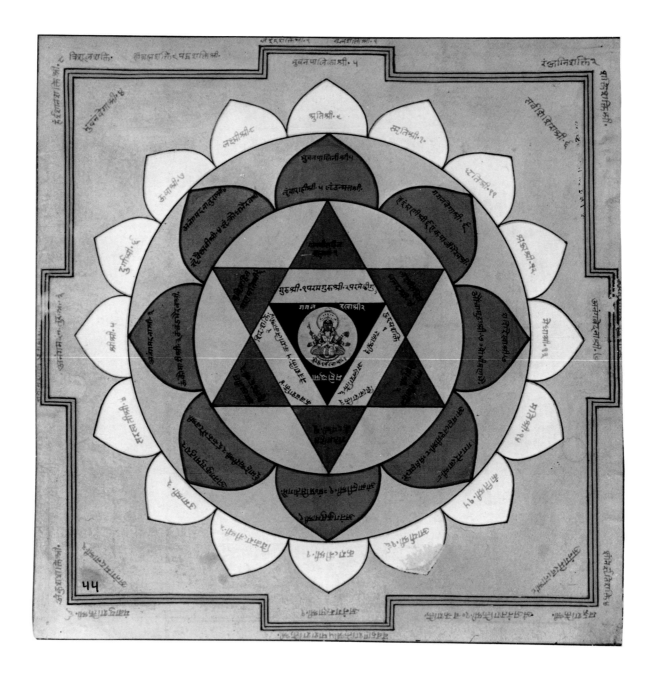

33 Yantra of the Mahāvidyā Bhuvaneśvarī, fourth of the ten aspects of the great goddess Kālī. The goddess who presides at the centre of her yantra is approached during ritual worship by means of the mantras of her surrounding deities. Correctly chanted, these mantras bring about progessive transformations in the psychic state of the sādhaka (see pp. 102–5). Rajasthan, c. 18th century. Gouache on paper

34–37 The sixteen lunar goddesses, the Nityā Śaktis, together provide a model of Cosmic Time, understood by Indian thought as cyclical. Four deities of lunar phases during the bright half of the month are (from the top, left to right) Kāmeśvarī Nityā, Bhagamālinī Nityā, Nityāklinna Nityā and Bheruṇḍā Nityā. Rajasthan, c. 19th century. Ink on paper

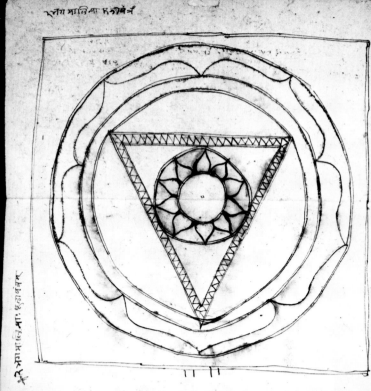

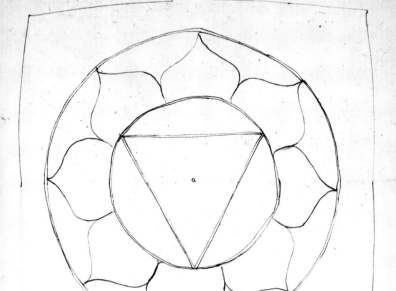

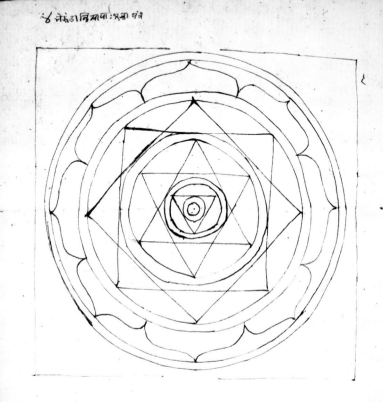

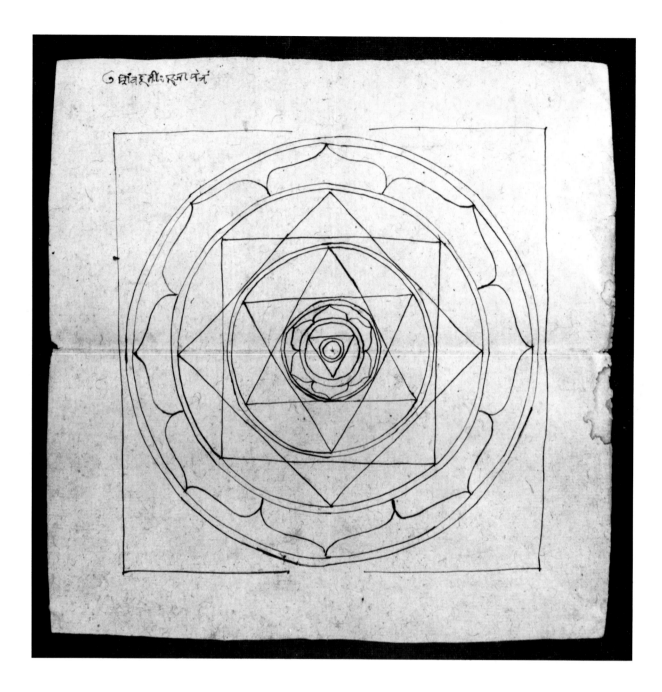

38–42 Each Nityā Śakti is a partial yet complete manifestation of cosmic energy, the partial aspects symbolized by the elemental forms of each yantra, the universal by the circle which encloses them all, like the moon, never losing its completeness. Above, a yantra of a single moon phase, Śivadutī Nityā; opposite, yantras of Vahnivāsinī Nityā, Mahāvajreśvarī Nityā, Tvaritā Nityā and Nityā–Nityā. Rajasthan, c. 19th century. Ink on paper

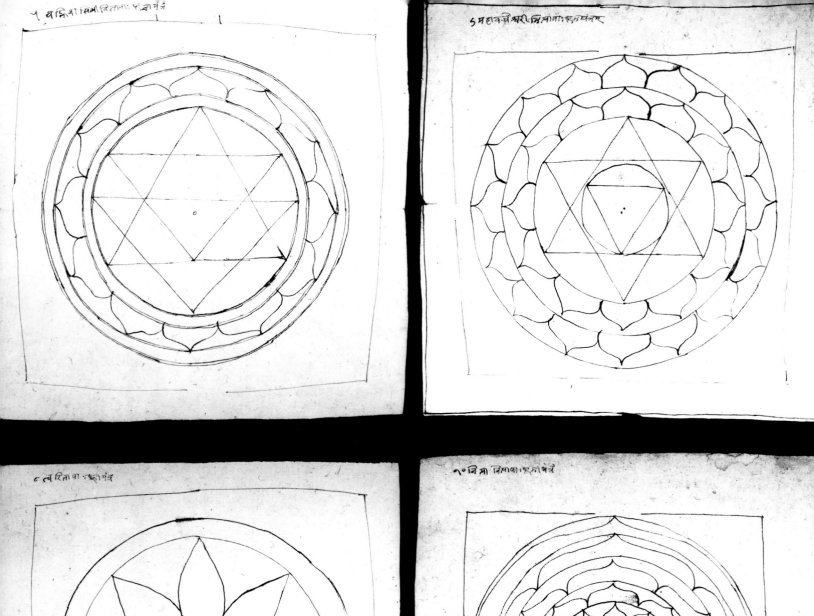
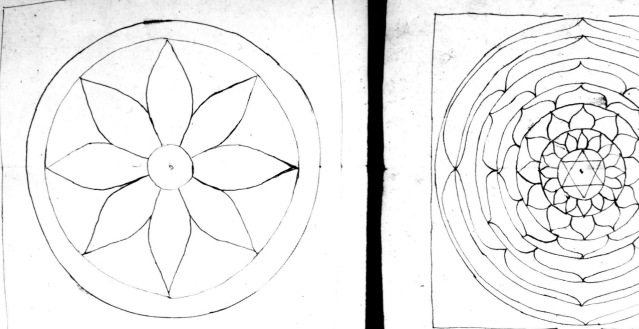

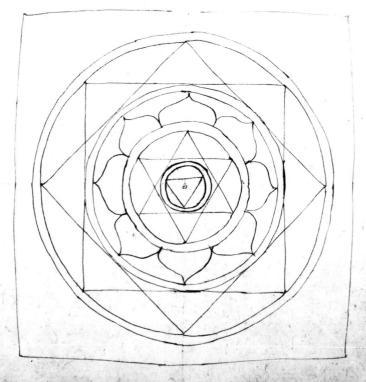

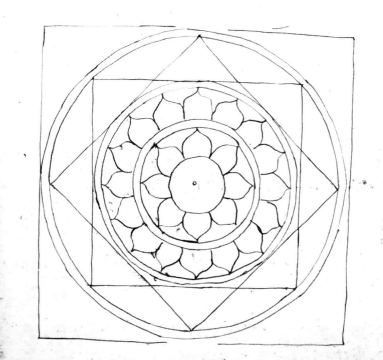

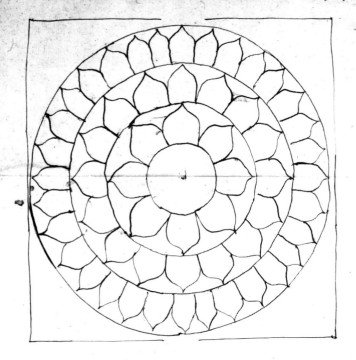

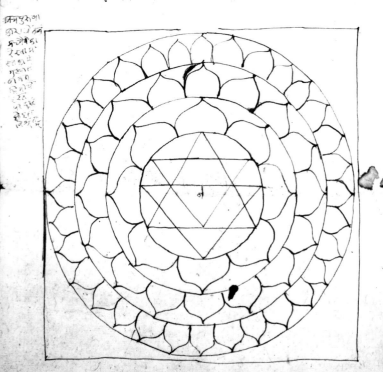

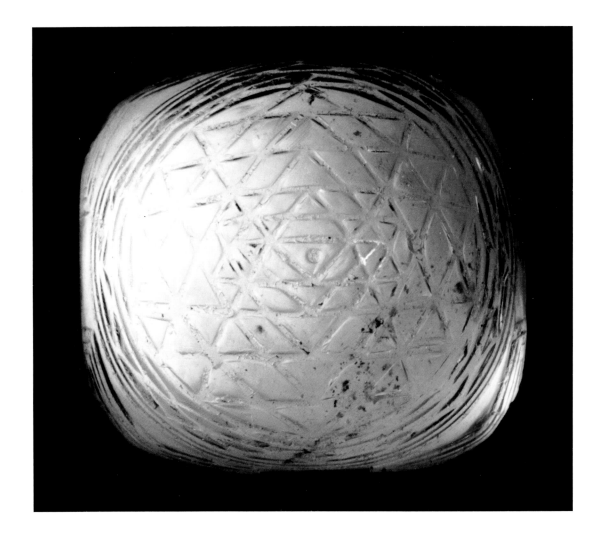

43–46 Goddesses of the concluding phases of the lunar cycle: Nilpatakā Nityā, Vijayā Nityā, Sarvamaṅgalā Nityā aṅd Chitrā Nityā. The last is Ādyā Nityā, worshipped in the Śrī Yantra (see p. 73). Rajasthan, c. 19th century. Ink on paper

47 Śrī Yantra, image of the evolution of the cosmos. Viewed from the centre, the bindu, outwards to the periphery, each of the nine circuits of the yantra represents a stage in the unfolding which gives birth to the apparently separate entities of the manifested world. The substance, rock crystal, on which this yantra is incised, is itself symbolic: its translucent substance is believed to contain every colour, as the yantra embraces the totality of creation. Viewed in the opposite direction, from the periphery to the centre, known as the involution mode, the Śrī Yantra is a tool of ritual worship, enabling the sādhaka to intuit the One and to rediscover his original wholeness. Nepal, c. 1700

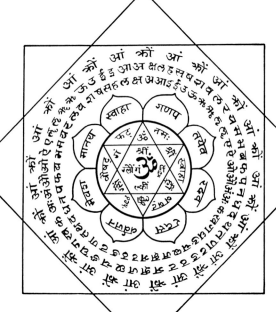

48, 49 Yantras of Gaṇesha, the elephant-headed god, honoured as a symbol of good luck and wisdom, and as a dispeller of obstacles. Above, his iconic yantra embossed on copper (Tamil Nadu, contemporary image based on traditional forms). Right, his abstract yantra inscribed with mantras. Contemporary image

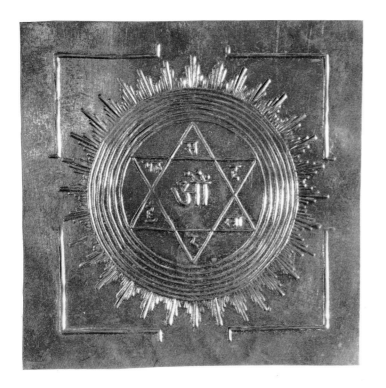
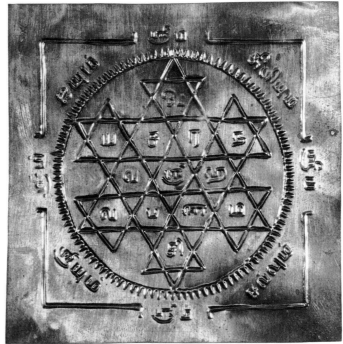
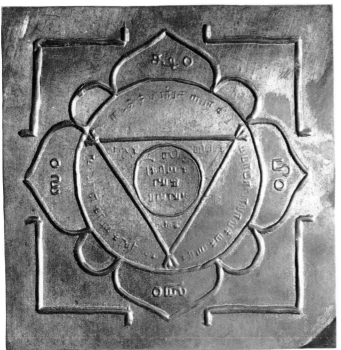
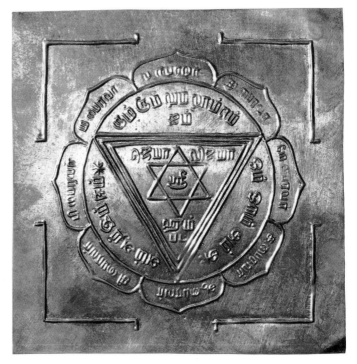

50–53 Yantras embossed on small copper plates, to be used in ritual worship. From top left to bottom right: Sudarshana Yantra, symbolizing Vishṇu's power and radiance; Vishṇu and Lakshmī Yantra symbolizing the unity of the male and female principles; yantra of Vishṇu, the preserver of the cosmos; and Kāla Bhairava Chakra, an auspicious yantra of one of the epithets of Śiva. Tamil Nadu, contemporary images based on traditional forms

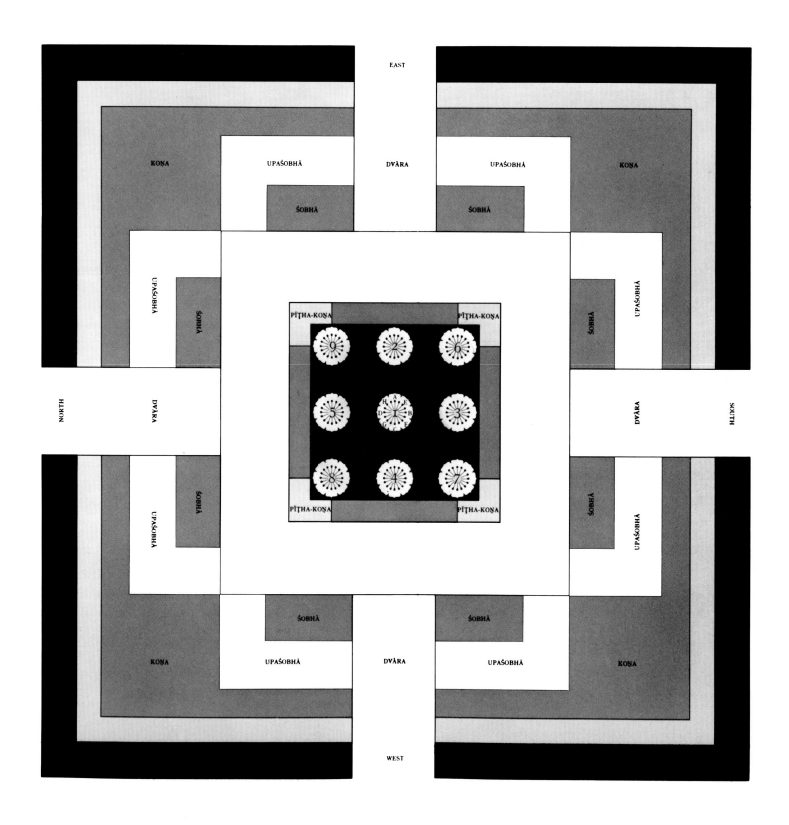

54 Navapadma (nine lotus) Maṇḍala, a tantric yantra devoted to the worship of Vishṇu. The nine lotuses in the centre are the seats of Vishṇu's nine epithets. The square forms are characteristic of tantric Vaishṇava yantras used by the sect of Pañcarātras. Contemporary diagram based on traditional form

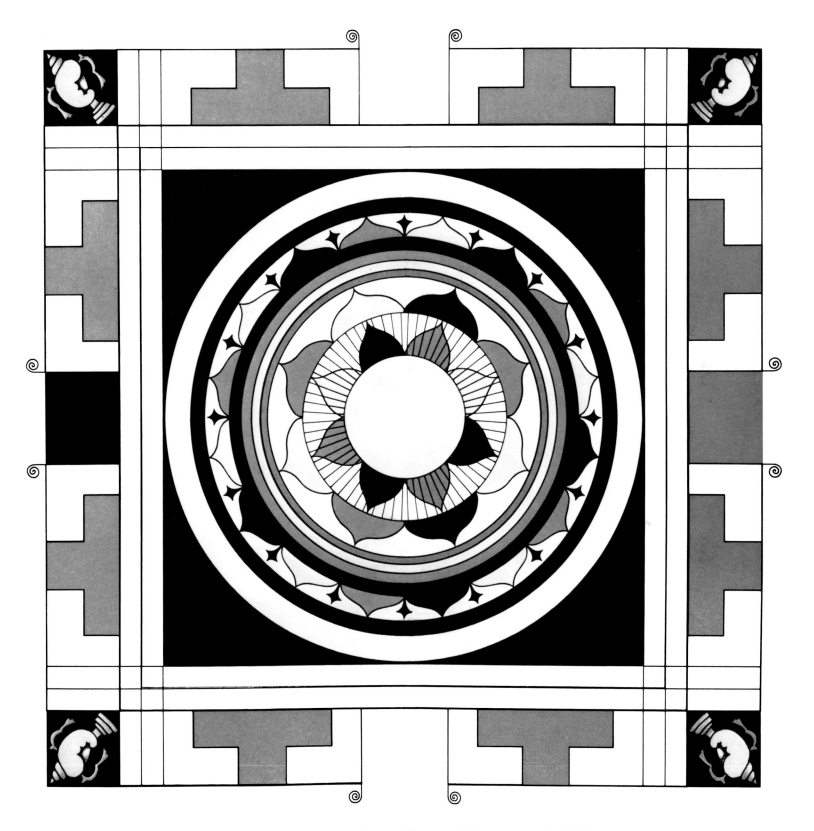

55 Chakrābja Maṇḍala, a yantra made up of circuits of lotuses, which is used in tantric initiation ceremonies. South India, contemporary diagram based on traditional form

कर्षिणीशरीराकर्षणा: ६ सर्वाशापारिपूरक
चक्रस्वामिनी सर्वाशापरिपूरक चक्रस्वामी
७ गुह्ययोगिनी गुह्ययोगी ८ अनंगकुसुमा
अनंगकुसुम: १ अनंगमेखलाअनंगमे
खल: ४ अनंगमदनाअनंगमदन: ६
अनंगमदनातुराअनंगमदनातुर: ८
अनंगरेखाअनंगरेख: १० अनंगवेगिनी
अनंगवेग ११ अनंगांकुशाअनंगांकुश:
१४ अनंगमालिनी अनंगमाली १६ सर्वसं
क्षोभणचक्रस्वामिनी सर्वसंक्षोभण चक्र
स्वामी १८ गुह्यतरयोगिनी गुह्यतरयोगी ३०
सर्वसंक्षोभिणीसर्वसंक्षोभण: ३२ सर्वविद्रा
वणीसर्वविद्रावण: ३४ सर्वाकर्षणीसर्वाक
र्षण: ३६ सर्वाह्लादिनीसर्वाह्लादन: ३८
सर्वसंमोहनीसर्वसंमोहन: ४० सर्वस्तंभनी
सर्वस्तंभन: ४२ सर्वजृंभणीसर्वजृंभण ४४
सर्ववशंकरीसर्ववशंकर: ४६ सर्वरंजनी
सर्वरंजन: ४८ सर्वोन्मादिनीसर्वोन्मादन: ५०
सर्वार्थसाधनीसर्वार्थसाधन: ५२ सर्वसंप
त्तिपूरणीसर्वसंपत्तिपूरण: ५४ अथाष्टाभ्रं
सा: सर्वमंत्रमयीसर्वमंत्रमय: ३ सर्वद्वंद्व
क्षयंकरीसर्वद्वंद्वक्षयंकर: ४ सर्वसौभाग्य
दायकचक्रस्वामिनी सर्वसौभाग्यदायकच
क्रस्वामी ६ संप्रदाययोगिनी संप्रदाययो
गी ८ सर्वसिद्धिप्रदासर्वसिद्धिप्रद: १० स
र्वसंपत्प्रदासर्वसंपत्प्रद: १२ सर्वप्रियंकरी
सर्वप्रियंकर: १४ सर्वमंगलकारिणीसर्वमं
गलकारी १६ सर्वकामप्रदासर्वकामप्रद: १८
सर्वदु:खविमोचनीसर्वदु:खविमोचन: २०
सर्वमृत्युप्रशमनीसर्वमृत्युप्रशमन: २२
सर्वविघ्ननिवारिणीसर्वविघ्ननिवारण: २४
सर्वांगसुंदरीसर्वांगसुंदर: २६ सर्वसौभाग्य
दायिनीसर्वसौभाग्यदायी २८ सर्वार्थिसाध

कचक्रस्वामिनी सर्वार्थसाधकचक्र स्वामी ३०
कुलोत्तीर्णयोगिनीकुलोत्तीर्णयोगी ३२
सर्वज्ञासर्वज्ञ: ३४ सर्वशक्तिसर्वशक्ति: ३६
सर्वैश्वर्यप्रदासर्वैश्वर्यप्रद: ३८ सर्वज्ञानम
यीसर्वज्ञानमय: ४० सर्वव्याधिविनाशिनी
सर्वव्याधिविनाशन: ४२ सर्वाधारस्वरूपा
सर्वाधारस्वरूप: ४४ सर्वपापहरासर्वपाप
हर: ४६ सर्वानंदमयीसर्वानंदमय: ४८
सर्वरक्षास्वरूपिणीसर्वरक्षास्वरूपी ५०
सर्वेप्सितफलप्रदासर्वेप्सितफलप्रद: ५२
सर्वरक्षाकरचक्रस्वामिनी सर्वरक्षाकरचक्र
स्वामी ५४ निगर्भयोगिनी निगर्भयोगी ५६
वशिनीवशी ५८ कामेश्वरीकामेश्वर: ६०
मोदिनीमोदी ६२ विमलाविमल: ६४ अ

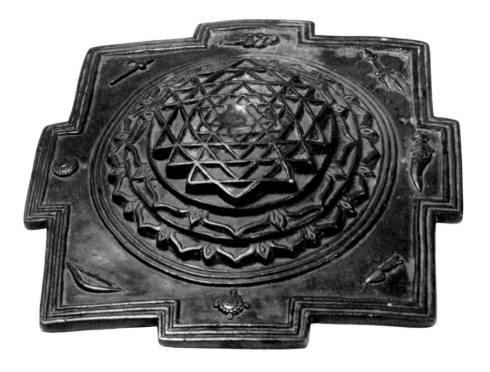

56, 57 Scroll (left) with mantras for Śrī Yantra pūjā (ritual worship, normally performed daily). The correct rhythmic chanting of these yantras energizes the static pattern of the Śrī Yantra (below). South India, c. 17th century. Copper

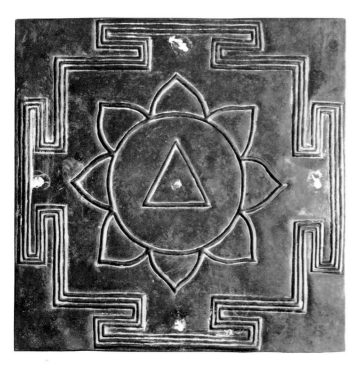

58, 59 Yantra of the Mahāvidyā Tārā (left) bearing the marks of sandal paste and red powder used in pūjā (South India, *c.* 18th century. Copper plate). The Meru form of the Śrī Yantra (below), in contrast, is generally used for meditation. Its pyramidal form of nine levels represents the sādhaka's steps of ascent from the world of matter to the highest spiritual level, the summit/bindu. Rajasthan, 18th century. Bronze

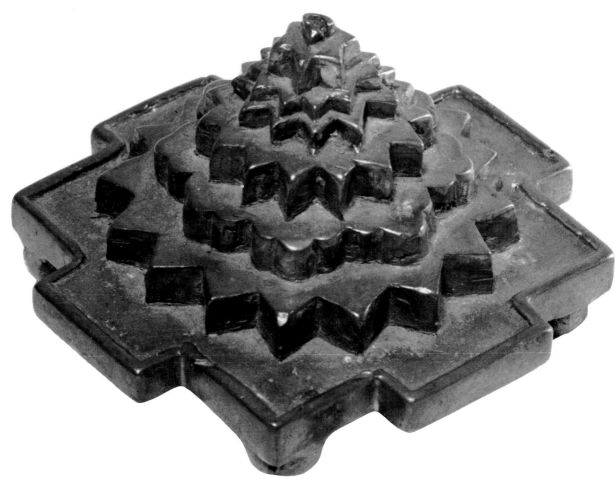

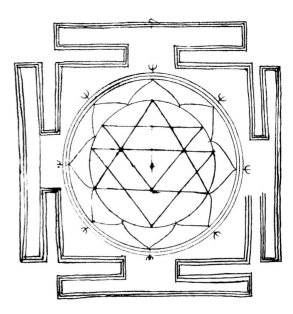

60, 61 The magnificent traditional image of the goddess Durgā, with her yantra, a bold contrast in expression. Yet image and yantra are 'sparks of the same fire', and in worship are interchangeable. Clay figure, 20 feet high, West Bengal; yantra based on the tantric work *Tantrasāra*, Rajasthan, 19th century. Ink on paper

4
Dynamics of Yantra: Ritual

The practices of ritual and meditation involve an internalization and externalization of symbols by means of parallel activities, the one inward and the other outward. This constant interplay of inner and outer constitutes the dynamics of yantra. For it is held that the energy (śakti) of the power diagram remains inert until it is activized and made meaningful through sacred activity. It is through ritual that power descends into the yantra and man is able to begin his ascent into a higher realm of being.

'There can be no sādhanā in an unreal world by an unreal sādhaka of an unreal lord.'[1] This statement implies that the god or goddess must be known as a 'presence' – visibly through the yantra, audibly through the mantric chants – and that the sādhaka must try to achieve an inner experience of the divinity. The sādhaka must ritually purify and prepare both himself and the yantra lest the deity he wishes to invoke in the yantra remains a stranger to him.

Ritual initiation

Initiation is the first major existential experience which prepares the sādhaka for the return to his inner centre and maps his journey towards integration with the cosmos. It is through the rite of initiation that he learns the nature and use of the yantra-mantra complex and begins to grasp the inner meanings of its signs and symbols.

Traditionally, the ceremonies of initiation mark a passage from one world to another. The rite is not simply a static event but is a dynamic transforming experience of the whole being, a second or 'true' birth, which conditions the sādhaka towards the primordial sources. Elaborate ceremonies are conducted to bring about 'death' and 'rebirth' which are understood as taking place literally. Some Tantras[2] list as many as twenty-five different types of initiation which last for many days and form a complete yoga sequence. The simplest form of initiation consists of mantra initiation (mantra-dīkshā) performed by a guru. Yantras generally play an important part in initiation ceremonies; and among the Śāktas, for example, initiation may be performed with the aid of the Śrī Yantra. In the simplest form of ceremony, the guru initiates the disciple in three stages: first he touches the disciple (sparśa-dīkshā) concentrating deeply on Devī; then he looks at the disciple with love and grace (dṛik-dīkshā); finally, he imparts to him the words of knowledge and introduces to him the esoteric techniques of Chakra-pūjā (ritual worship of the chakras or circuits of the Śrī Yantra). This is followed by the recitation of the hundred-syllable mantra of the Devī and the offering of flowers to the Śrī Yantra.

Some initiatory rites are quite elaborate, like the one described in the *Mahānirvāṇa Tantra* (x, 109–97), followed by the Kaulas, or 'left-hand' tantrikas. This rite, known as puṛṇābhiśeka, is performed with the five 'forbidden elements', wine, meat, fish, cereals and intercourse, using the Sarvatobhadra Maṇḍala made on an earth altar with rice powder, and coloured yellow, red, black, white and dark blue. A jar is placed in the centre of the maṇḍala, and in an extended ceremony consisting of bodily purification, nyāsa, meditation and recitation of mantras, the five ingredients are offered on the jar symbolically. Finally, the guru imparts the mantra to the disciple and gives him a new name. Then the disciple worships his tutelary deity on the maṇḍala. Such rites may take one day, or three or five or seven or nine days, with a special yantra for each day.

72

Among the tantric Vaishnavites (Pañcarātra) also, initiation is performed with the aid of maṇḍalas. The *Lakshmī Tantra* gives an elaborate version of one such rite which uses the Chakrābja Maṇḍala, divided into nine sections, each of which is named after one of the aspects of Vishṇu. After the initial phases of the ritual the adept is given a new name. For this, he is blindfolded and made to cast a flower on the Chakrābja Maṇḍala; according to the section where the flower has fallen, the disciple is named after one of Vishṇu's epithets. Another feature of this form of initiation is what is called the 'tattva-dīkshā', in which the guru prepares a thread made of three strands, each to represent one of the three qualities of material nature – sattva, rajas and tamas – and each with nine knots. These twenty-seven knots symbolically denote all the cosmic principles in the body of the sādhaka and are offered as oblation into the sacred fire, a ritual act to denote symbolically the 'death' of the old self which is accompanied by the birth of a new self open to the life of the spirit.

55

Irrespective of the method that is followed, it is through the ritual of initiation that the psychological transformation of the adept begins. The rites of initiation bring a complete renewal of the sādhaka and equip him to carry out the various practices of yantra sādhanā.

The prāṇapratiṣṭhā ceremony

Just as the sādhaka is ritually transformed by the rites of initiation, so the yantra has to undergo a complete ritual transformation in order to be accessible for worship. One of the most important rituals of yantra worship is the infusing of vital force (prāṇa) into the geometrical pattern of the yantra, called prāṇapratiṣṭhā. The goal is to cause the spiritual universe underlying myth and iconography to 'descend' into the yantra so that it becomes a radiant emblem and receptacle of cosmic power (śakti-rūpa), and conciousness (chaitanya), transforming into sacred archetypal space what is phenomenally no more than a mere design.

The transfer of power from the sādhaka to the yantra changes the nature of the diagram, and the consecration of profane space conversely elevates the sādhaka to realizing the inherent energy of the theophany, so that the yantra becomes a powerful means of contact between the sādhaka and the cosmos.

In the beginning of the ritual, the yantra which is to be made a living entity is ritually established (yantra sthāpanā) on a wooden pedestal. A maṇḍala is the seat on which the yantra will be consecrated, and it is purified by worshipping the specific divinities of the seat (pīṭha pūjā) and the four regents of space by chanting appropriate mantras. The yantra on its pedestal is then placed on a plate and put on the table, on the maṇḍala, for the ritual of prāṇapratiṣṭhā proper. To create a ritually pure archetypal space devoid of negative vibrations, the rite of expelling negative or evil forces (bhūtapāsaraṇa) is performed with a mantra. There follows another rite, known as 'fencing the quarters' (digbandhana), in which the sādhaka symbolically binds the four quarters of space by snapping his right thumb and middle finger ten times (8 points of the compass + nadir + zenith).

The sādhaka's body is next symbolically purified. It is through his purified body, in which the deity is present, that divine consciousness will be transmitted into the yantra to make it a living entity. The sādhaka's body is made infinitely radiant by means of the ritual of bhūtaśuddhi, in which the deification of the body is achieved by the symbolic dissolution of the five elements. Each element is dissolved by the chanting of mantras. The sādhaka then uses meditation to concentrate deeply on the deities, and performs the ritual of nyāsa, in which he touches various parts of his body while reciting mantras.

Through these rituals the sādhaka becomes an embodiment of conscious force and his body an epitome of divine energies. Thus 'purified' and 'cosmicized', he is considered an appropriate vehicle for the transference of power to the yantra.

This descent into the yantra can be achieved in several ways, but one of the chief methods is a breathing technique (prāṇāyāma). While the adept is in complete concentration, the devatā is exhaled by pranic transmission through the right nostril as he chants an appropriate mantra. He controls his breath, exhaling it over a red flower which he holds in his hand. The divine essence is thus communicated through the adept's body on to the flower. He then places the flower at the centre of the yantra which begins to be permeated with the spark of consciousness. The *Mahānirvāṇa Tantra* (VI, 63–74) describes this process:

> Then, while making with both hands the 'tortoise mudrā' [finger gesture], let the worshipper take up with his hands a beautiful flower scented with sandal, fragrant aloes, and musk, and, carrying it to the lotus of his heart, let him meditate therein [in the lotus] upon the most supreme Ādyā.
> Then let him lead the Devī along the Sushumṇā Nāḍi, which is the highway of Brahman to the great Lotus of a thousand petals, and there make Her joyful. Then, bringing Her through his nostrils, let him place Her on the flower, [her presence being communicated] as it were, by one light to another, and place the flower on the Yantra. Then, uttering the bija [seed-mantra] Krīng, say the following: 'O Ādyā Devī Kālīkā! come here [into the yantra] with all Thy following, come here; [and then he says] stay here, stay here; [and then] place Thyself here; [and then] be Thou detained here. Accept my worship.'
> Having thus invoked [the Devī] into the Yantra, the Vital Airs of the Devī should be infused therein by the following *pratiṣṭhā mantra*:
> 'Āng, Hrīng, Krong, Shrīng, Svāhā, may the five Vital Airs of this Devatā be here; Āng, Hrīng, Krong, Shrīng, Svāhā, Her Jiva is here placed; Āng, Hrīng, Krong, Shrīng, Svāhā, all senses; Āng, Hrīng, Krong, Shrīng, Svāhā, speech, mind, sight, smell, hearing, touch, and

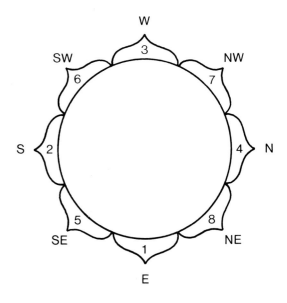

A lotus unfolding its petals towards the eight regions of the cosmos provides the sacred seat on which the yantra is consecrated for ritual worship

the Vital Airs of the Ādyā-Kālī Devatā – may they come here and stay happily here forever. Svāhā.'

Another method of infusing vital force into the yantra is by the means of symbolic finger-gestures (Āvāhana-mudrā).[3] The adept exhales his breath on to the appropriate finger-positions to 'arrest' symbolically the essence of the divinity. He then slowly lets his closed hands descend on to the yantra.

In other ceremonies, the deity may be installed by uttering the tantric version of the famous Gāyatrī Mantra (see p. 40) or variants of other well-known mantras. Some ritual manuals[4] also outline a ceremony based on the ritual washing of the yantra with several liquids; in such a case the washing is symbolically suggestive of cleansing away impurities.

No matter what method the adept follows, the prāṇapratiṣṭhā ceremony effects a transformation of the yantra, which now begins to function on a different level of reality: it has become a receptacle of divine manifestations, divinity in abstract form. The yantra is 'transformed' into a unit of archetypal space (ākāśa) which is identified with power (śakti). No longer can the yantra be equated with gross matter veiling the spirit, but it has become instinct with the being of the deity with which it is aroused.

Āvāhana-mudrā, the gesture by which the divinity is brought to presence in the ritual of prāṇapratiṣṭhā

Yantra pūjā

Then follows the external ritual of pūjā (adoration), or offering homage to the deity through the symbol of the yantra. Yantra pūjā is generally carried out daily, as an individual ceremony in which the adept establishes a link with the cosmic forces invoked in the yantra through the mystic groupings of devatās. By means of an aesthetically pleasing ceremonial involving a variety of ritual ingredients – flowers, incense, water, food offerings, etc. – all of which have a deep symbolism and involve his entire psycho-physical complex, the worshipper strives to achieve a state of concentration.

The type of offering and technique of pūjā will vary depending upon the sect of the worshipper. For instance, the 'left-hand' cults of tantrikas will always symbolically offer the five forbidden ingredients (Pañcha-makāra) – wine, meat, fish, cereal and intercourse – whereas others will use simple everyday symbolic ingredients, such as flowers and perfumed substances and finger gestures. Though pūjā may involve complex techniques and elaborate accessories, its value and essence lie in the attitude (bhāva) and inner experiences (anubhāva) of the devotee. The ritual is approached with a deep sense of compassion or humility, with utter dedication and a feeling of total surrender towards the object of worship. Then every offering, however small, has meaning:

> Whatever man gives me
> In true devotion:
> Fruit or water;
> A leaf, a flower:
> I will accept it.
> That gift is love,
> His heart's devotion. *Bhagavad-Gīta* (Chap. IX)

Yantra pūjā may sometimes be performed with a specific purpose in view (sakāma). When it is for such a particular, temporary, purpose a yantra may be drawn on a metal plate with sandal paste, red pigment (kum kum) or saffron; or it may be engraved on copper, silver or gold. The colour of the material is generally decided in relation to the goal of worship, so that if the ritual is performed for auspicious purposes, the yantra is generally red; for magico-propitiatory rites it may be yellow.[5]

One tantric text enjoins that before he worships the Śrī Yantra, the sādhaka must put on a red garment and red garlands, smear his body with sandal paste, and scent himself with camphor. He should sit in the lotus posture facing east and then may begin the ritual.

After invocation of the chosen deity (Ishṭa-devatā) with the prāṇapratiṣṭhā ceremony described above, the adept symbolically clears away all the obstructions or negative forces from the site where the yantra is placed. This preparatory ritual is considered particularly important because it serves to create a cosmic circuit around the yantra, 'fencing' the four sides to guard them against negative forces. The adept then touches various parts of his body with his fingertips (nyāsa, or worship by gesture), while chanting mantras, in order to free his being of all impurities and make it fit for worship, thus symbolically preparing for the descent of the deity into his own person. Either of two types of nyāsa may be performed. The first, Kara-nyāsa, involves touching parts of the hands with specific mantras:

> The thumbs: Hrāṃ Namaḥ
> The forefingers: Hrīṃ svāhā
> The middle fingers: Vaṣaṭ
> The ring fingers: Hraīṃ huṃ
> The little fingers: Vaṣaṭ
> The palm: Hraḥ
> The back of the hands: Phaṭ.

In the second type, Aṅga-nyāsa, the parts of the body are consecrated with the following mantric sounds:

> The heart: Hrāṃ Namaḥ
> The head: Hrīṃ
> The top of the head (to the left of the hairline): Hrīṃ vaṣaṭ
> The arms below the shoulders: Hrauṃ vaṣaṭ.

Both forms of nyāsa are followed by mental concentration on the deity propitiated in the yantra. Then the accessories of the ritual are purified by sprinkling them with water consecrated with the appropriate mantra (the weapon mantra, Phaṭ), and making the ritual finger gesture (dhenu-mudrā).

After these preliminaries, the yantra is worshipped with ritual offerings, commonly five (pañchopacāra) – sandal paste, flowers, incense, lighted oil-lamp, food – which are associated with the five elements. The adept offers them in deep concentration while reciting the seed mantra corresponding to each:

Haṃ to thee (Devī) in the form of Earth, I offer sandal paste.
Haṃ to thee (Devī) in the form of Ether, I offer flowers.
Yaṃ to thee (Devī) in the form of Air, I offer incense.
Raṃ to thee (Devī) in the form of Fire, I offer light.
Vaṃ to thee (Devī) in the form of Water, I offer food.

The five offerings also symbolize the devotee's senses which he surrenders: his ultimate aim is 'to become what he worships'.

At this point begins the Āvaraṇa pūjā, which is specific to yantra worship. The worshipper makes ritual offerings with the appropriate mantra to each of the enclosures, the physical containers of the Śaktis disposed on the yantra's lotus petals, circles, and angles, starting from the principal divinity placed in the centre, exactly as the universe is conceived as unfurling itself from the bindu. The Śrī Yantra is also worshipped in this way, starting with Devī Tripura-Sundarī (Lalitā) in the bindu, then moving outwards to all the Śaktis successively until the outermost square is reached, whereupon the sādhaka involutes back to the centre for the final offering.

The Āvaraṇa pūjā proceeds in a clockwise direction, beginning from the east side of the yantra. This circular movement is meant to produce a sense of subjective rhythm, and to give a feeling of return to the source before the sādhaka moves on to the worship of the next circuit of the devatās.

33 The Āvaraṇa pūjā of the Mahāvidyā Bhuvaneśvarī (after the *Śrī-Bhuvaneśvarī-Nityārchana*), which is conducted on the nine enclosures of her yantra, illustrates on one hand the mantra/yantra synthesis, and on the other the symbolism of cosmic evolution/involution.

The mantras consist of seed syllables and the names of the deities, and are untranslatable. They exert their influence by their sound-vibrations.* They are meant to transmit, like music, their own meaning, as their sounds seep through our senses. As we have seen earlier, cosmos, deities and mantras are considered identical, therefore chanting of the name of the deities in tantric ritual is conducive to intuitive illumination and recapitulates a transcendental 'presence'.

The rhythmic pattern of the reiteration of the mantras makes the static pattern kinetic, and infuses the yantra with a mobile linear force, capable of impinging on the senses for transformation.

First circuit: the bindu

[The Goddess is invoked with Śiva in the bindu by chanting the following mantra]

•

Śriṃ hrīṃ Śrīṃ Amṛetaśvrśivasahita Śrī Bhuvaneśvar-yai namaḥ / śrī Amṛetaśvrśivasahita Śrī Bhuvaneśvarī
[followed by the major mantra, which is]
Śrī pādukāṃ pujyāmi namaḥ tarpyāmi namaḥ

[Protection is invoked around the bindu by chanting the names of the deities of the eight regents of space with mantras associated with parts of the body]

*For note on Sanskrit pronunciation, see p. 170.

Āgneye [S E], Śrīṃ hrīṃ Śrīṃ hrāṃ hṛdyāya [heart] namaḥ hṛdyaśakti [followed by the major mantra, see above]
Naiṛtye [S W], śrīṃ hrīṃ śrīṃ śirse [head] svāhā śira-śakti [followed by the major mantra]
Vāyavye [N W], śrīṃ hrīṃ śikhāyai vaṣaṭ sikhā [crown of the head] [followed by the major mantra]
Īśāne [N E], śrīṃ hrīṃ śrīṃ hriaṃ kavacāya huṃ kavaca [followed by the major mantra]
[back to the centre] śrīṃ hrīṃ śrīṃ hrauṃ netratrayāya [eyes] vauṣṭ netre traya [followed by the major mantra]
[around the centre] śrīṃ hrīṃ śrīṃ astraya phaṭ astra [followed by the major mantra]
[back to the centre] śrīṃ hrīṃ śrīṃ hṛllekhā [followed by the major mantra]

Purve [E], śrīṃ hrīṃ śrīṃ aiṃ Gaganā [followed by the major mantra] Dakṣiṇe [S], śrīṃ hrīṃ śrīṃ auṃ Raktā [followed by the major mantra] Paśchime [W], śrīṃ hrīṃ śrīṃ iṃ Karālikā [followed by the major mantra] Uttare [N], śrīṃ hrīṃ śrīṃ āuṃ Mahocchuṣmā [followed by the major mantra]

[Now is chanted the concluding root mantra in which the sādhaka beckons the Goddess of the first circuit to grant success and good fortune]

etāḥ prathamāvaraṇadevatāḥ sāṅgāḥ saparivāraḥ sāyudhāḥ saśaktikāḥ pūjitāstarpitāḥ santu namaḥ
Abhīṣṭsiddhiṃ me dehi śaraṇāgatavatsle bhaktyā samarpaye tubhyaṃ prathamāvaraṇ-ārchanaṃ

Second circuit: hexagon

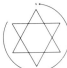

[Invoking the devatās with their śaktis from the north triangle onwards]
Śrīṃ hrīṃ śrīṃ Gayātrīsahita caturānana Brahmā / Savitrī sahit Viṣṇu / sarsvatīsahit Rudra / Lakshmīsahit Kuvera / Rati sahit Kāma / Puṣṭi sahit Vighanrāja [followed by the major mantra]
[on the sides of hexagon] Śaṅkhanidhi sahit Vasudhā / Padmanidhi sahit Vasumati / Gayatryādisahit Śrībhuvaneśvarī [followed by the major mantra] [Then are chanted the mantras associated with the parts of the body starting from the heart ending with eyes]
Hrāṃ hṛdayāya [heart] namaḥ / hrīṃ śirse [head] namaḥ / hruṃ śikhāyai [crown] namaḥ / hraiṃ kavacāya namaḥ / Hrauṃ netratrayāya [eyes] namaḥ / Hrḥ astrāya namaḥ [followed by the root mantra, as above but concluding dvitīyāvaraṇārchanam = deities of the *second* (dvitīya) circuit]

Third circuit: eight-petalled lotus

[Invoking the deities on the petals] Anaṅgakusumā / Anaṅgakusumāturā / Anaṅga-mandanā / Anaṅgamadanāturā / Bhuvanapālā / Śrīgaganavega / Śrīśśirekhā / Anaṅgavega

[followed by the major mantra after each name and finally the root mantra as above but concluding tritīyāvaraṇārchanaṃ = the deities of the *third* (tritīya) circuit]

Fourth circuit:
sixteen-petalled lotus

[Invoking the sixteen deities on the petals together with the major mantra] Śrīṃ hrīṃ śrīṃ Karālā / Vikrālā / Umā / Sarsvatī / Śrīḥ / Durgā / Uṣā / Lakshmī / Śruti / Smṛiti / Dhṛti / Śraddhā / Meghā / Rati / Kānti / Āryā [followed by the root mantra, concluding cathurāvaraṇārchanaṃ = deities of the *fourth* (cathurtha) circuit]

Fifth circuit: outside the
sixteen petals invoking the
eight Mātrikā Śaktis together
with the major mantra

Śrīṃ hrīṃ śrīṃ āṃ Brāhamyai namaḥ Brāhmī / Iṃ Māheśvryai namaḥ Maheśvarī / Uṃ Kaumāryai namaḥ Kaumārī / Ṛṃ Vaiṣṇavyai namaḥ Vaiṣṇavi / Lṛṃ Vārāhyai namaḥ Vārāhī / aiṃ Indrāṇyai namaḥ Indrāṇī / Auṃ Chāmuṇḍāyai namaḥ Chāmuṇḍā / aḥ mahālakshmyai namaḥ Mahālakshmī [followed by the root mantra concluding pañcāvaraṇārchanaṃ = deities of the *fifth* (pañca) circuit]

Sixth circuit: inside the
square invoking the deities
with the major mantra

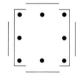

Śrīṃ hrīṃ Anaṅgarupā / Anaṅgamadanā / Anaṅgamadanāturā / Bhuvanavegā / Bhuvanapālikā / Sarvaśirā / Anaṅgavednā / Anaṅgamekhlā [followed by major mantra after each name and the root mantra concluding Ṣaṣṭhāvaraṇārchanaṃ = deities of the *sixth* (ṣaṣṭha) circuit]

Seventh circuit:
points of the outer periphery

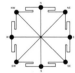

[Invoking the deities of the eight regents of space, nadir and zenith with their respective seed mantras]

Śrīṃ hrīṃ Śrīṃ laṃ Indrāya [E] namaḥ / yaṃ Agni [SE] / yaṃ Yama [S] / Kṣhaṃ Nirṛti [SW] / Vaṃ Varuṇa [W] / Yaṃ Vāyu [NW] / Saṃ Soma [N] / Haṃ Īśāna [NE] / āṃ Brahmā [zenith] /

Hrīṃ Ananta [nadir] [followed by the major mantra after each deity, and finally the root mantra concluding, saptāvaraṇārchanaṃ = deities of the *seventh* (sapta) circuit]

Eighth circuit:
outside the square enclosure

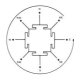

[Now the energies of the deities of the quarters who guard the sacred space of the yantra are invoked naming each of their emblems, which are symbols of their power and strength and display their eminence over the whole universe]

Śrīṃ hrīṃ śrīṃ vajra śakti [thunderbolt, E] / agni śakti [fire, SE] / daṇḍa śakti [staff, S] / khaḍga śakti [sword, SW] / Pāśa śakti [noose, W] / dhvaja śakti [flag, NW] / gadā śakti [goad, N] / Triśula śakti [trident, NE] / padma śakti [lotus, zenith] / chakra śakti [disc, nadir] [followed by the major mantra, and finally the root mantra concluding aṣṭamāvaraṇār-chanaṃ = the deities of the *eighth* (aṣṭa) circuit]

Ninth circuit: back to
the bindu = involution

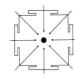

[The culmination of the Āvaraṇa pūjā is reached at the ninth enclosure when the sādhaka reverses the movement of the rite precisely as the universe involutes back to the centre, and invokes the protective divinities around the bindu followed by the major mantra]
Śrīṃ hrīṃ vaṃ vatuka [E] / yaṃ yoginī [N] / kṣhaṃ khetrapāla [W] / gaṃ gaṇapatī [S] / Vāyavye vāṃ aṣṭavasu [NW] / Īṣāne dvādaśāditya [NE] / āgneye ekādaśa rudra [SE] / nairṛtye sarvabhut [SW]
[Now the final offering is made thrice with a handful of flowers, perfumes, the waving of lights and chanting of the root mantra, concluding navāvaraṇārchanaṃ = deities of the *ninth* (nava) circuit, and inviting the Devī to bestow her grace with the hand-gesture of the yoni-mudrā.]

Next, the devotee will perform japa, the repetition of a mantra a specified number of times. In South India it is still common to recite the one thousand names of the Goddess (Lalitāsahasranāma) or to repeat the esoteric mantra of the Śrī Vidyā (see p. 42). This may be followed by meditation by the sādhaka on the chakras (internal yantras) of his subtle body (see Chapter 5).

At the end of pūjā, the yantra may be erased if it has been drawn for temporary worship, or the sādhaka may use his middle finger to make a dot between his eyebrows with the vermilion paste offered on the yantra.

Visarjana

At the end of pūjā the yantra is symbolically forsaken in a rite known as visarjana – the dissolution of the yantra into the primordial plenitude (or whatever term may be used to indicate the Ultimate Ground of Being – archetypal space, Śakti, Brahman, etc.). Using a finger gesture (generally yoni-mudrā) and pronouncing the appropriate mantra, the adept dismisses the deity contained in the yantra. In certain forms of visarjana the deity is brought back into the adept's heart from where it was first installed into the yantra, either by the adept's inhaling his breath or smelling the flower through which the deity was first installed, during the prāṇapratiṣṭhā ceremony. The visarjana ceremony reverses the existential status of the yantra, so that what was earlier, at the start of the liturgy, a near-sacred archetype of the sacred reverts to the status of a diagram.

Yantra rituals follow one another as 'microcosmic enactment of the macrocosm'. The whole dynamic of ritual worship is analogous to the cyclical dynamics of cosmic time. The unity of 'cosmic time' which is divided into three phases in Indian tradition pp. 77–9) is perfectly identifiable with 'ritual time' in daily worship, which is also divided into three phases. The three phases of yantra liturgy – prāṇapratiṣṭhā or consecration, pūjā or worship and visarjana or ritual departure – succeed one another as a cosmogony and repeat the classical symbolism of creation, preservation and dissolution of the universe.

Cosmos	Yantra	Aspirant
Creation	prāṇapratiṣṭhā = ritual birth	initiation = ritual birth
Preservation	pūjā or worship	sādhanā
Dissolution	visarjana	identity of microcosmic self with the macrocosm

Further, the triple cosmogonic motif is repeated on three levels: on the level of the visual motif (yantra); on the level of the aspirant, who like the cosmos and the symbol attains a new state of identity, a process which begins from the moment he is initiated in the theory and practice of yantra; and on the ontological plane. Hence psyche, symbol and cosmos are gathered into a single identity, as the symbol is assimilated into the body and the body into the cosmos, forming a circuit of cosmic unity.

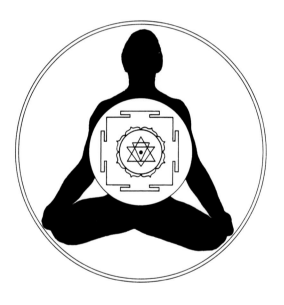

Identity of psyche, symbol and cosmos through ritual

5
Dynamics of Yantra: Meditation

Ritual is an introductory phase of spiritual discipline, but not the main and most significant element. Outer worship gradually gives way to an inner form of contemplation which leads the sādhaka through stages of spiritual unfolding, proceeding from the gross to the subtle levels of consciousness. As he passes from stage to stage his worship becomes more and more contemplative in character, and the visual aids which he uses become progressively simpler. In the earliest stages of yantra meditation he may use the yantra to visualize the iconic images of devatās; at the highest stage of all, the yantra is condensed into an imaginary bindu; and at the last, even the primal point disappears and the sādhaka and object of contemplation are one. The internalization of symbols as they become subtler is supported by the dynamics of the yantra until a culmination is reached when man, symbol and cosmos are united.

Yantra meditation is usually combined with the classical techniques of yoga meditation, which begin with the adept gaining perfect control over his mind by censoring the riot of mental impressions, sensations and memory associations which make up ordinary consciousness to achieve a mental state of lucidity and centration. Patanjali (c. 200 BC), originator of the classical yoga system, recognized the importance of external symbols as aids to achieving the mental state of ekāgratā, or single-pointed concentration: 'Concentration may be attained by fixing the mind upon any divine form or symbol that appeals to one as good.'[1] He further declared that the object in question can be of any size, from the 'atomic to infinitely great'.

Yantras provide a powerful tool for the preliminary centring of consciousness, but yantra meditation should not be understood superficially, as though attention were merely pegged on to a symbol, as for instance when we focus on any symmetrical figure to control our mental flux. On the contrary, genuine yantra meditation produces an active mental state and induces receptivity to symbolic revelations. Yantra meditation proper begins when the yogi has mastered the traditional bodily disciplines, such as energizing of the body by means of yogic postures (āsana) and regulating the breathing to a steady rhythm (prāṇāyāma).

Deity meditation

In one type of meditation iconic image and yantra are meditated on simultaneously. Each part of the iconographic image of the devatā is built up progressively during intense visualization. A verse dedicated to the goddess Triputa (an epithet of the

goddess Tripurā who is worshipped in the Śrī Yantra) gives an account of one such visualization:

> Let him then meditate upon two angles [of the yantra] in the lotus,
> And the Devī Herself in the lotus as follows:
> Her lustre is that of molten gold,
> With earrings on Her ears,
> Three-eyed, of beauteous throat,
> Her face like the moon,
> And bending from the weight of Her breasts.
>
> She holds in many arms, decked with diamonds and other gems,
> Two lotuses, a noose, bow, golden goad, and flowery arrows.
> Her body is adorned with great jewels,
> Slender is She of waist and beautifully girdled. . . .
>
> The Sādhaka who, having thus for a long time contemplated Her
> On a yantra set before him,
> And welcomed Her with great devotion,
> Worshipping Her with Svayaṁbhu flower,
> Attains success in all the four dimensions of life. . . .[2]

In a more elaborate variety of meditation the adept may contemplate the devatās in each of the successive enclosures of the yantras. After consecrating the yantra by means of the prāṇapratiṣṭhā ceremony (see p. 98), he begins his meditation by fixing his attention on the yantra's periphery, at the eastern portal, in preparation for the journey to the centre. The geometrical symmetry of the diagram helps to draw his attention towards the bindu, the fixed point of concentration. The adept interiorizes the form of the yantra and pursues his meditation, circuit by circuit, in obedience to the symbolism of the deities disposed on the circuits. These deities may be seen as symbols of the forces acting within the sādhaka which he must either restrain, conquer, transform, or interiorize for meditative experience. Behind the metaphysical realities of those deities lie the reality of psychic facts, the data of psychic experience and the reality of conscious and unconscious forces. The reality experienced through the complex iconographical structure is the reality of feeling and thought. Each deity can be considered the embodiment of a mental state or thought-form. On the higher level of insight, adepts consider the deities as the radiation of their own psychic faculties and as manifestations of their own being.

Equally, indwelling deities personify aspects of the physical being of the adept. Each part of a yantra is associated with a part of the body and with sense faculties.

Since man, the microcosm, and the universe, the macrocosm, are integrally related, there are fundamental affinities between the cosmic scheme, the subtle (or psychic) body and the yantra. In this form of meditation the external yantra is transformed into an internal yantra. Energizing psycho-cosmic affinities, the adept can begin to make the ascent, or journey of return. Hence it is important to view these yantras not merely as symbols of the cosmos but as symbols of the integrated psycho-cosmos (man/universe).

In most, if not all, yantras for meditation the progressive stages from material or gross to subtle are well marked. Closed concentric circuits (maṇḍalas) of various geometric shapes correspond to the planes of the sādhaka's consciousness. Each enclosure is an ascent of one's being, a way-station (pandāni), a plateau (dhamani), towards the *sanctum sanctorum*.

The number of circuits in each yantra is prescribed by tradition and codified in tantric texts. It can vary considerably. The Śrī Yantra (see below) has nine.

In each of the enclosures specific deities are invoked, each circuit being considered as a cosmological form which supports devatā-clusters, or groups of goddesses (see Chapter 3). The power and harmony of each circle of deities is relative to the central deity: the deity-clusters are like veils concealing the yantra's innermost essence. After the sādhaka has invoked all the devatās in the prescribed manner for meditation, he reaches a level of consciousness in which all the devatā-circles are fused to become the presiding deity at the centre of the yantra. Gradually, this central deity itself disappears and merges into the centre of spiritual consciousness, the bindu of the yantra and the highest psychic centre between the adept's eyebrows.

The bindu is a fusion of all directions and of all levels, a point of termination where ALL IS. From the gates which are his own subconscious forces, the yogi has passed through the circuits to be reunited with the permanent element of the universe. The ultimate state of union is achieved when he experiences the out-petalling of the soul-flower, the thousand-petalled lotus, rising at the crown of the head.

The awareness that ensues from such meditation constitutes a spiritual climax, a state of yogic enstasis (samādhi). This is a state of psychic continuum, free from mental fluctuations, in which there is perfect merging of symbol and psyche. The journey from the periphery to the centre of the yantra may be measured physically in a few inches, but psychologically the return to the primordial source represented by the bindu is a vast mental distance, demanding the discipline of a lifetime.

The Śrī Yantra and psycho-cosmic identities

Man's spritual journey from the stage of material existence to ultimate enlightenment is mapped on the greatest of yantras, the Śrī Yantra. We find the sequence of meditation set out in the *Bhāvanopaniṣad*, the text of the Samaya sect of right-hand path tantrikas. The spiritual journey is taken as a pilgrimage in which every step is an ascent to the centre, a movement beyond one's limited existence, and every level is nearer to the goal, an affirmation of the unity of existence. Traditionally such a journey is mapped in nine stages, and each of these stages corresponds with one of the nine circuits of which the yantra is composed. Starting from the outer square and moving inwards, the nine rings bear specific names, related to their characteristics; the first circuit (Trailokyamohana chakra) 'enchants the three worlds'; the second (Sarvāśaparipuraka chakra) 'fulfills all expectations'; the third (Sarvasaṅkshobaṇa chakra) 'agitates all'; the fourth (Sarvasaubhāgy-adāyaka chakra) 'grants excellence'; the fifth (Sarvarthasādhaka chakra) is the

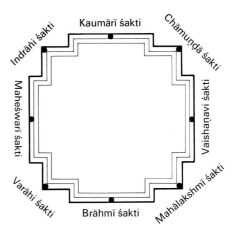

Indrāṇi śakti
Kaumārī śakti
Chāmuṇḍā śakti
Maheśwarī śakti
Vaishṇavi śakti
Varāhi śakti
Brāhmī śakti
Mahālakshmī śakti

1 Trailokyamohana chakra

'accomplisher of all'; the sixth (Sarvarakṣākāra chakra) 'protects all'; the seventh (Sarvarogahara chakra) 'cures all ills'; the eighth (Sarvasiddhiprada chakra) 'grants all perfection'; and the highest (Sarvānandamaya chakra) is 'replete with bliss'.

At the periphery of the Śrī Yantra, the square, the adept contemplates his own passions such as anger, fear, lust, etc., to overcome or conquer them.[3] The eight psychological tendencies that are considered obstacles of the mind are also invoked, as eight Mātṛikā Śaktis, in the second line of the outer periphery. Either they flank the four 'doors' of the yantra or they are invoked in the square band (bhūpura). Generally they are what we experience of the world through sense-activity and the cravings of our egotism. Thus the first Mātṛikā Śakti, Brāhmī, is associated with worldly desire, the passion that impels us to seek ephemeral joys; Maheśwarī is representative of anger; Kaumārī of constant avarice and greed; Vaishaṇavi fascinates and infatuates; Varāhi is symbolic of obstinacy and false pride; Indrāni of jealousy; Chāmuṇḍā of earthly rewards; finally, there is Mahālakshmī, who symbolizes our deficiencies and blameworthiness generally.

Around the Mātṛikā Śakti, in the third line of the square, preside Mudrā Śaktis who represent the chakras of the subtle body (see below).[4]

Because it is through our bodies that we experience the world at large and all our likes and dislikes, emotions, feelings and responses are experienced through our

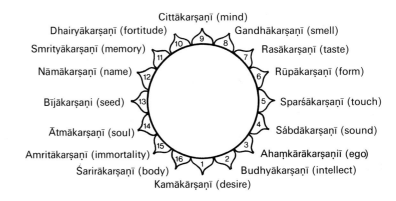

Cittākarṣaṇī (mind)
Dhairyākarṣaṇī (fortitude)
Gandhākarṣaṇī (smell)
Smrityākarṣaṇī (memory)
Rasākarṣaṇī (taste)
Nāmākarṣaṇī (name)
Rūpākarṣaṇī (form)
Bījākarṣaṇi (seed)
Sparśākarṣaṇī (touch)
Ātmākarṣaṇī (soul)
Sābdākarṣaṇī (sound)
Amritākarṣaṇī (immortality)
Ahaṃkārākarṣaṇīī (ego)
Śarirākarṣaṇī (body)
Budhyākarṣaṇī (intellect)
Kamākarṣaṇī (desire)

2 Sarvāśaparipuraka chakra

Anaṅgamadanā
Anaṅgaveganī
Anaṅgakuśa
Anaṅgamekhalā
Anaṅgamadanāturā
Anaṅgarekhā
Anaṅgamālinī
Anaṅgakusumā

3 Sarvaśaṅkshobaṇa chakra

bodily senses, and since our physical being is composed of sixteen components – the five elements (earth, water, fire, air, ether), ten sense-organs of perception and action (ears, skin, eyes, tongue, nose, mouth, feet, hands, arms, genitals), and the oscillating mind – these sixteen components are related to the sixteen petals of the Śrī Yantra lotus. Each petal is presided over by a deity of attraction who stimulates our 'sense-consciousness' through our bodily faculties, which leaves us spellbound in infatuation with ourselves.

These sixteen 'attractions' veil our existence, blind our spiritual sight, keep us from knowledge, and chain us to the ceaseless cycle of life. Since they mirror our consciousness at the stage of false knowing, these Śaktis must be contemplated at the beginning of our spiritual journey.

The eight-petalled lotus, the third circuit, governs speech, grasping, locomotion, evacuation, enjoyment, and the three attitudes of rejection, acceptance and indifference. These petals are also each presided over by a Śakti.

After transcending the limitations of the physical self, the meditator has to attain an understanding of his subtle body; from the physical shell he must enter into his psychic self represented by the subtle nerves, etheric channels and vital energy of the body-cosmos. Accordingly, fourth, fifth, and sixth circuits of the Śrī Yantra symbolically illustrate the subtle nerves, and the modification of the vital energy

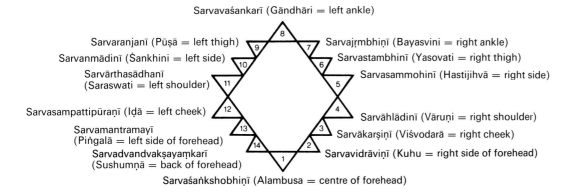

Sarvavaśankarī (Gāndhāri = left ankle)
Sarvaranjanī (Pūṣā = left thigh)
Sarvajṛmbhiṇī (Bayasvini = right ankle)
Sarvanmādinī (Śankhini = left side)
Sarvastambhinī (Yasovati = right thigh)
Sarvārthasādhanī (Saraswati = left shoulder)
Sarvasammohinī (Hastijihvā = right side)
Sarvasampattipūraṇī (Iḍā = left cheek)
Sarvāhlādinī (Vāruṇi = right shoulder)
Sarvamantramayī (Piṅgalā = left side of forehead)
Sarvākarṣiṇī (Viśvodarā = right cheek)
Sarvadvandvakṣayaṃkarī (Sushumṇā = back of forehead)
Sarvavidrāviṇī (Kuhu = right side of forehead)
Sarvaśaṅkshobhiṇī (Alambusa = centre of forehead)

4 Sarvasaubhāgyadāyaka chakra

111

Sarvaduḥkhavimociani

Sarvamṛtyuprasamanī

Sarvakāmapradā

Sarvavighanivārīṇī

Sarvamaṅgalākarini

5 Sarvarthasādhaka chakra

Sarvāṅgsundarī

Sarvapriyaṁkarī

Sarvasaubhāgyadayinī

Sarvasampatpradā

Sarvasiddhīprada

(prāṇa) which regulates the vitality of the subtle body. The first of these, the fourteen-triangled circuit, corresponds with the fourteen etheric nerves in the subtle body: six run through the right side of the body starting at the ankle and moving upwards through the right thigh, shoulder and cheek, and ultimately meeting at the centre of the forehead; four are on the left, the rest along the axis of the subtle body.

The fifth circuit of ten triangles exemplifies the dynamic life-force called prāṇa, the essential link between mind and body. The triangles represent the tenfold functions of the universal prāṇic energy in the individual subtle body: the five vital currents (Prāṇa, which draws life-force into the body; Apāna, which expels life-force; Vyāna, which distributes and circulates energy; Samāna, which controls digestion; Udāna, which controls circulation), and the five medial currents (Nāga, Kūrma, Kṛkara, Devadatta, and Dhananjaya) which mirror them.

The sixth circuit which is also ten-triangled relates to the interaction between the ten functions of prāṇic energy and the ten types of digestive fire, each presided over by a deity. The mobilization of the prāṇa through the energy centres is fundamentally important.

Sarvadharasvarūpiṇī

Sarvapāphara

Sarvavyadhivināśinī

Sarvānandamayī

Sarvajñānamayī

6 Sarvarakṣākāra chakra

Sarvarakshāsvarūpiṇī

Sarvaiśvaryapradā

Sarvapsitaphalpradā

Sarvaśaktā

Sarvajña

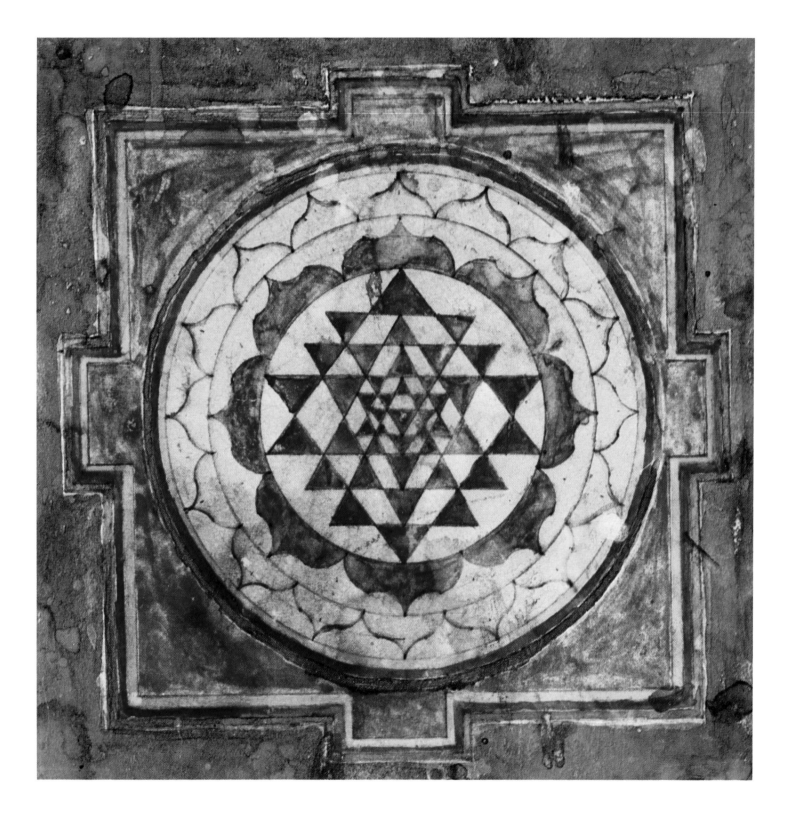

62 Śrī Yantra, the most celebrated of all tantric yantras. A mystical construction of the cosmos, the Śrī Yantra is formed by the interpenetration of two sets of triangles, four, apex upward, representing the male principle and five, apex downward, representing the female principle. The yantra is devised to give a vision of the totality of existence, so that the adept may internalize its symbols for the ultimate realization of his unity with the cosmos. Rajasthan, c. 1700. Gouache on paper

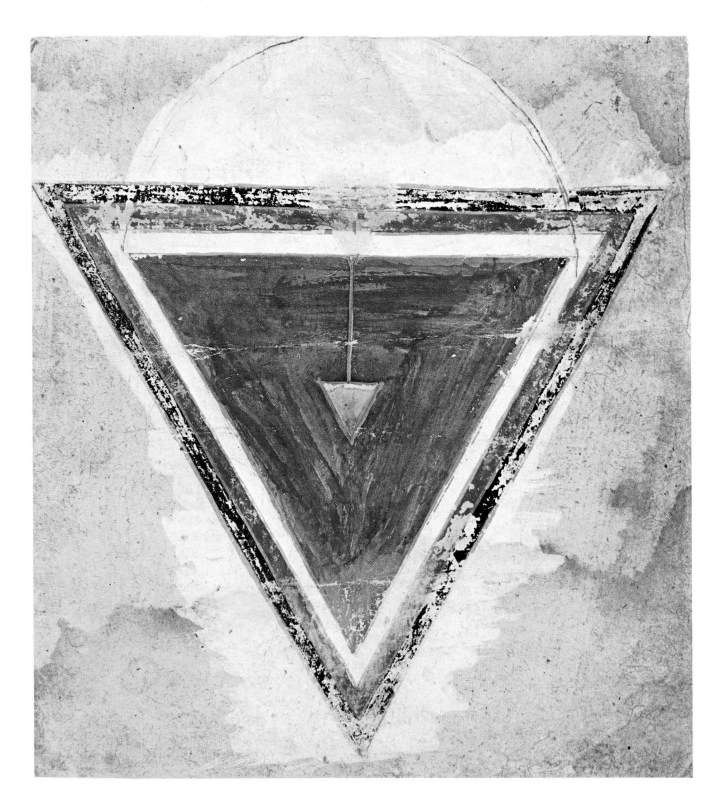

63 'The Goddess Śakti taking the form of a triangle brings forth the three worlds' (*Jñārnava*, Chapter x). The three sides of the yoni, the primordial triangle, creative matrix of the cosmos, stand for the three qualities composing material nature: sattva, the ascending quality, seen as white; rajas, the kinetic quality, seen as red; tamas, the descending quality or inertia, seen as black. Rajasthan, c. 17th century. Gouache on paper

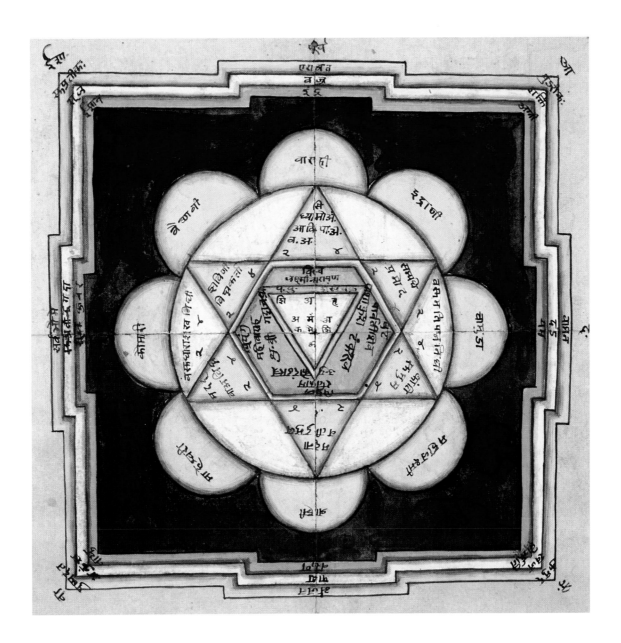

64 Yantra devoted to Śakti, used for meditation. Rajasthan, c. 18th century. Gouache on paper

65 Śrī Yantra created in an electronic vibration field, an experiment in the translation of sound into vision. A similar experience is 'sensed' during ritual worship when the yantra pattern 'dematerializes', appearing to dissolve into a sound-pattern or vibration field of spoken mantras. Still from a film by Ronald Nameth

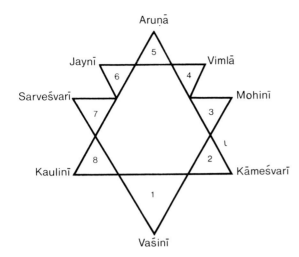

Aruṇā

Jaynī 5 Vimlā

6 4

Sarveśvarī Mohinī

7 3

8 2

Kaulinī Kāmeśvarī

1

Vaśinī

7 Sarvarogahara chakra

Conscious experience of the psychic spectrum becomes more and more subtle as one moves to the Śrī Yantra's inner enclosures. The seventh, eight-triangled circuit (Sarvarogahara) represents, first, the three constituent principles of material nature: sattva which is associated with purity or the stuff of intelligence; rajas which denotes the force or energy activating and impelling creation; tamas, mass or matter equated with inertia. These three qualities exist in individuals in varying degrees and are variously manifested: sattva is expressed psychologically as purity, tranquillity and calmness of mind; rajas as passion, egoism, restlessness; tamas as resistance to all change. The devotee can cultivate any of these qualities by his actions and thoughts; ideally, an aspirant will cultivate the sattva element of his nature over rajas and tamas. Ultimately, however, he will strive to overcome even the sattva element as the ultimate essence is above and beyond all. The other five triangles of this circuit represent two sets of polarities – pleasure/ pain, cold/heat – and the individual's will or capacity to decide upon action. Decisiveness guides the psyche to balance the continuous flux of mental activity. On the ascending scale of reality, after having understood the working of his senses the adept should begin to

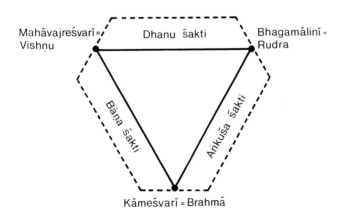

Mahāvajreśvarī = Vishṇu Dhanu śakti Bhagamālinī = Rudra

Bāṇa śakti Aṅkuśa śakti

Kāmeśvarī = Brahmā

8 Sarvasiddhiprada chakra

117

harness his mind. From his existential reality as an individual caught in a state of flux, enriched and moved by an uninterrupted exchange between the inner and the outer world, he contemplates certain traditional symbols of the senses: the bow, noose, goad and arrows. These are seldom depicted in the yantra, but they are always visualized around the primordial triangle as an imperative for final union.

Mental fluctuations are caused by the psyche's contact with the world at large. Thus the mind is visualized symbolically as a bow, and the noose as our attachments of the senses to external stimuli, the goad stands for anger, the perturbed psyche unable to penetrate through the last waves of psychic life, and the five arrows are symbols of the five gross and five subtle elements which attract our senses but leave us unfulfilled.

As meditation nears the innermost triangle, a dramatic change takes place with the fading of the Śakti-clusters into the emptiness of the centre. The innumerable Śaktis of the earlier phases are reduced to three principles of existence. The unmanifest principle of creation (Avyakta), the cosmic principle of force (Mahat), and the principle of ego-formation (Ahaṃkāra) give rise to the experiences of subject and object through which the adept perceives the distinctions and diversity of external nature.

9 Sarvānandamaya chakra

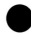

Śrī Lalitā = one's innermost self

The ninth chakra, the bindu, is the symbol of final release. It is the summit of reality and represents the innermost centre of the consciousness, the abode of the supreme goddess Lalitā, whose mysterious presence is experienced in the depths of one's being. The bindu marks the end of the spiritual pilgrimage. Where outer life ends, the inner life begins: there is no shape, no form, all is immersed in the void.

The Śrī Yantra's nine Śakti-clusters are thus nine levels separating man from his primordial wholeness, or, conversely, nine steps that can lead him through the principles of spiritual evolution. When the highest stage of exaltation is reached the yantra is internalized; it becomes a psychic complex. The truth of the cosmos, illuminated in the yantra, is the sādhaka himself illumined, and his body itself becomes the yantra.

In another type of meditation, the adept experiences both evolution and involution through the Śrī Yantra. In deep concentration, the adept mentally constructs the entire image of the Śrī Yantra from the centre, in the same fashion as the cosmos is held to unfurl itself in the process of evolution. After the whole image has been visualized, he begins his meditation from the outermost periphery of the figure. Moving inwards, enclosure after enclosure, he is symbolically involved in the 'dissolution' of all the cosmic principles projected by the nine Śiva-Śakti triangles. In such meditation the adept lives through the whole drama of descent and ascent, as an act of purging his consciousness. He is summoned to and surrenders to initiatory death through which he is reborn. When he has attained the sought-after identity, the extended universe (of the yantra) symbolically collapses into the bindu, which itself vanishes into the void.

The body yantra: Kuṇḍalinī dhyāna

In the Tantras the human body acquires a unique role and is considered the most perfect and powerful of all yantras. What is counselled is not a withdrawal from existence or a cold ascetism which teaches us to sever our links with life, but a gathering up of existence into our own being. This gathering up is effected by cosmicizing the body, and treating it as a 'tool' for inner awareness by taming it with yogic rituals, awakening zones of consciousness and activizing its latent subtle energies. But would this be possible if man and his body were not taken to be a cosmicized circuit and a powerful spiritual vehicle?

In the earliest speculations of the Vedas the macrocosm and its creator were conceived in human terms. The 'Purusha Sūkta' hymn in the *Rig Veda* portrays the world as coming into existence from the bodily parts of the Cosmic Person: 'The sun came out of his eyes, the moon from his mind, Indra and Agni [fire] from his mouth, wind from his breath, air from his navel, sky from his head, earth from his feet. . . .'[5]

In later literature, not only is the affinity between the world and the Cosmic Person maintained, but relationships are pointed between the elements and human functions. Thus in equally graphic terms the *Aitareya I* states: 'Fire became speech and entered in the mouth of the individual, mind became breath and entered his nose, the sun [became] sight in his eyes, the quarter of heaven hearing in his ears, plants and trees hairs in his skin, moon, mind in his heart.'[6]

Man is regarded, not as a separate and accidental product of evolution, but as an extension of divine consciousness expressing the fundamental unity of creation. His life, like the cosmos, is bound by a purpose; his biological rhythms are tuned by planetary phenomena. Man's existence is ordained and regulated by the governing principle of nature. The external world, and the inner world of man, are formed of the same 'stuff', and are related by an indivisible web of mutually conditioned affinities, which are often expressed in terms of the human body.

In the Tantras the relationship of man and cosmos has been reversed, and man himself has 'become' the cosmos. That is, his significance in the cosmic order has been exalted to the extent that he, and his body, are seen as a tool (yantra) of unlimited power, capable of transforming even his baser capacities into eternal values, an exaltation considered as a movement of power from the realm of god to the realm of man. Indeed, his body is seen as condensing the entire universe.

In your body is Mount Meru
encircled by the seven continents;
the rivers are there too,
the seas, the mountains, the plains,
and the gods of the fields.
Prophets are to be seen in it, monks,
places of pilgrimage
and the deities presiding over them.
The stars are there, and the planets,
and the sun together with the moon;
there too are the two cosmic forces:
that which destroys, that which creates;
and all the elements: ether,
air and fire, water and earth.
Yes, in your body are all things
that exist in the three worlds,
all performing their prescribed functions
around Mount Meru;
he alone who knows this
is held to be a true yogi.[7]

	Subtle body chakra	Number of petals	Associated element and/or properties	Cosmic category or 'tattva' (see p. 74)	Seed mantra and animal symbol	Male deity	Female Energy	Ascending plane of the universe
	Sahasrāra above the head	1000	Abode of bliss (Sat cit ānanda)			Paramśiva		Satya-loka
	Ājña between the eyebrows	2	mind (manas)	Mahat = Supreme Principle	Oṃ	Śaṃbhu	Hākinī	Tapo-loka
	Viśuddha throat centre	16	Ether, space Activates hearing	Organ of cognition: ears Organ of action: mouth	Haṃ white elephant	Sadāśiva	Śākinī	Jana-loka
	Anāhata heart centre	12	Air, movement Activates sense of touch	Organ of cognition: skin Organ of action: genitals	Yaṃ antelope	Iśa	Kākinī	Mahar-loka
	Maṇipūra navel centre	10	Fire, expansion Activates sight	Organ of cognition: eyes Organ of action: anus	Raṃ ram	Rudra	Lākinī	Svar-loka
	Svādhishthāna below the navel	6	Water, contraction Activates organ of taste	Organ of cognition: tongue Organ of action: hands	Vaṃ makara (mythical crocodile)	Vishṇu	Rākinī	Bhūvar-loka
	Mūlādhāra base of spine	4	Earth, connection Activates sense of smell	Organ of cognition: nose Organ of action: feet	Laṃ airāvata (elephant)	Brahmā	Dākinī	Bhūr-loka

Subtle body chakras

To illustrate the mutual correspondences of the human body and the cosmos, tantra 66, 68 has created a system of psychic 'crosspoints' in which the infinite world of time and space are seen reflected in the psycho-physical structure of man. The cosmos, according to the Tantras, consists of seven ascending planes of existence, starting from earthly, gross existence, and this hierarchy is mirrored in the psychic vortices functioning as invisible yantras in the human body.

The seven (in the Hindu tradition) major points of power in the subtle body function as yantras for inner meditative experience in Kuṇḍalinī yoga. They are visualized as geometrical figures, as wheels (chakras) or lotuses, spaced on the vertical axis of the subtle body, the Sushumṇā, which corresponds roughly to the spinal column and brain. Since these chakras embrace the entire psycho-cosmos, each is associated with a sound vibration, element, colour, devatā or animal symbol.[8]

The first chakra, known as the Mūlādhāra (root) Chakra, is situated at the base of the spine and is the gathering point of the energy of the psychic body. Its symbol is a square with an inverted triangle. In the centre of this yantra is the snake-symbol of the latent microcosmic form of energy, Devī Kuṇḍalinī, coiled around a liṅga emblem. It is governed by the element earth, and its seed-mantra is Laṃ.

The second, Svādishthāna Chakra, lies behind the genitals. It is coloured vermilion, and its form is a circle with six petals, containing a white crescent moon. In the centre is inscribed the mantra of the water element, Vaṃ.

The third, Maṇipūra Chakra, is the navel centre, governed by the element fire. It is visualized as a lotus of ten petals. Within the lotus is a red triangle with three swastika marks (T-shaped). Its seed mantra is Raṃ.

The fourth, Anāhata Chakra, is located at the level of the heart, which is conceived as a lotus of twelve petals with a hexagon at the centre. The Anāhata Chakra is the seat of the air element, and is a prime revealer of cosmic sound during meditation. Its seed mantra is Yaṃ.

The fifth chakra is known as Viśuddha Chakra and is situated at the level of the throat. It is of smoky purple hue, and its symbol is a sixteen-petalled lotus with a downward pointing triangle. In its centre is the symbol of the ether element, represented by a circle with the seed mantra Haṃ.

The sixth chakra, Ājña, is located between the eyebrows and commands the various levels of meditation. Its symbol is a circle with two petals and an inverted triangle bearing a liṅga emblem. Its seed mantra is the primordial vibration, Oṃ.

The seventh chakra, Sahasrāra Chakra, represents the apex of yogic meditation, the seat of the Absolute (Śiva-Śakti). It is visualized as measuring four fingers' breadth above the crown of the head, and is represented by an inverted lotus of a thousand petals, symbolically showering the subtle body with spiritual radiance. The Sahasrāra neutralizes all colours and sounds, and is represented as colourless.

These internal yantras mark the phases of the spiritual journey of the Kuṇḍalinī Śakti, the energy which is aroused in meditation for the ascent of the path of the Sushumṇā to unite with the Sahasrāra Chakra. They indicate the seven stages of

67

yogic sādhanā, and provide the mechanism through which the adept works out his psychic synthesis with the cosmos. Each of the inner chakras may be meditated upon either independently or with the aid of an external yantra. A common practice is to equate the various circuits of the external yantras with each of the seven chakras. In pyramidal-shaped yantras, each level of the hierarchy may be identified with each level of the chakras.

In addition to the seven chakras of the subtle body, the Tantras have described a vast network of subtle channels and inner vital energies which constitute, as it were, the etheric body. Cosmic biunity is represented by two invisible conduits, Iḍā (female, representing the moon) and Piṅgalā (male, representing the sun), on the left and right of the central channel. The cosmic power, Śakti, that permeates all creation lies inert in our subtle body as Devī Kuṇḍalinī (the potent source of energy of the Śakti of Śiva). Her symbol, a serpent of three and a half coils, lies blocking the entrance to the central channel with its mouth.

The technique of Kuṇḍalinī yoga consists in using prāṇa to awaken the consciousness-as-power (Śakti) in the root chakra (Mūlādhāra), located in the region of the perineium, and causing it to rise up Sushumṇā, the central channel of the subtle body, energizing the seven chakras through which the tantric universe can be absorbed into the body. Once the Kuṇḍalinī Śakti has ascended to Sahasrāra, the highest psychic centre at the crown of the head, it is made to reverse its course and return to rest in the base centre again.

In a special method of meditation practised by advanced adepts, under the guidance of a guru, the adept learns to achieve union between the Kuṇḍalinī of the microcosm (Piṇḍa) and the macrocosm (Brahmāṇḍa). These affinities are struck in the subtle body by meditation on its chakras and by finding correlations and similarities between the subtle body and the totality of the cosmos.

As we have seen earlier, spiritual endeavour in tantrism proceeds by a process of introversion. The basic aim is to reverse the journey of the individual from a chaotic outward flow of constant change to an inward state of rest; technically, a reversal of the world of pravṛtti (activity) to a state of nivṛtti (rest). The extent to which the symbolism or reversal has been integrated in Kuṇḍalinī yoga can be seen from the practice of the tantric Nātha yogis, who consider that the part of the body above the navel is Śiva (static) and that below is the personification of Śakti (dynamic), so that the place assigned in the subtle body to Śiva is the Sahasrāra Chakra (the psychic centre at the crown of the head) and to Śakti the Mūlādhāra Chakra (at the base of the spine). Between these two poles lies the expanding and contracting universe. The form of yoga practised by the Nātha yogis consists in making the kinetic flow of Śakti be absorbed in and united with Śiva. The union of the dynamic Śakti with Śiva as it ascends piercing the internal yantras means the arresting of the process of constant becoming, and a retrogression of the cosmic process to its ultimate source. The Nātha tantrikas follow a psychological and physiological discipline based on a regressive process (ultā-sādhanā) whereby the kinetic flow of the Kuṇḍalinī Śakti, which in the ordinary course of life flows downward, is made to come to a state of rest in its upward flow and unite with Śiva. Physiological functions of the body also

Biunity in the subtle body. Śakti, the kinetic principle, is at the base of the spine; Śiva, the static principle, is in the highest psychic centre

undergo progressive 'reversals', for instance, by absorption of semen and sublimation of sexual energy, which is reversed for the upward journey in Kuṇḍalinī yoga.

The basic principle in all forms of contemplation and meditation in Kuṇḍalinī yoga is that the energies should involute back to the primal source. The grosser elements of the subtle body should dissolve in the subtle elements; each class of bhutas (gross elements) is dissolved into the next class of tattvas in the ascending order (subtle elements). *Śiva Saṃhitā* (1, 78) explains: The earth [Mūlādhāra Chakra] becomes subtle and dissolves into water [Maṇipūra Chakra]; water is resolved into fire [Svādhishthāna Chakra]; fire similarly merges into air [Anāhata Chakra]; air is absorbed into ether [Viśuddha Chakra]; and ether is resolved into avidyā, which merges into great Brahman [Sahasrāra Chakra].'

The seven inner chakras may be meditated upon in turn with the aid of an external yantra such as a yantra from Nepal which has the symbols of the seven chakras inscribed on the petals of a lotus enclosed in a four-gate square. A common practice, however, is to equate the circuits of the yantra to the body chakras.

A text[9] devoted to Śakti worship relates the chakras of the subtle body to the nine circuits of the Śrī Yantra as follows:

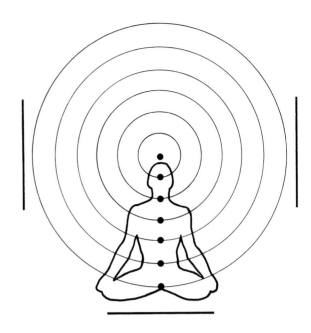

The seven chakras of the subtle body corresponding to the seven circuits of the yantra, whose subtle energies are interiorized in ritual and meditation

Śrī Yantra	*Chakra*
The outer square (Trailokyamohana)	Mūlādhāra (root chakra)
Sixteen-petalled lotus (Sarvāśaparipuraka)	Svādhishthāna (chakra below the navel)
Eight-petalled lotus (Sarvasaṅkshobaṇa)	Maṇipūra (navel chakra)
Fourteen-angled figure (Sarvasaubhāgyadāyaka)	Anāhata (heart chakra)
Ten-angled figure (Sarvarthasādhaka)	Viśuddha (throat chakra)
Ten-angled figure (Sarvarakṣākāra)	Ājña (chakra between the eyebrows
Eight-angled figure (Sarvarogahara)	Brahmarandhra (chakra of palate)
Triangle (Sarvasiddhiprada)	Brahman (chakra of the Supreme)
Bindu (Sarvānandamaya)	Sahasrāra (chakra of space)

Hence the Śrī Yantra can be viewed as a composite image of the subtle body.

Other forms of concordance are drawn between the subtle body and the Śrī Yantra. In its three-dimensional variety, for instance, when the Śrī Yantra is known as 'Meru' (after Mount Meru, the mythical axis of the earth), its nine circuits are divided into three elevations which match the scheme of the subtle body, whose chakras can also be divided into triads. Alternatively, three chakras each containing the liṅga-emblem of the male principle are seen as marking three levels corresponding to the three elevations of the Meru form of the Śrī Yantra. These chakras are called 'knots' (granthi), and are nodes where the transformation of the adept is said to take

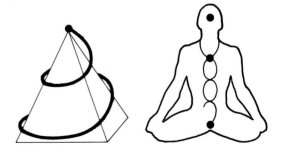

The three elevations of the Śrī Yantra (left) and the three corresponding planes of the body-cosmos (right)

123

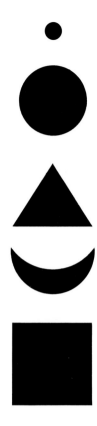

Symbols of the five elements in ascending order: earth, water, fire, air, ether, visualized during meditation for psycho-cosmic integration

66 The human body is considered the best of all yantras. The seven psychic centres, or chakras, on the axis of the spine are activated in sequence during meditation. From the root chakra upwards, they are known as Mūlādhāra, Svādishthāna, Maṇipūra, Anāhata, Viśuddha, Ājña and Sahasrāra. South India, c. 18th century. Copper with gold wash

place. They are associated with the earthly desires and passions to be overcome during the process of Kuṇḍalinī yoga.

Meru form of the Śrī Yantra	Chakra	Deity	Liṅga-emblem
Square and two lotus rings	Mūlādhāra (root)	Brahmā = creation	Svayambu liṅga
Fourteen- and two ten-angled figures	Anāhata (heart)	Vishṇu = preservation	Bāṇa liṅga
Eight-angled figure, triangle and bindu	Ājña (eyebrows)	Śiva = destruction	Itara liṅga

The practitioners of Anavopaya[10] in Kashmir use the Śrī Yantra when visualizing the chakras of the subtle body in a form of Kuṇḍalinī yoga called Chakrodaya. Breathing-control techniques are used to force prāṇa to circulate upwards and then downward to strike the latent Kuṇḍalinī energy in the root chakra. This circulation of the prāṇa-śakti is felt to be concomitant to the expansion of the Śrī Yantra. When the Kuṇḍalinī reaches the highest chakra, the Sahasrāra, this centre merges with the bindu of the Śrī Yantra.

A sect of 'right-hand' tantrikas, the Samayacāra, advocates a highly esoteric type of internal worship, again combining the Śrī Yantra and the chakras. Upon concentrating on the chakras in turn, all the 'truths' which they embody are spontaneously known by illumination.

The chakras[11] can be used as foci for concentration without the aid of external yantras, either separately or together; or meditation may be carried on using the body-maṇḍala and concentrating on graphic symbols associated with each part of the subtle body. One yoga text describes this form of meditation:

> From the knee to the foot is the seat of earth. The Earth-goddess, yellow, square, and with the bolt of Indra as her emblem, should be reflected upon for five Ghatikas [two hours], after having filled the part with vital breath. From the knee to the hip is said to be the seat of water. Water, shaped as a crescent, white, and with silver as her emblem, should be reflected upon for ten Nadikas [four hours], having filled the part with vital breath. From the waist to the hip is said to be the seat of fire. There should be reflected upon [a triangle], a red, flaming fire, for fifteen Ghatikas [six hours], after a period of holding the vital breath (Kumbhaka), so it is said. From the navel to the nose is the seat of air. The strong elemental air, of the colour of smoke and the shape of a sacrificial altar, should be reflected upon there, for twenty Ghatikas [eight hours], holding the vital breath (Kumbhaka). From the nose up to the cavern [crown of the head] of the Brahman is the seat of ether. There is ether of the colour and brightness of well-pounded collyrium [black]. One should hold the vital breath (Kumbhaka) in the seat of ether with great effort.[12]

In this meditation on the five cosmic elements the adept directs the vital energies of his body to the appropriate part, suspends his breath for the required periods, and concentrates on each symbol of the elements in ascending order: the square for earth, the triangle for fire, the hexagon for air, the circle for ether. Chanting seed mantras and visualizing the presiding deities, he obtains insight into the secret forces through the body maṇḍala, and gains mastery over the elements.

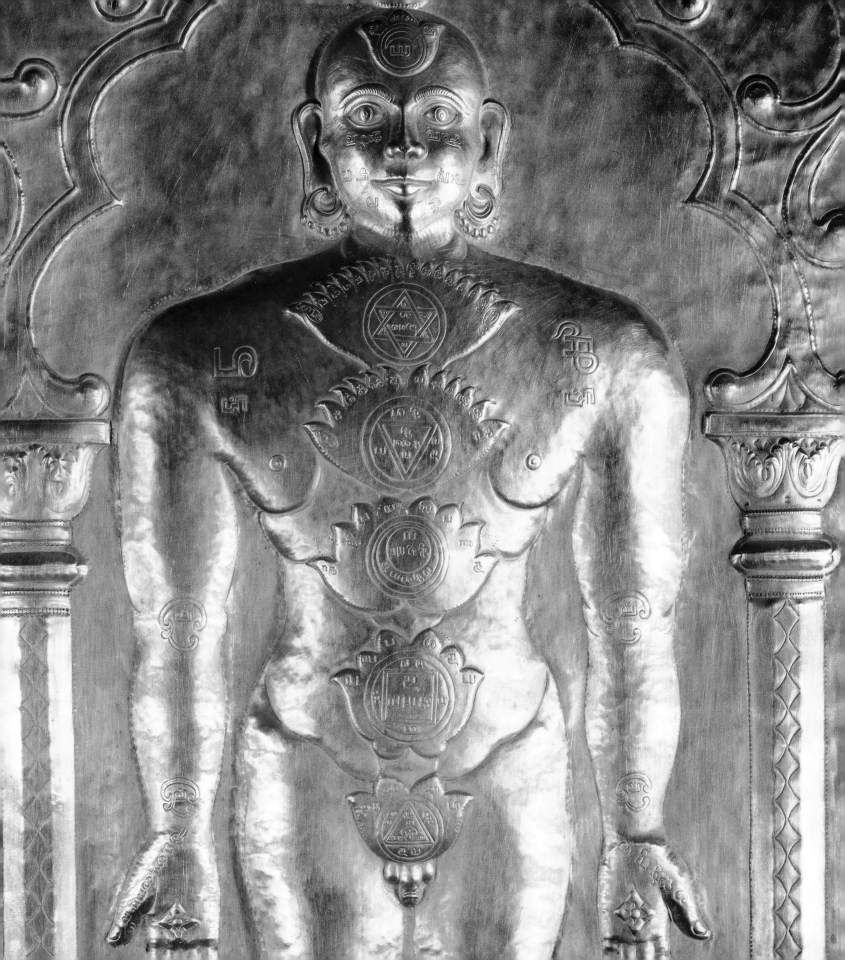

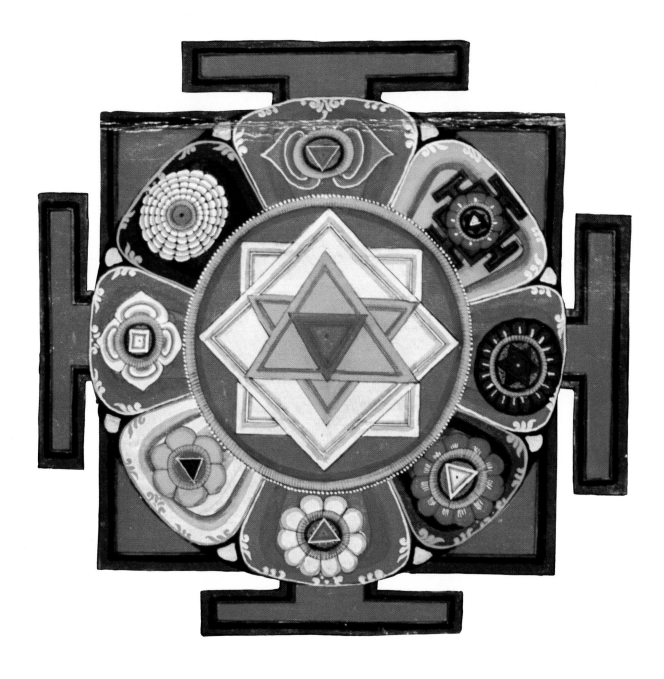

67 Yantra of Mahāvidyā Bagalā-mukhī bearing emblems of the psychic centres of the subtle body disposed on the eight lotus petals. In meditation, the body yantra acts in conjunction with the diagram to achieve the ultimate aim of unity of yantra, body and cosmos. Nepal, c. 1761. Gouache on paper

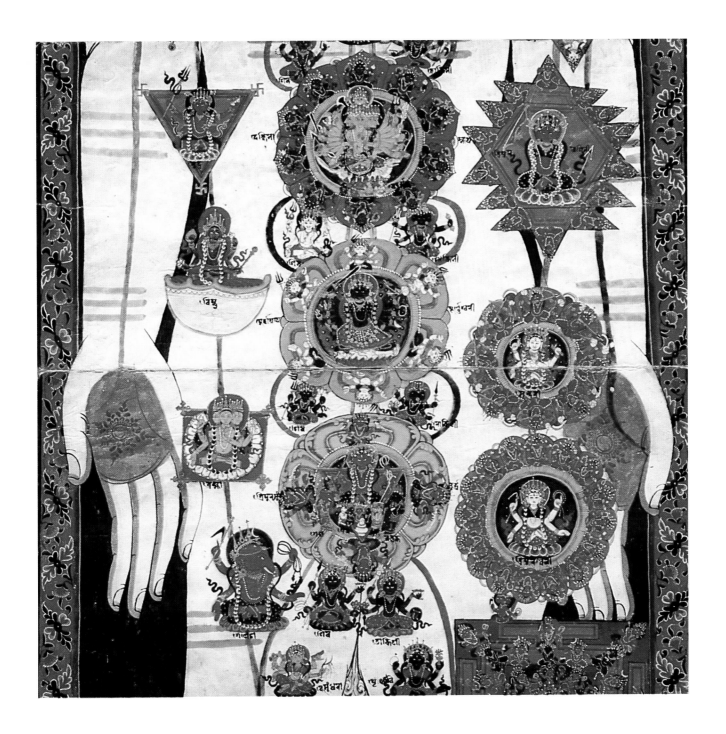

68 Three of the chakras of the subtle body, in ascending order: Mūlhādhāra at the base of the spine, Svādishthāna below the navel, and Maṇipūra at the navel, with their related symbols. Meditated upon in turn during Kuṇḍalinī yoga, these chakras represent stages in the sādhaka's progress towards Enlightenment, achieved when the Kuṇḍalinī Śakti is finally united with Śiva at the topmost psychic centre, Sahasrāra, represented by the thousand-petalled lotus. Nepal, c. 1761. Gouache on paper

69 Enlightened sādhaka, experiencing in the Sahasrāra Chakra the ultimate unity of the bindu state. Maharashtra, c. 19th century. Gouache on paper

यन्त्रोत्समबिम्बेषु

The disc of the body-cosmos is the best of all yantras.

Śākta Darshan (15, 1, 30)

Internal yantras

Meditation on the yantra takes the most subtle form of all when it consists of inner illumination, a method of meditation without any yogic, ritual or visual aids.

In the early phases of the practice of sādhanā the devotee is instructed in the iconic images of deities. Later, even yantric symbols are discarded, and worship becomes highly abstract, subtle and esoteric. It is at this stage that meditation on internal yantras composed of simple graphic symbols is performed. This technique is only divulged to those practitioners who have been through all the stages of sādhanā, and is attained after a long and arduous training under the strict instruction of highly advanced gurus. The texts[13] state that all the ritual offerings made in the external form of worship are spontaneously present in the interior form, and it is for this reason that in many texts the contemplative experience is called 'mental oblation' (antaryajña).[14]

The whole process of mental oblation is described in the *Kaulāvalīnirṇaya*, a work of the Kaula sect of tantrism. After preliminary purifying rites, the sādhaka builds up, in deep concentration, a square yantra enclosed by three concentric circles. In the centre of the square he visualizes the emblem of the yoni (a half-moon and bindu). The square symbolizes the vessel of consciousness (cit-kuṇḍa) in which burns the fire of consciousness, and into this symbolic fire the adept 'surrenders' all his mental offerings. The sādhaka first makes an offering of his impulses, then his senses, then his selfhood, then his acts, both good and evil, and finally his entire inner-outer self which is none other than the thirty-six cosmic principles of which the universe is composed (see p. 74). Through this unconditional surrender, the adept dissolves every bond with outer life. This mental offering of his entire being is the prelude to new birth.

The devotee apprehends the true nature of the absolute principle as void, the undifferentiated ultimate ground of reality. He is then said to become indistinguishable from the vessel into which the symbolic oblations were offered: in this final stage his entire being is perfectly assimilated with the cosmos: 'The act of offering is Brahman, the offering is Brahman, the person offering is Brahman.'[15]

Mantras of oblation in the *Kaulāvalīnirṇaya* (Chap. III, 85ff.) describe this process:

Into the Fire of Consciousness
In the navel centre, kindled with knowledge,
I offer as oblation the impulses of the senses
Using the mind as sacrificial ladle, svāhā.

I offer functions of the senses,
As oblation into the Fire which is Ātman,
Fed by righteousness and unrighteousness like ghee
With the mind as ladle held by the handle which is the path of Sushumṇā, svāhā.

I offer all acts good and evil as
Oblation into the all-pervading Fire, fed by Time.
The two hands with which I hold the ladle are
Śiva and Śakti,
The ladle of the offering is Consciousness [unmani], svāhā.

I offer as oblation this universe of thirty-six principles,
The first which is Śiva and the last earth.
Into the Fire of Consciousness which though fuelless
Is constantly burning within. From which emanate
Rays of wondrous light which purify
Though obscured by the darkness of ignorance [Māyā], svāhā.

I offer all as oblation by the darkness into the Fire of Complete Oblation . . .

The essential difference between the outer form of yantra worship (pūjā) and inward meditation through yantric symbols is that the former produces mental states that are like 'seeds' for the future workings of consciousness, while the latter is 'without seed' (nirbīja) and relies on intuitive apprehension of the real, revelling in the ontological plenitude in which being, knowledge and bliss are inseparable and indistinguishable.

The bindu experience

The culmination of yantra meditation is reached when the sādhaka begins to internalize the bindu in the yantra as an inner, still centre. He may then contemplate an imaginary point in his subtle body. The spiritual experience of the bindu marks the end of spiritual involution.

The 'bindu-state' experience is unique. Psychically, it implies the sādhaka's awareness of his wholeness, which is spontaneously discovered through inward illumination. All the outward directed energies of the phenomenal ego are brought together to an inward state of rest and unity by the ultimate realization of Ātman. 'Neutrality of the senses' has superseded the creative play of Māyā Śakti, and he is now the silent seer, no longer attached to the world of phenomena. He neither laughs nor weeps, loves nor hates, for he has transcended all dualities. The adept attains precisely the state, mentally and spiritually, that the symbol of the bindu denotes, an ideal mid-point, the balancing of all polarities. But this is not the end, the aspirant is still to soar beyond the bindu-state to merge with the Void – the primordial plenitude of Śiva-Śakti in oneness.

This highest stage of spiritual absorption (samādhi) achieved through yantra ritual worship and meditation is not susceptible to any verbal analysis. It is contemplated in absolute silence: 'Higher than the original syllable is the point, the echo higher than this; the syllable vanishes with the sound, the highest state is silent.'[16]

When the adept is able totally to re-establish himself in primordial equilibrium by retracing his steps to his original source, absorbing and reintegrating all fragmentation and multiplicity of existence into unity, what is there to seek? To see? To hear? To touch? For:

When there is duality, one sees another, one smells another, one tastes another, one speaks to another, one hears another, one touches another, one understands another. But where everything has become just one's own self, then who can be seen by what? Who can be smelt by what? Who can be tasted by what? Who can speak to what? Who can think of what? Who can touch what?[17]

Cit-kuṇḍa Yantra with the yoni emblem, the seat of bliss, in the centre. The four points of the square represent the four aspects of one's psyche: the pure self (ātman), the inner self (antarātman), the cognizing self (jañanātman), the supreme self (paramātman). These constitute the vessel of one's inner stream of consciousness (cit-kuṇḍa) into which is offered all aspects of one's being in the meditation of inward oblation. After the tantric work Kaulāvalīnirṇaya

All external aids such as yantras and mantras have become like shadows. In the most advanced form of internal meditation, when ecstasy bordering on trance has been reached, even the inner yantra is regarded as obsolete, serving no spiritual purpose: 'The yogi engaged in samādhi cannot be controlled by yantra or mantra; he is beyond the power of all corporeal beings.'[18] At this stage the yantra is abandoned and may be passed to another sādhaka or immersed in holy water.

In the early stages of meditation the yantra was considered as a partial archetype of the noumenon, whereas the adept was a part of phenomenal existence. When the sought realization is achieved, the yantra becomes a part of phenomena (mundane existence) and the sādhaka an external aspect of noumena. This paradox of a yantra being eternally sacred (full of cosmic realities when seen from a specific dimension of ritual process) and profane (empty of universal truths when viewed outside the ritual process) emphasizes the core-nature of the yantra symbol: it is purely a functional symbol in tantric liturgy, yet shielding unbounded truths, the secret forces of cosmic mystery.

6
Aesthetics of Yantra

Traditional Indian art, which includes the yantra, is never considered a means to individual self-expression but serves as a primary focus of the spirit. The work of art reflects the divine archetype and is a bridge between the finite and infinity over which the beholder or devotee 'travels' into another realm of being. Such an art-form has its subject matter and its treatment of form from inner sources. An artist who seeks to plumb the mystery of creation within such a tradition acts as an exponent of a doctrine, a messenger who translates universal spiritual intuitions into visual terms. These intuitions strive for revelation, to transcend the accidental aspects of form and to relate themselves to archetypal analogues. This process of emergence may involve the transfiguration of phenomenal entities, so that their ultimate form, the expression of their essential qualities, bears no likeness to their outward or 'real' appearances. Indeed, produced form, according to the Indian theory of the science of forms (Ṣaḍaṅga), never exists as it appears to the physical eye but as an object 'known', corresponding to a mental prototype. Hence form is never valued for its own sake, but only so far as it serves to provide experience of religious or metaphysical truth. What is sought in form is an indwelling presence, the 'soul' imprisoned in the material.

All Indian images are 'symbols' of the Supreme Principle and vary only in degree of abstraction. Consequently, the outer form of an image should always be perceived in relation to its symbol-value. The material 'reality' of a yantra's form depends on the spiritual reality of its content; or, to put it another way, the metaphysics of yantra coincides with its aesthetics, in that form and content are inextricably related by an internal logic.

In certain instances, form value and symbol-value are closely congruent; that is, parallelism, if not identity, exists between the intrinsic nature of the shapes and their transcendental correspondents. Thus, for instance, in geometry the point is the primary principle of all figures. In the yantra, the geometry of the point is amplified into a metaphysical 'truth' in the symbolism of the bindu: the bindu, as we have seen earlier, is a natural symbol of the Supreme Principle just as the point is a fundamental principle of all shapes. Similarly, just as the point in geometry represents indivisible unity and the beginning of all dimension and concrete shape, the Supreme Principle represented by the bindu cannot be qualified in dimension because it is conceived of as unmanifest, and therefore cannot be circumscribed by any measure or dimension, yet remains the basis of all spiritual dimension and empirical being.

In the form-language of tantra, the triangle is the simplest planar expression of cosmic location after the point. It is thus the first sacred enclosure of the Śiva-Śakti

principle. The three points of the triangle are related to certain triads of cosmic principles: sattva; rajas and tamas; creation, preservation and dissolution. Content determines form with the nine circuits of the Śrī Yantra that are related to the ninefold division of cosmic principles; to the nine apertures of the body[1] (eyes, ears, mouth, nostrils, genitals and anus); to the nine psychic centres (the seven chakras and the one below the thousand-petalled lotus and the one below the eyes); to the nine names of the Devī[2] (Tripurā, Tripureśi, Tripurā-Sundarī, Tripuravāsinī, Tripuraśrī, Tripuramālinī, Tripurasiddhā, Tripurāmbā, Mahātripurāsundarī); and to the nine planets and the nine divisions of time[3] (24 minutes – ghatika; 3 hours – yama; day and night – ahorātra; day of the week – vāra; lunar day – tithi; fortnight – paksha; month – māsa; season – ṛitu). The cosmic concepts relating to five principles – the five elements, for example, or the five aspects of Śiva – are associated with the pentagon; and the sixteen lotus petals which recur in several yantras are made the dwelling of sixteen divinities and, as in the Śrī Yantra, are associated with the sixteen vowels of the Sanskrit language.

Similarly the application of colour in the yantra is purely symbolic. Colour is never used arbitrarily to enhance the decorative quality of a diagram, but refers to philosophical ideas and expresses inner states of consciousness.

One of the most important colour-schemes is white, red and black, which stands for the three qualities of material nature (Prakṛiti): sattva, rajas and tamas. The sattva or ascending quality has been given the 'colour' of purity, white; rajas, which denotes the dynamic or creative principle, is red; tamas, which is inertia or the descending force, is black. The eight regions of space also have symbolic colours.

Similarly with the five elements: in ascending order, from gross to most subtle, earth is yellow; water is white; fire is red; air is grey; ether is misty-smoky.[4] In a grid-square yantra, each square may be painted with a flat tone to denote one of the five elements.

The aspects of the Goddess are represented by colours in accordance with her qualities; conferring liberation she is contemplated as white; as preserver of all, she is seen as red; as destroyer she is tawny; conferring bliss she is rose-coloured; as bestower of wealth and good fortunes she is saffron-yellow. Coloured black, she withdraws the entire world into herself. Black is seen as containing all the colours, hence Kālī is represented as dark-hued, as 'white and other colours disappear into black in the same way as all beings enter Kālī'.[5]

Traditionally, the particular goal of the yantra worship may decide the colouring used for the yantra, though not all texts prescribe the same colour symbolism. Yellow (pita) and vermilion (rakta) are the two basic auspicious colours. For temporary worship, yantras are drawn with saffron, a red powder (kum kum) or sandalwood paste. Brown, tawny colours or dark blue may be used for 'negative' yantras.

Yantras are often made of rock crystal, since within its translucent brilliance are latent all the colours of the spectrum. Gold, a vibration between saturated yellow and brilliant light, represents transcendence, and is used in some yantras for the bindu to indicate the experience of Light, or spiritual Bliss.

The colours associated with the directions. After the Mahānirvāṇa Tantra, Chap. XIII, 90–5

Four primal yantra shapes, based on mathematical equations from the Sanskrit treatise on mathematics, the Gaṇita Kaumudī (1356)

Generally speaking, then, the aesthetics of yantra would be meaningless if content and expression were separated. The yantra for meditation, both in its structure and use of colour, is not a haphazard conglomeration of percept and concept. It is directed by a philosophical content which expands and multiplies its forms. Whether the figures of the yantra appear singly or as parts of a more complex structure they never lose their intrinsic meanings or their symbol-value.

The construction of the power-diagram

The symmetry that permeates creation as a norm is fundamental to the construction of the yantra. Leaves of plants do not grow out of tune with nature's laws, and the yantra similarly evolves in accordance with traditional rules and in an orderly and harmonious mathematical progression. The three principal modes of evolution are the emergent, which is straight and symmetrical (ṛiju); the curved and symmetrical (suṣama); and the quasi-symmetrical or eccentric (viṣama).[6] The root principle of this mathematical descent from the bindu to the unified and orderly periphery is called ardhamātrā (from the Sanskrit root, rdh = to grow, mātrā = measure), or the measure that is not static but grows and evolves in accordance with the laws of harmony and rhythm.

From the source, the bindu, derives the expanding line, seen as the continuum (nāda); from nāda originate magnitude and dimension (parimeya); from parimeya arise the symbiotic opposites (plus-minus, male-female), centrifugal and centripetal polarities and the order of numbers (saṃkhyā). Number provides harmony and stability, integration and unity. Thus the number 3 gives specific location to magnitude and becomes a triangle, 4 a square, 5 a pentagon, 6 a hexagon, etc. As we have seen, these numbers are not simply sums of integers, but have specific symbolic relationships with philosophical ideas.

This integral relationship of form and content also operates in reverse. If the structure of the yantra is imperfect, that is, if the balance of the outer form is distorted or if even a single line or symbol is eliminated, then the content and symbolic significance will be abolished simultaneously. Moreover, according to this principle, the maker of a deformed yantra (as well as the one who worships it) will suffer a cognate distortion of the archetypal image within his psyche. Any disregarded error in the making of the symbol will lead to a psychic disequilibrium in the sādhaka and destroy his sādhanā. To avoid error, the yantra is executed with extreme care following traditional prescriptions to the minutest detail. No corrections are ever possible. If an error is made, the yantra is immersed in holy water and a new one is begun.

The yantra-siddhāis (sages to whom the powers of the yantra have been revealed) declare that if a yantra fails to become 'active' the fault lies with the person using the yantra and never with the yantra itself, for the power-diagram is never tentative or arbitrary, but is based on laws of space, vibration, number and dynamics.

The greatest of all yantras, the Śrī Yantra, devoted to the worship of the Goddess, is a visual masterpiece of abstraction, flawless in its proportions and symmetry. The

technique[7] of its construction is outlined in a number of texts, and is a unique and complete rite. Lakshmīdhara, the commentator of *Saundaryalaharī*, a collection of devotional hymns dedicated to the Goddess, outlines two principal methods of construction: one, used by the 'right-hand' path tantrikas, is the order of evolution (sṛiṣṭi-krama) in which the yantra is constructed in geometrical progression from bindu outwards; the other, the order used by the 'left-hand' path tantrikas, is the order of dissolution (laya-krama), in which construction is from the circle moving inwards.

In traditional Indian art, the process of creation falls into a pattern similar to worship. Coomaraswamy,[8] quoting several Sankskrit sources, describes the various disciplines which an artist has to undergo. As the first step in the ritual which precedes creation of a sculpted image, for example, he goes to a solitary place. There he must discipline his impulses, control his physical and mental processes and suppress the chaotic world of the subconscious through penetrating concentration. Sometimes, to reach the inner depths of his consciousness, 'the imager, on the night before beginning his work and after ceremonial purification, is instructed to pray: O thou Lord, teach me in dreams how to carry out the work I have in mind.'[9] After the artist has reached an 'inner poise and moral grace', and integrated himself emotionally and spiritually, he evokes the deity by the means of dhyāna (trance) mantras, which provide him with a sort of mental blueprint for the execution of the image. After the work is completed a priest consecrates the image in a rite called the 'opening of the eye' which endows it with sacred power. This procedure emphasizes how far such artistic expression is from being an 'aesthetic' exercise. At no point in the whole discipline is the 'artist' separated from his art; and in the activity of creation, he annihilates all trace of his individuality and selfhood. The shapes and forms he creates reveal to him the macrocosmos as it exists within himself. In this sense the created object 'prepares' its maker for a spiritual return to his primordial source.

Similarly, the construction of a yantra is a complete rite to be followed meticulously. Care is taken to choose the most propitious place and time of the day. The surface to which it is applied must bear auspicious signs and be smooth. The drawing, however, may be perfect in its proportions, correct in its brushwork, and faultless in its colourings, it may be scrupulously drawn according to all the rules of linear formation set out in the shāstras (texts), and yet may fail to reflect the true significance of the yantra, unless the maker can transmit to the figure his inner life-tie with cosmic forces. Until he can 'feel' the nature and substance of the cosmic bond in the deeper layers of his psyche, until he is able to impart the reality which he has intuited and is himself a part of, the yantra he draws will fail to reflect its participation in the transcendent. The maker pours forth an 'intensity for which there is no word'. He must feel the very nature of the energy to be transmitted to the yantra, affecting all who view it.

This type of creation has obviously no room for 'art for art's sake'. Indeed, this 'metaphysical aesthetics' holds that someone who views a yantra in its original environment, whether a temple or a humble house, can know it and comprehend its

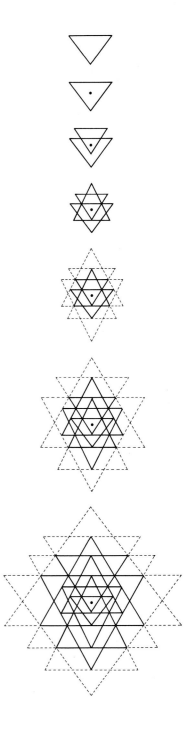

The traditional method of drawing the Śrī Yantra, in the evolution mode (sṛiṣṭi-krama), as outlined by the sage Lakshmīdhara in the tantric text, the Saundaryalaharī (8th century)

inner meaning better than the person who views it in the artificial setting of a museum or gallery. The yantra exteriorizes a universal intuition, and is experienced through stages, beginning with worship and ending in reintegration.

Icon and yantra

The inseparability of form and content is only one aspect of the aesthetics of the yantra. Another concerns the radical abstraction of its symbolic forms, in contrast to the 'realism' of iconographic art. An example is the iconographic image of the tantric goddess Durgā, as described in the 'Devī-Māhātmya' of the *Mārkaṇḍeya Purāṇa*, as opposed to her yantra form prescribed in the tantric texts, an extremely bold contrast in expression.

60
61

In her iconographic form, Durgā is described as having emerged from the energies of Vishṇu, Śiva and all the gods who sent forth their power in the form of streams of flames, combining themselves into a mass of cloud which grew and grew until it condensed into the shape of the goddess. The verses of the Devī-Māhātmaya describe the formation of her physical body and her iconographical attributes:

> Born out of the bodies of all the Gods, that unique effulgence, combined into a mass of light, took the form of a woman, pervading the triple worlds with its lustre.
> In that effulgence, the light of Śiva formed the face. The tresses were formed from the light of Yama and the arms from the light of Vishṇu.
> The two breasts were formed from the moon's light, the waist from the light of Indra, the legs and thighs from the light of Varuṇa and the hips from the light of the earth.
> The feet from the light of Brahmā and the toes from the sun's light. The fingers of the hand from the light of the Vasus and the nose from the light of Kuvera.
> The teeth were formed from the light of Prajāpati, the lord of beings; likewise, the triad of her eyes was born from the light of fire.
> The eyebrows from the two Sandhyās; the ears from the light of the wind. From the light of other gods as well, the auspicious goddess was formed.[10]

Projecting an overwhelming omnipotence, the three-eyed goddess adorned with the crescent moon emerged with her eighteen arms each holding auspicious weapons and emblems, jewels and ornaments, garments and utensils, garlands and rosaries of beads, all offered by individual gods. With her pulsating body of golden colour, shining with the splendour of a thousand suns, standing erect on her lion-vehicle (vāhana) and displaying her triumph over the dark forces, she is one of the most spectacular of all iconic personifications of cosmic energy.

In contrast, Durgā's yantra form is described in the *Tantrasāra*[11] as a composition of three triangles forming nine angles surrounded by three circles, with an eight-petalled lotus enclosed by a square with four gates, and the Goddess's seed mantra in the centre. The yantra forms a linear field of energy, without any likeness (amūrta) to the concrete image (mūrti) of Durgā. The magnificent conception of Durgā, with all her complex iconographic attributes, has been resolved into a simple geometrical equation retaining the vitality and life-force of all her auspicious personifications.

70 Ekaliṅgatobhadra Yantra, an example of a yantra of Śiva with liṅga-yoni emblem (in the centre) illustrating the cosmic wholeness of the male and female principles. Benares, hand-blocked colours, contemporary image based on traditional forms

71 Diagram of a Vedic fire altar (1500 BC), whose symbolic grid-square form has survived in the yantra diagrams of later periods

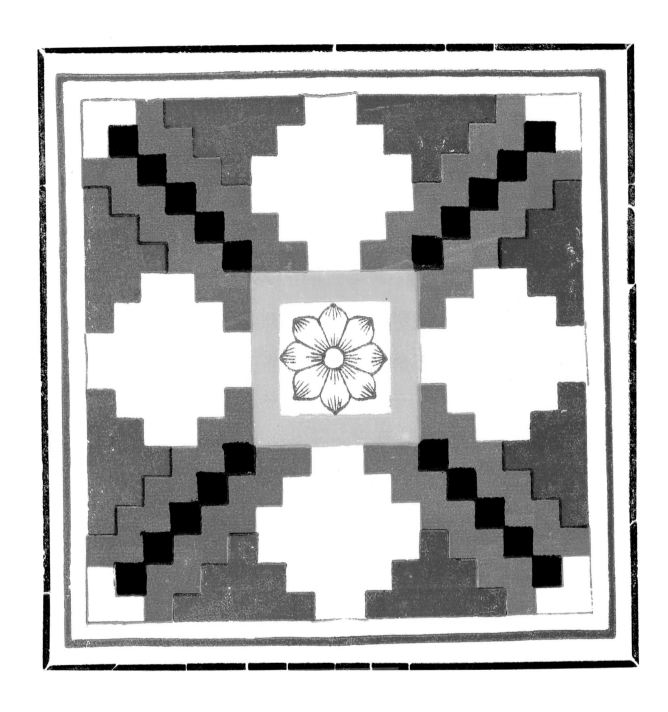

72 Sarvatobhadra Yantra, which may be used in the worship of any deity. The main deity
is invoked in the centre and the surrounding deities in each of the coloured squares
extending to the four cardinal directions. Benares, hand-blocked colours, contemporary
image based on traditional forms

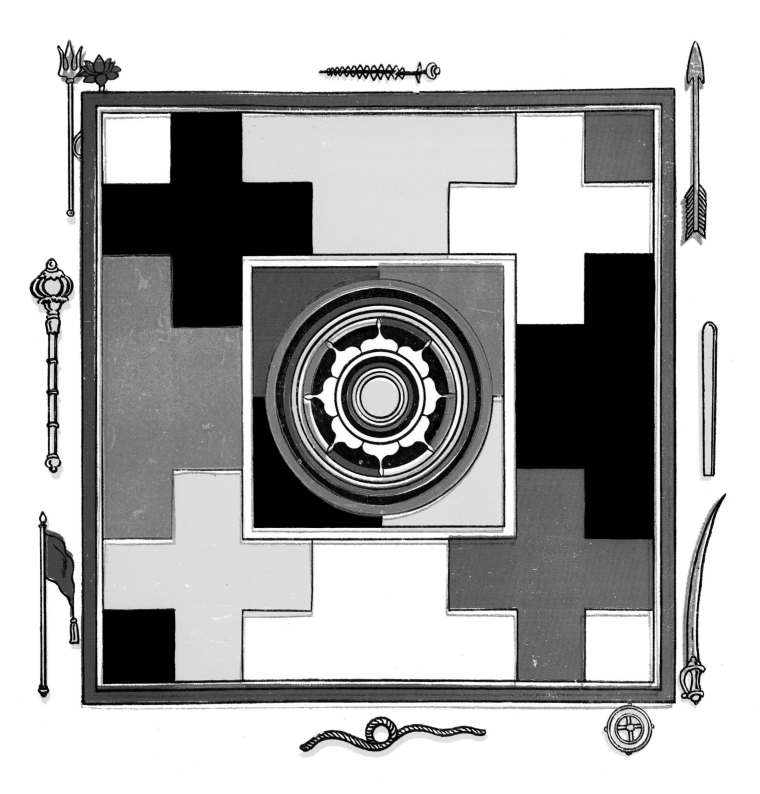

73 Varuṇa Maṇḍala. The deity of cosmic order is also 'Lord of Waters', invoked in the ceremonial jar which is placed in the centre of the yantra. The emblems of the deities and regents of space guard the yantra's sacred enclosures. Benares, hand-blocked colours, contemporary image based on traditional forms

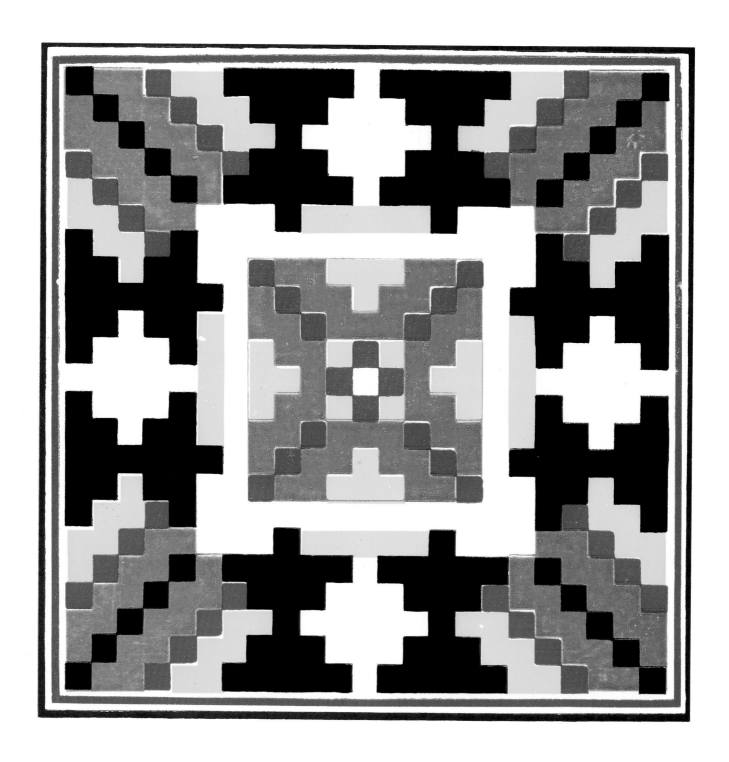

74 Aṣṭaliṅgatobhadra Yantra, a yantra of Śiva with eight liṅga-yoni emblems symbolizing the unity of the cosmic male-female polarity. Benares, hand-blocked colours, contemporary image based on traditional forms

The overwhelming appeal to the senses and arousal of emotions of fear or reassurance characteristic of the icon are not the purpose of the yantra, whose abstraction and serene equilibrium take the viewer beyond the partial aspects of the deity to the universal. Further, the yantra, unlike the icon, is universal in the sense that it is not subject to geographical or historical variations of style, but has maintained a common tradition throughout India.

Visually, the yantra has more in common with Indian temple architecture than with icons of the deity, as we shall see in Chapter 7. Echoing the yantra, the main image of the divinity of the temple is placed in the inner sanctuary which is surrounded by enclosures adorned with figures of secondary divinities, and the inner space of a temple, like the yantra, is so arranged that the devotee has to cross a series of sacred enclosures in order to reach the most sacred centre. Temple and the devotional yantra each create a total 'universe-pattern', combining in its multiplicity and hierarchy all levels and aspects of existence.

Each deity may be apprehended by the sādhaka for meditation or worship in any or all of the following forms: as a mūrti (icon); as a yantra (aniconic geometrical equation); as a mantra (esoteric sound-syllable); as a bīja-mantra (an atomic monosyllable). The icon is the grossest manifestation of the devatā; the yantra is the geometrical counterpart of the icon; and the mantra condenses the aesthetic potentiality of form as sound. In this sequence from gross to subtle, the yantra forms a link between form and formlessness, visible and invisible energy. The abstraction of the yantra is a first major step towards the resolution of dense materiality into its subtlest transformation, the monosyllabic mantra. We have seen earlier (Chapter 2) that yantra and mantra form a continuous dialectic. Hence the aesthetic of yantra should never be considered as divorced from its sound dynamics.

Concrete and abstract images offer alternatives to the worshipper according to his devotional needs and temperament. The cult-bound devotee may concentrate on the divinity in concrete form, where a highly advanced adept may use only mantra and yantra. Yet icon and yantra should not be seen as separate entities; they are two ways of apprehending the Supreme Principle, two sparks of the same fire.

Traditional abstract Indian art

Abstraction and simplicity as compared with representational and decorative art styles are believed by some to be alien to Indian art, yet the most significant characteristic of the yantra is its geometrical elegance and purity of archetypal form. The art of yantra is akin to the art of the Zen painters who seek to convey the whole mystery of creation in a few brush strokes, eliminating all detail and condensing form to its root essence.

Geometrical abstraction of forms has a long history in India. It can be traced back as far as Vedic times (second millennium BC) to a variety of carefully constructed fire altars whose symbolic form parallels that of yantras. Literary evidence shows that art, 71 in the Vedic period, had reached a high level of symbolic expression. As Vedic religion was one of non-anthropomorphic nature worship, icons and temples were

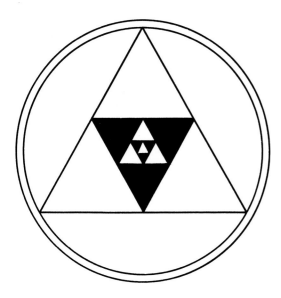

Smar-hara Yantra (detail), the 'remover of desire'. The circle is the latent Kuṇḍalinī Śakti, which when aroused can penetrate beyond the successive planes of inwardness illustrated by the five male and female triangles which correspond to the five psychic sheaths that envelop the innermost self

Pranga-cit. Vedic fire altar in a form of a magical triangle, associated with rites for gaining strength and supremacy

absent. Consequently the place where the sacred rites were held was marked only by a sacred enclosure, the container of the ever-burning ritual fire, symbolically the point where heaven and earth met.

The Vedic altars were given simple shapes. Their plans range from circular and square to combined geometrical figures, and were purely abstract in their genesis as well as in their final form. Of celestial significance, the square is the fundamental shape of Vedic altars, as with the Ahvaniya fire, the Uttara Vedi, the Ukha; all the other shapes are either based on or derived from it. The altar represented the material elements of the cosmic being (Purusha). Its bricks were laid pointing towards the cardinal directions to symbolize the vast extension of the universe; its heart was the place where the ritual fires were kindled. The altar combined the symbolic features of the deity, i.e. fire, and the sacrificial rites, linked together by the sacred plinth. Fire was the *axis mundi* that united the heavens and earth, and the altar symbolically represented the pillar that held the four regions (E W N S) together: 'Upon the back of Aditi I lay thee [altar], the sky's supporter, Pillar of the Quarters.'[12] Fire ruled over the three zones of the cosmos (earth, air, sky), and the altar's construction embodied this principle: three of its five layers were arranged to represent the three levels of the Vedic cosmos.

Many yantras used for ritual worship have retained archaic characteristics of these Vedic altars, though wide variation in detail was introduced as they came under the influence of tantrism. Altar-plan and yantra equally have strong cosmic affinities and are executed according to mathematical principles without any vestige of ornamentation.

Centrality and 'wholeness'

Despite its varieties the yantra's form retains its mathematical perfection. The extension of the bindu into line suggesting direction, motion and energy, continuing with regular expansion of linear shapes creates geometric patterns of increasing complexity. The yantra emerges as a perfect 'hologram', a figure of inner coherence and unity. A line can be divided to give smaller units without assuming wholeness or organic unity of composition. But when a point is placed in the centre of a given composition (as in a yantra), its spatial values begin to relate to the centre and all its parts are transfigured into a whole. Though all the concentric figures in the yantra are 'closed' shapes and form integral units in themselves, their inner balance is maintained, even where strongly contrasting shapes are related. No matter how it is arranged, a yantra's centre integrates all linear flow.

The cosmos is conceived as 'holon' (a perfect whole) or a 'closed universe' in which all elements of life are constantly recomposed at the end of cosmic cycles. Thus all manifestation within this closed universe is balanced by an eternal immutable reality, the indivisible centre. A yantra is thus a geometrical paradigm of a holon, and a mystical construct of the universe in which all polarities are harmoniously united.

7
Architectural Yantras

In Hindu tradition, temples are considered as the abode and bodies of gods. Though the earliest Hindu shrines and temples were small and simple structures, with the passage of time temples grew more varied and complex in plan and elevation, gradually including a variety of subsidiary structures within their compounds. The exterior walls of the temples are richly overlaid with carvings and sculptures, a teeming assembly of male and female figures, animal, vegetable and floral forms, mythic images of gods and goddesses, divine and semi-divine beings – all representing the entire panorama of the life of nature. In contrast, the innermost cella, the womb-chamber (Garbhagriha), lies hidden among the folds of the massive outer walls, reached through a series of ceremonial halls and stairways, whose walls and ceilings are covered with paintings or lined with icons installed in niches. These halls lead gradually up from ground-level, the mundane, to the highest regions of the spiritual, opening finally on to the dark, relatively small Garbhagriha, where an image or emblem of the temple's tutelar deity resides. The Garbhagriha represents the culmination of the individual's search and is the *sanctum sanctorum* of the temple. It lies directly beneath the temple's spire.

Whether humble sanctuaries or complex temple compounds, all Hindu temples have been built on the scheme of the ritual diagrams, yantras and maṇḍalas. These yantras are of a specific type, different from those used for personal ritual worship and meditation.

Architectural yantras are not ground-plans for temples but schematize the principles on which the sacred precincts of the temples are constructed. The dimensions and measurements of temple architecture are specified in early architectural manuals that also prescribe rituals to accompany the laying-down of a building's basic plan.

Plan and elevation of the Dharmarāja-ratha at Mahabalipuram, illustrating the centred, three-tier yantra-like construction

The Vāstu-Purusha Maṇḍala

Most manuals[1] stipulate that the ground-plan of every Hindu temple must conform to a simple graph, similar to a yantra, called the Vāstu-Purusha Maṇḍala, which was also the model for early towns. This diagram is basically an imprint of the ordered cosmos and reveals the form assumed by the Universal Purusha as a maṇḍala in the phenomenal world (Vāstu = bodily existence or site; Purusha = Supreme Principle or source of the cosmos; maṇḍala = closed polygonal figure). The precise proportions of the Vāstu-Purusha Maṇḍala are not of importance since it is never an exact blueprint of the temple but a 'prognostication' or 'forecast' within which a wide

Four types of Vāstu-Purusha Maṇḍala. The centre is the seat of the principal deity, with auxiliary deities extending to the outer borders

Sthāṇḍila, Maṇḍala, an architectural yantra for South Indian temples, based on the divisions of the grid square

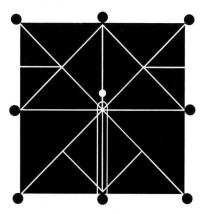

Kāmakalā Yantra, symbol of the unity of Śiva and Śakti. After the Śilpa-Prakāśa

range of possibilities of temple architecture is implied. The ritual diagram is an 'ideogram', while the temple is a materialization of the concepts it embodies.

The Vāstu-Purusha Maṇḍala is basically a square of squares but it can be converted into other primal shapes. The simplest arrangement consists of 64 (8 × 8) or 81 (9 × 9) squares, in which the nuclear central zone of 4 or 9 divisions is dedicated to the principal deity, Brahmā. Other, more highly complex, types can be elaborated by gnomic progression into 1,024 squares. When the maṇḍala is used architecturally its central zone locates the temple's womb-chamber. Around the nucleus, 12 squares are designated as seats of divinities, with specific reference to the 8 directions of space. These are surrounded by another 32 divinities associated with celestial bodies (28 lunar and 4 that preside over solsticial and equinoctial points).

Thus this simple graph-like diagram not only represents the energies of the directions of the compass but has astronomical connotations, providing a chart of cyclical revolution, of day, month, year, etc. These maṇḍalas, of which Hindu manuals of architecture provide thirty-two variations, are the earliest type of architectural yantras, contributing substantially to the rhythms, designs and conceptual basis of the Hindu temple.[2]

South Indian architectural yantras are generally constructed to reflect a different cosmic order. Three concentric squares create a hierarchy: the innermost is assigned to the Universal Being, the middle square is the sphere of gods, the outer square the terrestial region. Beyond the outer square are the creatures of the netherworlds. The Sthāṇḍila Maṇḍala of South India, however, resembles North Indian architectural yantras, being generally a composition of 49 squares.

Though architectural yantras are highly symbolic mathematical constructs they nevertheless provide certain practical indications. The Vāstu-Purusha Maṇḍala sets out the position of the devatā images in a temple, while its use in planning a town prescribes the town's orientation and the sites where temples are to be constructed. Before a temple is built, the ground is levelled, purified and consecrated, and the Vāstu-Purusha Maṇḍala is ritually drawn on the site. Thus 'the building draws its power from the Vāstu-Purusha [Supreme Principle] who lives at its base and converts, by his presence, the plan of existence [Vāstu Maṇḍala] into the shape of the Purusha, in whose likeness the temple is set up'.[3]

Śakti and Yoginī Yantras

Tantrism puts great emphasis on the use of yantras in temple architecture, especially for the construction of temples devoted to Śakti worship. Not only was the architectural yantra used as the basic inspiration for the plan and elevation of the temple, but yantras were actually incorporated into the fabric of the building. Yantras were, for example, laid into the foundation of the Garbhagriha and into important angles of the temples. Yantras also influenced the composition of the numerous sculptural images adorning the outer and inner temple walls (see below).

A recently discovered tantric manuscript from Orissa (Śilpa-Prakāśa, 9th–12th centuries) has thrown light on the distinctive features of the specifically 'left-hand'

tantric Śakti temples and their architectural planning rituals. According to this manual, at the appropriate site a peg is placed in the ground, symbolizing the central axis of the universe and called 'the womb of the yantra' (yantra-garbha). A circle is drawn around the peg and ten cardinal points are marked off relating to the regions of space (the eight directions, the nadir and zenith), to each of which is assigned a specific divinity. These ten points determine the entire plan of the temple. The construction from the centre outwards parallels the construction of yantras for worship and meditation,[4] and the peg is analogous to the bindu.

The principal architectural yantra of Devī (Goddess) temples, as prescribed by the *Śilpa-Prakāśa*, is rectangular, as opposed to the square of the Vāstu-Purusha Maṇḍala. Whereas the square is a static form, with four fixed points, the rectangle of the Devī temples symbolizes the rhythmic continuity of the creative play of Śakti, and her invincible power over life and nature. The Yoginī Yantra, which is meant to be installed in Śakti temples, does not dictate the plan of the temple but reinforces the pre-eminence of Devī's power in a ritual during the construction of the temple. The Yoginī Yantra is drawn on the base of the womb-chamber, and then consecrated and worshipped by the priest. After these preliminary rites, it is covered over and laid into the foundations of the innermost sanctuary. The symbolic meaning of the Yoginī Yantra is as complex as that of the Vāstu-Purusha Maṇḍala, incorporating various elements of the tantric conception of the cosmos. Three points on the median line running north to south denote the threefold manifestations of Śakti exhibited through her threefold tendencies: sattva, rajas, tamas (purity or intelligence, energy, mass or inertia). Three rajas-triangles indicate dynamic activity behind creation, balancing the opposing forces: the ascending tendency, the two sattva-triangles at the top, the descending tendency, the two tamas-triangles at the bottom. The seven triangles stand for the attributes of the Devī, who is the primary source of all creation.

In the outer points of each triangle, a cluster of 64 goddesses, known as the sixty-four yoginīs, are invoked. These divinities represent the rhythmic cycle of day and night which is divided into 30 parts (muhūrtas) – 15 for day and 15 for night. Each muhūrta is presided over by two of these yoginīs, with two yoginīs each for dawn and twilight. The Yoginī Yantra is installed in the Vārāhi Temple (c. 12th century) in Caurasi, Orissa, where esoteric practices such as sexo-yogic rites, virgin worship, etc., were practised by the 'left-hand' tantrikas (Kulāchāras).

The use of yantras in tantric shrines dedicated to Śakti extends beyond prescription for the plan and preliminary rites. The esoteric aspect of the left-hand doctrine is vividly illustrated in the imagery of the Kāmakala Yantra. This yantra, considered exceedingly potent, is either a square or rectangle, and has the Śiva emblem of the liṅga rising from the centre of the base line, around which there are sixteen yoni triangles, each presided over by a Śakti. Above the liṅga is a dot which is the abode of the Supreme Śakti, Mahā-Kāmakalesvarī. This yantra is considered necessary for every temple devoted to Śakti and Śiva, warding off any obstacle that may hinder the sādhana of the worshippers in the temple. In addition, the Kāmakala Yantra has an esoteric meaning, and was always to be concealed under the mithuna

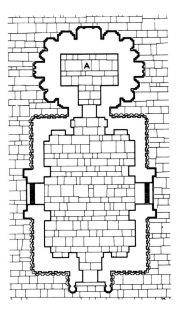

Yoginī Yantra, for tantric shrines devoted to Śakti worship, after the Śilpa-Prakāśa (top), and the Vārāhi Temple (above), where the Yoginī Yantra is laid in the foundation of the womb-chamber (A)

Bhairava Yantra, a compositional yantra of Śiva (left) and icon of Śiva superimposed (right). After the Śilpa-Prakāśa

(amorous couple) images installed in the temple. This yantra expressed the quintessential philosophy of the left-hand practitioners, who believe that 'Desire is the root of the universe. From desire all beings are born. Primordial matter (Mūlabhūta) and all beings are reabsorbed again through desire,'[5] so the text concludes that a place without love-images (kāmakalā) is a 'place to be shunned'.

It has been mentioned above that in tantric temples yantras were applied to regulate the design and creation of the sculptures adorning temple walls.[6] Such 'compositional yantras' are not used for meditation or worship but to provide an abstract framework, based on mathematical proportions, which determines certain fundamental compositional principles for the execution of sculptures of devatās such as the ten Mahāvidyās, and especially for the presiding deities of tantric shrines. The basic schemes of the compositional yantras may be a grid of vertical, horizontal and oblique lines, with a central focus. It is on the basis of the line divisions of these yantras that the whole sculptural image is built up. Each type of yantra matches an image of a particular deity. We may infer the immense role yantras have played in tantric temple art.

The Sūrya Pañcābja Maṇḍala and Navagraha Yantra

A particularly fine example of a temple based on and incorporating yantras is the magnificent Sūrya Temple in Konārak near Bhuvaneśvar in Orissa. This was built about AD 1240–80 in honour of Sūrya, the Sun God, source of all light, spiritual and earthly. Recent research[7] has shown that yantras were embedded in the pedestal of the presiding Sūrya image. The temple had two principal structures: a high tower (Vimāna), now in ruins, in which the cult image of Sūrya was placed, and a step-pyramidal assembly hall (Jagamohana) that led into the inner chamber of the sanctuary. The manner of construction of the yantra underlying the shrine, the Sūrya Pañcābja (=5 lotuses) Maṇḍala, and of worshipping its various devatās, is explained in a tantric manual:

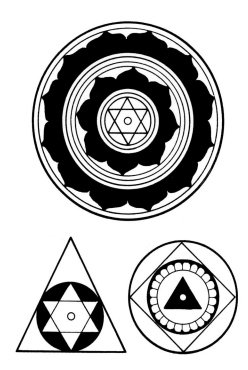

Sūrya Yantra (centre) dedicated to the Sun God, with yantras of his two Śaktis, Chāyā (left) and Māyā (right). These yantras are imbedded below the cult image of Sūrya in the Padmakeshara Temple at Orissa. After the Maṇḍala Sarvasva, an ancient text on architecture

> This Saurapañcabja Maṇḍala is greatly loved by Sūrya; it is made for the worship of Sūrya together with four other devatās. For this yantra a square has to be made with divisions and subdivisions, so that the whole field is divided into twenty-five parts.
> By tracing two diagonals the centre-point is found. Around the centre, a circle with eight sectors has to be drawn not exceeding the size of the central division.
> The lotus in the centre is eight-petalled; in the corners are twelve-petalled lotuses. . . .
> In the centre of this yantra is a bindu, and a hexagram inside the circle with an eight-petalled lotus.
> On the south side Gaṇeśa and Rudra, on the north side Ambikā and Vishṇu, are to be worshipped [on the small lotuses]. Then, leaving a half-part of the outer square, a square is made with a karṇikā [ear] in each of the corners. In those karṇikās three bindus are to be made. Two are on the sides and one in the centre. On these three bindus the Sūrya Śaktis are worshipped.
> In the Agni [south-east] corner Dīptā, Sūkṣmā and Jayā; in the Nairṛtya [south-west] corner Vijajā, Bhadrā and Ūṣmā. In the Vāyu [north-west] corner Tikṣṇā, Vegā and Pracaṇḍa; in the Īśāna [north-east] corner Tāpinī, Svarṇāmśu and Akskārikā.
> These have to be worshipped with seed mantra Hrīṃ, with flowers, perfume and rice they have to be worshipped.

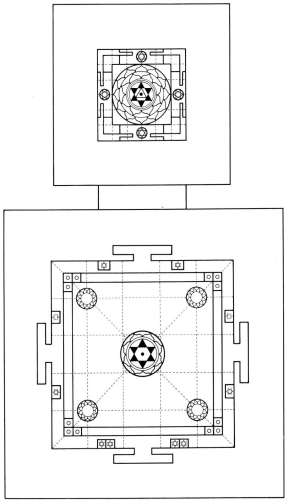

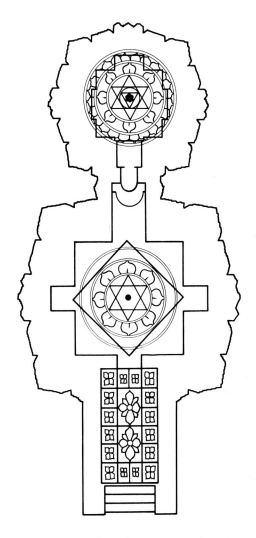

Ground-plan of the Sūrya Temple at Konārak showing the yantras underlying the womb-chamber (top, Sūrya Pañcābja Maṇḍala) and ceremonial hall (Mahā Sūrya Yantra). After the Maṇḍala Sarvasva

Three architectural yantras underlying the Mahā Gāyatrī Temple at Orissa, to represent three Śaktis of the Sun God, Sūrya. The circular yantra represents the goddess Gāyatrī who presides over morning devotions. She is the symbol of life, energy and creation. The square yantra represents the goddess Savitrī, Śakti of mid-day worship, and is the symbol of the consuming fire of dissolution. The rectangular yantra is of the goddess Sarasvatī who presides over the twilight hours, is worshipped in the evening, and represents sustenance and preservation of the universe. After the Trikāla Mahāmāyā Arcanā Vidhī

Again, in the second half of the square, the corners are to be left as they are, and one section by their side.

The Dikpālas [deities of the regents of space] have to be worshipped. On all four sides the bhūpura [outermost periphery] has projecting parts like portals. The Dikpālas are worshipped with their mantras in their proper places. Only by the side of the front Brahmā and Ananta have also to be worshipped.

Sūrya pūjā is done in the centre with [Sūrya's Śaktis] Chāyā and Māyā.

The Smārtas [Brāhmins] worship the five Devatās on this place.

Hrīṃ bīja [seed sound] is for Sūrya, Klīṃ bīja for Vishṇu, Guṃ for Gaṇeśa, Śrī bīja is for Ambikā. Rudra is worshipped with the Rudra-mantra by the Smārtas.

Ground-plan of the Nāt-Mandir in Konārak (left), corresponding to the divisions of the Yantra of the Nine Planets, or Navagraha (right). The symbols of the yantra are: square = Venus; bow = Mercury; snake = Ketu; triangle = Mars; lotus = the Sun, at the centre; sword = Rahu; crescent = the moon; circle = Jupiter; man = Saturn. After the Mandala Sarvasva

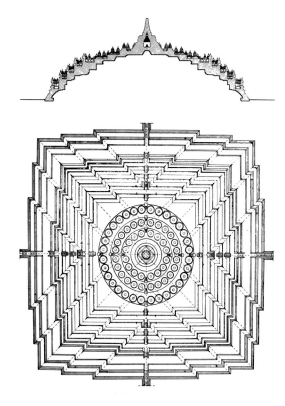

Ground-plan and elevation of the Barabadur Stupa, based on the conception of the Śrī Yantra

When a hall is built for a sacrifice [yajña] to Sūrya it is to be built according to this yantra, including all the four circles, with an altar [vedikā] in the centre.[8]

The central axis of the temple as it was built coincides exactly with the centre of the yantra laid into its foundations, and an imaginary line drawn vertically upwards from the centre of the yantra would strike the apex of the monument. Similarly, the four small lotuses in the four corners of the mandala correspond to the four pillars that still support the roof of the temple.

Adjacent to the main temple, a structure used as a ceremonial hall (Nāt-Mandir) is based on the Yantra of the Nine Planets (Navagraha Yantra). As Sūrya is the Lord of Planets, his worship is always accompanied by the worship of celestial bodies and their revolutions. The yantra is a square grid of nine units, each compartment presided over by a planetary divinity, with Sūrya's place at the centre of the yantra. The Nāt-Mandir is an architectural replica of the yantra, with the raised podium of its ceremonial hall divided into nine equal square compartments. The nine divisions are created by sixteen massive pillars, each of which stands at the corner of one or more squares. The Nāt-Mandir was used for daily rites during which a portable image of Sūrya was placed in the centre of the platform, corresponding to the place assigned to Sūrya in the yantra, and worshipped at dawn when the rays of the rising sun fell upon it.

Stone mandala

The relationship of yantra and architecture is especially close in monuments which may be called 'mandalas in stone'. A striking example is the Buddhist Barabadur Stupa (8th century AD) in Indonesia, which rises like a terraced mountain with nine levels corresponding to the nine circuits of the Śrī Yantra. Built on a square foundation, with four doorways and five walled-in terraces, it has three circular structures with innumerable images of the Buddha. Finally, the ninth level is crowned with a terminal stupa which is the realm of the Supreme Buddha.

The Śrī Yantra itself is essentially three-dimensional, like a terraced mountain, and both yantra and stupa represent the cosmological scheme of the mythical 'world-mountain', Mount Meru. As Paul Mus[9] has demonstrated in his study of Barabadur, the internal design of the temple can best be understood through a description of the Śrī Yantra.

The Barabadur Stupa like the yantra is conceived as a place of spiritual pilgrimage. In the stupa the journey starts at one of the four doorways, and continues through the lowest galleries, which illustrate in relief scenes from the Buddha legends representing the world of desire and illusion. As the pilgrim moves in a spiral to the upper terraces which open out to the sky, the Buddha images become more and more abstract – a change which represents the transition from the world of matter to the world of the spirit. It parallels the sādhaka's journey from the material to the spiritual during meditation on the Śrī Yantra. Movement from the lower, outermost levels to the centre, the summit/bindu, is to be translated from the world of matter to the world beyond thought.

75, 76 Every step brings the sādhaka nearer to the spiritual goal. The nine ascending levels of a pyramidal brick structure in an ancient shrine in West Bengal (c. 15th century) have at their summit the sacred seat (pīṭha-sthāna) of the goddess. This imagery resembles stupa architecture (opposite) and the pyramidal form of the Śrī Yantra (left), each used for the journey of meditation from the material level of the base to the spiritual level of the bindu/summit. Rajasthan, 19th century. Bronze

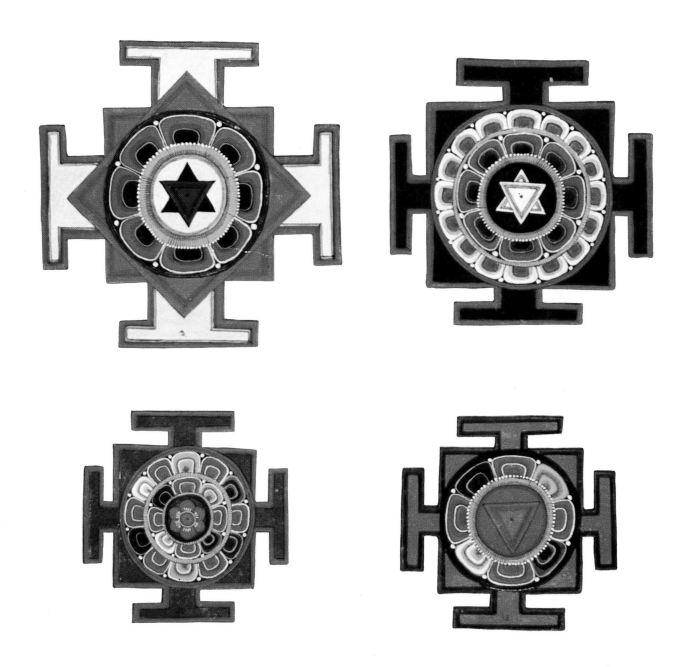

77–80 Yantras for meditation. Each graphic shape can be seen as a psychological schema: the outer gates are the gates of one's consciousness; the lotus petals, spiritual enfoldment; the inner geometrical figures, the stages of spiritual ascent; and the bindu, one's innermost self. Nepal, c. 1761. Gouache on paper

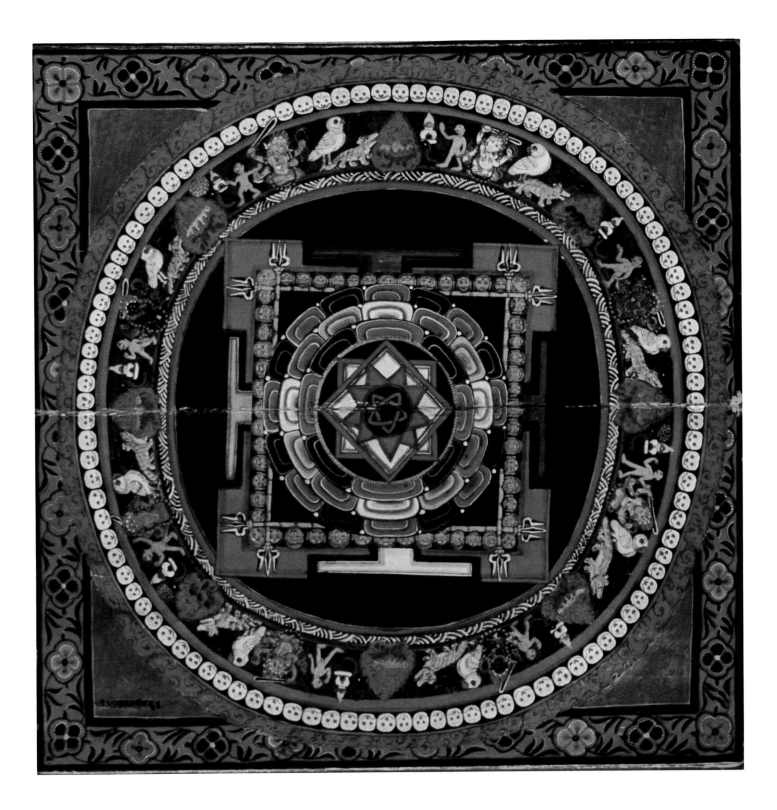

81 Guhya-Kālī Yantra, used for meditation: the power-diagram of one of the nine esoteric aspects of Kālī, with auspicious symbols. Nepal, *c.* 1761. Gouache on paper

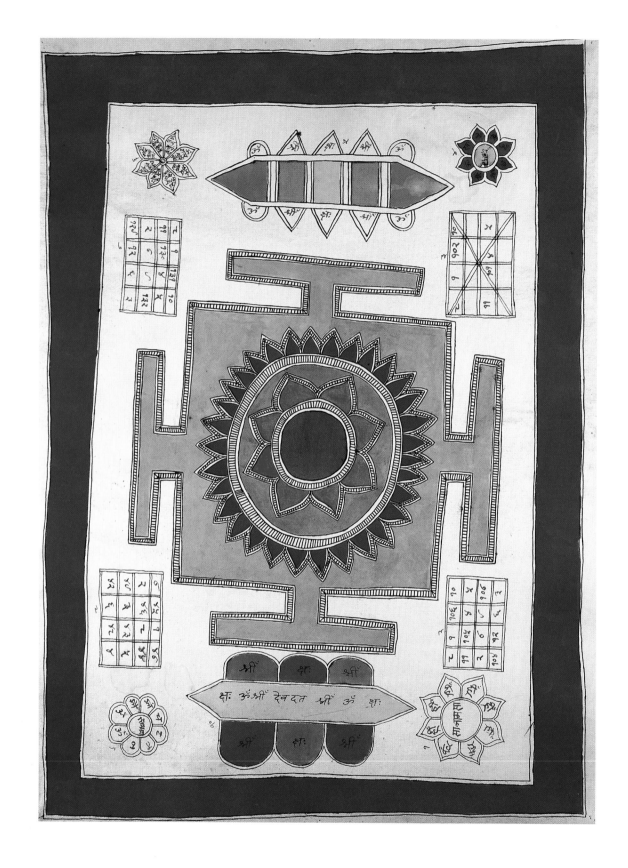

8
Occult Yantras

Yantras concerned with magic formulae, divination and propitiation rites form a small but significant group among tantric mystic figures. Tantrism, a synthesis of many diverse elements, has assimilated during its history the entire corpus of yogic disciplines, along with its occult practices, magico-propitiatory and magico-defensive rites. Yogic sādhanā enables the yogi to tap hidden psychic sources in order to achieve mastery over nature. It is traditionally held that he could, for instance, increase and decrease in size, or become light or heavy; that he could cover vast distances at will, leave his body to travel space faster than the speed of light, call up the dead, enter the bodies of men, women, animals , and return again to his own body. So subtle are claimed to be the senses developed by the yogi that he could gain knowledge of distant worlds without ever visiting them.

Among the most conspicuous sources of this esoteric occultism were tantric-yogic cults like that of the Nātha Saints, which originated in India around the seventh century AD. The Nātha cults combined a spiritual mysticism with paranormal practices such as multiplication of the body at will, resurrection from the dead, aerial visits and so on. Tradition has it that they achieved alchemical and healing powers by āsana (yogic postures), breathing techniques and ascetic disciplines.

Esoteric occultism also employed various non-physical aids such as graphic figures (yantras) and mystic chants (mantras), which take their inspiration from autochthonous spirituality. Hindu occultism can be traced to the *Atharva Veda* (c. 1000 BC), which preserves the early, non-Aryan traditions of India and was the ancient magical-propitiatory formulary.

In general, the whole theory of magical rites rests on the belief that there is an all-pervading, somatic, magic potency which can be transformed or divinized by means of spells, incantations and charms. The *Atharva Veda* indicates two types of cultic formula: the first, benign, is called 'atharvan' after the sage from whom the Veda derives its name; the second, malefic, is named 'aṅgiris', after another sage. Some scholars trace the ambivalence of the 'six rites' described below to this source.

The occult yantra is distinguished from all other kinds of power diagram by its practical application and utilitarian ends. The primary purpose is to gain control over the forces of nature, for positive or negative ends, but mainly for the attainment of worldly rather that spiritual goals, especially those not easily attainable by secular or religious effort. As practical magic, occult yantras have played an important role in Indian rural life, and remain a living tradition.

The practices associated with occult yantras are kept a closely guarded secret and their knowledge is confined to priests and teachers, especially in village

Manju-Ghosha Yantra which increases the talent for oratory and gives divine power. After the Tantrasāra

82 Occult yantras. The Agni Yantra (centre) is devoted to the Fire God (Agni) who devours ritual offerings, and is a symbol of the power through which man transcends the forces of nature. Top, from left to right, are diagrams for tantric magical rites to paralyse one's enemy, subjugate one's family, to enchant, and to bestow luck. Bottom, from left to right, are yantras to bring another under one's control, to ensure progeny, to entice one's husband, to paralyse another, and to give protection. Madhubani (Mithila), North Bihar state, contemporary images of traditional forms. Ink and colour on paper

Curative yantra to be inscribed on a gold plate and worn as a talisman. After the Saundaryalaharī

Occult yantra believed to cure diseases when worshipped ceremonially for forty-five days. After the Saundaryalaharī

communities. Despite this secrecy, which has resisted the dissemination of yantras as 'art', many of the diagrams are widely known. A number are illustrated and discussed in the Tantras and other texts. Square or oval thin metal plates, of gold, silver or copper, are often engraved or embossed with esoteric diagrams and mantras, and similar diagrams are inscribed on pieces of paper which may be rolled and carried as amulets.

Some occult yantras are linear enclosures with the trident of Śiva at their angles. Line in the yantra is generally employed to create absolute symmetry and a total organization of space. However there is another type of yantra, usually occult, in which soaring trajectories are created by the eccentric movement of linear impulses in space. Line (ṛju-rekhā) is the product of 'cosmic stress' and implies movement, flux and growth. Most traditionally, these yantras appear as a spiral around an invisible source, and are therefore to be associated with coiled Kuṇḍalinī Śakti, the energy of the subtle body. Others form eddies or curves, tracing wandering paths, or are intersecting ovoids, dissolving into space, mapping, as it were, the cosmic secrets.

The occult figures are not stereotypes but within the tradition vary endlessly. Each enclosure is a magical field in which power is circumscribed, controlled and used for occult proficiency. Each shape is a means to communicate with supernatural forces that work between heaven and earth. The forms and functions of the signs and diagrams are as many and individual as the human needs and purposes that they are intended to fulfil; and it is claimed that there is no wish that a yantra cannot satisfy. They are used for preventive medicine, as good luck charms, for exorcism, to ward off calamities, to gain wealth or learning, to enhance bodily charms, to restore alienated affection, to ensure conception or the birth of a son, to secure harmony and influence in the community, and so on.

The *Saundaryalaharī*, an eighth-century Sanskrit work, mentions 103 yantras and gives their ritual prescriptions. For instance, the yantra to give relief from disease, debt, etc., is said to be a circle with the seed mantra Straṃ inscribed in the centre. This yantra is to be consecrated for thirty days, pronouncing a mystic formula three thousand times in order to procure the desired result. Another text, the *Yantracintāmaṇi* ('Thought Jewel'), is solely devoted to 80 occult yantras, which it is claimed grant all desires, conscious or unconscious. The *Kāmaratna Tantra* is another such occult text; it lists a large number of occult yantras and the rituals to accompany them.

Dhāraṇa Yantra

One of the most popular occult yantras is the Dhāraṇa Yantra. The Sanskrit word dhāraṇa means to protect, possess, hold, bear, a receptacle. Worn for protection, the yantra is given to the devotee after a priest has consecrated it in a life-giving ceremony. Sometimes highly advanced priests, to increase the efficacy of the yantra, exhale their breath on to it, an act which symbolically represents the transformation of the diagram into a sacred entity. By such symbolic rites (see Chapter 4) these yantras are permanently imbued with psychic force. A particular

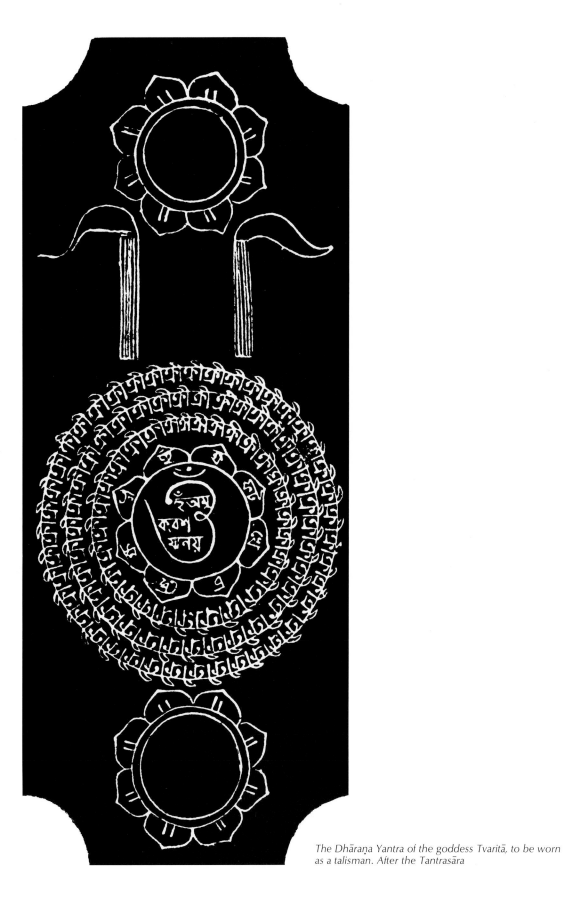

The Dhāraṇa Yantra of the goddess Tvaritā, to be worn as a talisman. After the Tantrasāra

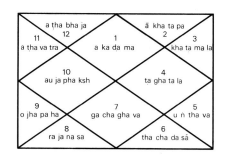

a tha bha ja 12		ā kha ta pa 2	
11 a tha va tra	1 a ka da ma		3 kha ta ma la
10 au ja pha ksh		4 ta gha ta la	
9 o jha pa ha	7 ga cha gha va		5 u n tha va
8 ra ja na sa		6 tha cha da sá	

Akadam Chakra, with mystic syllables transliterated. The arrangement of letters is used to determine the appropriate yantra for the particular individual

Mrritunjaya Yantra (of Śiva) which dispels fear, cures disease and brings fame and fortune. After the Tantrasāra

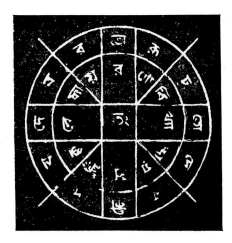

Ever-beneficent and auspicious Krishna-dhāraṇa Yantra. After the Tantrasāra

Dhāraṇa Yantra is selected according to the needs of the individual petitioner. One means of assuring the appropriateness of the yantra is to match the seed mantra inscribed on the yantra with the first letter of the petitioner's name.[1] For this a diagram called the Akadam Chakra is drawn, with twelve 'houses' each inscribed with the letters of the Sanskrit alphabet, arranged in a traditional manner and with a different combination in each house. The 'true' yantra for the person may be discovered by pairing the house in which the first letter of his name falls and the first letter of the seed mantra of the intended yantra. If the pairing is in the 3rd, 7th or 11th house, the yantra's mantra is considered to be beneficent; if in the 2nd, 6th or 10th house it is generally unlucky; and if it is in the 4th, 8th or 12th house, the match is held to be potentially disastrous.

Occult yantras often draw their power from the deities that are symbolically invoked in them. The *Tantrasāra*[2] specifies that the Dhāraṇa Yantra of the goddess Tvaritā, when inscribed on metal as an amulet, will relieve the ill effects of planetary influences, and subdue one's enemy. The Dhāraṇa Yantra called Nava-Durgā (of the goddess Durgā surrounded by a Śakti-cluster of nine deities), when tied by a thread around the arm or neck, prevents suffering from disease; the yantra of the goddess Lakshmī grants fame and wealth, and removes all dangers and anxieties. Similarly the Dhāraṇa Yantra of Kṛishṇa is considered to be all-beneficent; that of the goddess Tripurā-Sundarī enhances one's physical charm and beauty; the Mṛitunjaya (a name of Śiva) Dhāraṇa Yantra is said to cure disease, conquer fear and sufferings, and bring luck and fame to the seeker.

Metals, the materials of many occult yantras, are said to derive their power from particular planets: silver, a 'fragment of the moon', is believed to soothe fevers, cool the nerves and to draw its potent influences from the moon; copper draws its power from Mars, and copper Dhāraṇa Yantras have healing powers; gold is called a 'fragment of the sun', and is considered a perfect embodiment of sattva (equilibrium, truth, purity) and grants protection and good fortune.

Curative and prophylactic yantras

Certain yantras that serve as cures are drawn directly on the body of the afflicted subject. This practice is widely prevalent among the 'medicine-men' (Ojhās) of Mithila, the ancient kingdom in Bihar state, northern India. In the case of a scorpion

sting, the yantra is drawn symmetrically around the injury with an iron pointer, while chanting the appropriate mantra. The place of the sting becomes like the bindu of the yantra. The drawing of the yantra is repeated in mathematical proportion around the central yantra on the sting until the poison is neutralized and the sufferer is cured. In the case of snake bite, similarly, a yantra is drawn as concentric rings with an iron pointer, and this is believed to arrest the spread of the poison in the body.

The linear womb-shaped yantra called Chakra-vyūha, resembling a maze with a single opening at the top, is used in childbirth to ensure an easy delivery. At the appropriate hour the yantra is propitiated by the occult priest, who urges the woman mentally to enter the opening of the yantra and follow its zigzag course in deep concentration, completing each of its circuits and then reversing the course to return to the entry gate. Apart from the occult significance of the rite, the mental 'walk' through the yantra makes the subject circumambulate her own womb and helps her to use her mental powers to assist the birth.

A type of occult yantra based on arithmetical progression is the 'magic square'.[3] In the Tantras, such squares are often referred to as yantras because they possess mystical properties. A magic square is generally a chessboard figure in which numbers are so arranged that the sum of digits, no matter in which direction they are added, is always the same. One of the principal sources of the magic square is a mathematical treatise, the *Ganita Kaumudi* (AD 1356), in which an entire chapter discusses the construction of these squares with an odd or even number of cells.

The simplest type of magic square, said to be all-beneficent, is based on the magic power of the number 15. In this yantra, numbers from 1 to 9 are placed in the specified order within nine squares, of which four squares represent the elements. To cure cold, the numbers are written beginning from the 'fire square'; to cure fever, from the 'water square'; to effect the speedy return of a person from a distant land, from the 'air square'. It is believed that if the yantra is drawn with sandal paste or saffron on paper and worn as an amulet, its effect will be unfailingly beneficial.

The magical 'six rites'

In contrast to the uniformly beneficent Dhāraṇa Yantra, the tantric concept of polarity is embraced in the yantras associated with six magical rites – Ṣaṭkarma – in which the first one, Śhānti, a peace-bestowing rite, serves to counterbalance the ill effects of the other five, malefic, rites.

First: the Śhānti rituals and yantras grant protection from the ill effects of planets and curses, cure diseases and dispel fears. Second: Vashikaraṇa grants the power to attract and bring under one's control men, women, gods and animals, and have one's desires fulfilled through them. Third: Stambhaṇa lends the power of preventing or restraining another's actions. Fourth: Vidveṣana grants the power of separating friends, relatives, lovers. Fifth: Uccāṭan transmits the power to uproot. Sixth, Māraṇa grants the power to kill. The rites have been given a doctrinal basis, and are ascribed symbolic associations with deities, compass directions, mantras, elements and colours:

Chakra-vyūha, a maze pattern used to focus concentration during childbirth

Magic square based on the occult number 15

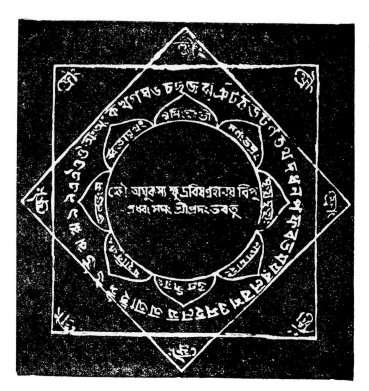

Narasiṁha-dhāraṇa Yantra, intended for the destruction of enemies and to overcome the negative aspects of planetary influence. After the Tantrasāra

Rite	Deity	Direction	Element	Seed mantra	Colour
Śhāntikarma	Rati	NE	water	Raṁ	white
Vashikaraṇa	Vāni	N	fire	Raṁ	red
Staṁbhaṇa	Ramā	E	earth	Laṁ	yellow
Vidveṣana	Jeṣṭhā	SW	ether	Haṁ	mixed
Uccāṭan	Durgā	SE	air	Yaṁ	black
Māraṇa	Bhadrakālī	SE	fire	——	ash

Tantric sources often warn of the danger that malefic yantras present to the initiator by inhibiting his spiritual quest. Power used for destruction is to be shunned. The use of these yantras is considered a lower form of spirituality, and tantric sources[4] declare that sādhanā of such types of occult yantra is never a vehicle of enlightenment, but a direct obstacle to any form of spiritual attainment.

Energizing the occult yantra

The effectiveness of occult yantras depends upon the power of the guru, priest or whoever performs the rites associated with them and their consecration. His power depends upon his knowledge of esoteric practices, his self-discipline (tapas) and his moral character. The *Yantracintāmaṇi* declares that the person who performs these

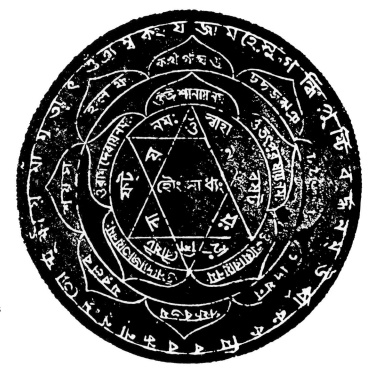

Śiva-dhāraṇa Yantra which prolongs life and bestows wealth. After the Tantrasāra

rites must have faith, for if there is a loss of faith, the effect of the yantra will not merely diminish but will be the exact opposite of what is intended.

According to the *Yantracintāmaṇi,*[5] to consecrate such a yantra the officiant should, with a pure mind, draw the yantra in a lonely spot. He should then consecrate it with the appropriate mystic incantations for three days, during which he is to remain celibate and sleep on the ground. The efficacy of the yantra can be gauged if during these three days he dreams: certain dreams are said to be premonitory of the accomplishment of the yantra's desired end. Auspicious dreams that indicate the presence of power (siddhi) to procure a desired end are dreams of association with women, of enjoyment on a mountain-top or in a royal palace, of a procession of elephants, of the singing and dancing of women, of rejoicing in festivals. Some inauspicious signs are seeing black soldiers, a state of anarchy, peril from fire, air or water, the death of a friend.[6]

The power of the yantra is often attached to a substitute or symbol. In the cure of diseases, the power to heal may be transmitted through the magic yantra and mantra by transferring that power to an inanimate object, a stone for example. Generally, the name of the person whom the yantra is intended to harm or benefit is inscribed in the centre of the yantra. The name or some of the syllables of the name may be included at the beginning, in the middle or at the end of the mantra; in the case of yantras granting prosperity, the mantra is added after each syllable of the name; if a yantra is intended to attract or fascinate another person, two sounds of the mantra are intoned, followed by two syllables of the name of the person to be attracted.[7]

In 'black' magic rites, the transmission of power is achieved by the 'principle of mimicry': by acting out a desired event. Thus a small figure will be made from clay taken from a spot where an individual has stood, resembling him as closely as possible, and will be consecrated surrounded by malefic yantras.[8] Sometimes, a yantra may be consecrated at crossroads, symbolically the *axis mundi*, and left there overnight in the hope that the affliction which has been transmitted to it will be passed on to the person who treads on it.

Yantra drawn on the walls of shrines dedicated to the goddess of children, Bāladevī, by women desiring children

The use of magic rites and magic yantras has particularly persisted in the rural communities of India. A great variety of yantras and auspicious signs are to be found, drawn on mud walls and the floors of huts. They are never applied for decorative purposes, but to cure and protect, to avert evil influences and hostile spirits. An interesting example of such a 'folk' yantra is associated with the number 5, which has a magical potency deriving from the powers of the five elements. It is generally drawn with five dots on the entrance or the sides of the door frame, or as a pentagon made without lifting one's finger. The Bhils, a tribal community in western India, draw five parallel lines girdling the outside walls of their huts to frighten away the evil eye; palm-prints (hastakāra-yantra), equilateral triangles and the swastika are all similarly used to ward off dangers and calamities and to counteract the power of the evil eye. The red of earth and the yellow of turmeric powder are generally used as auspicious colours, whereas the application of lamp-black is considered as an antidote to the power of evil.

The proven efficacy of occult yantras may be explained in psychological terms. To an individual who wears a yantra as a talisman, the diagram becomes a point of inner focus. It marks a sacred spot on his body where power manifests. He may even identify his entire being with the symbolic strength of the diagram. He believes that the diagram is a total embodiment of sacred power of the mysterious universe – the 'presence' of a divinity who dwells with him, albeit in him through the figure. Ultimately the empirical efficacy of the yantra is brought about by his own will-power, working through faith.

Practising siddhāis, on the other hand, give another explanation for occult esoterism. The Tamil siddhāis, for instance, explained their magical feats as a kind of 'game' with antimatter, claiming to believe (like the modern scientist) that there is another universe of antimatter, qualitatively different, with its own laws which govern occult practices. By reordering the arrangements of atoms with the aid of mantra chants, any process of nature can be brought under human control. Might there be another dimension of the universe, to which the siddhāis had access, and which modern man now seeks to rediscover?

83–86 Four occult yantras. Top left, yantra of the goddess Śrī, bringer of good fortune and plenitude, invoked in her yantra to attain all one's desires. Top right, Bālādhāraṇa Yantra, dedicated to the goddess as a young maiden, who protects against calamities if her yantra is rolled into an amulet and worn around the arm or neck. Bottom left, Bandhanmoksha-karana Yantra, a talisman to give release from bondages such as disease, pain, or the evil eye. The heads around the square band are to scare away spirits and negative vibrations. Bottom right, a yantra to confer immortality and to prolong active life. Madhubani (Mithila), North Bihar state, contemporary images of traditional forms. Ink and colour on paper

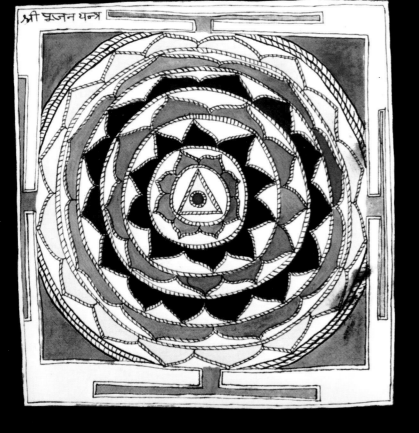

श्री पूजन यन्त्र

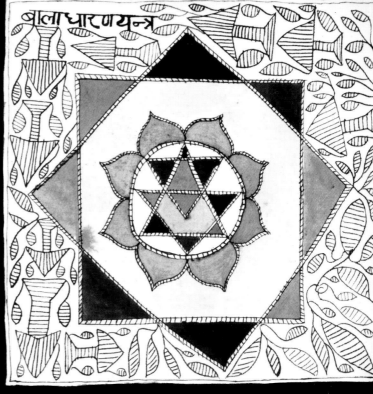

बालाधारणयन्त्र

बन्धनमोक्षकरं यन्त्रम्

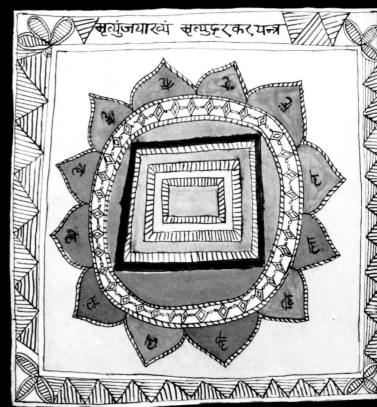

मृत्युंजयारव्यं सत्पुष्करकर यन्त्र

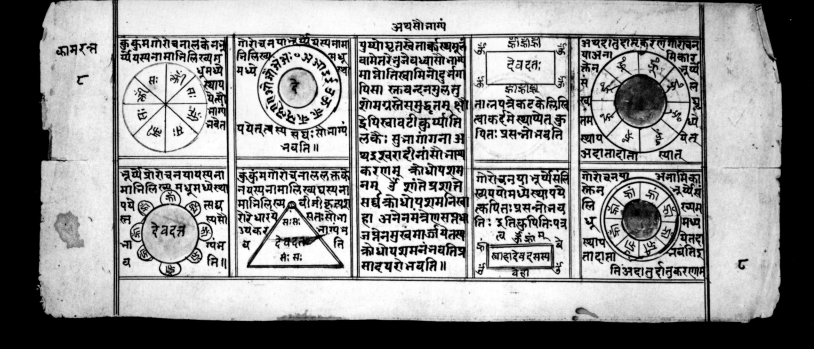

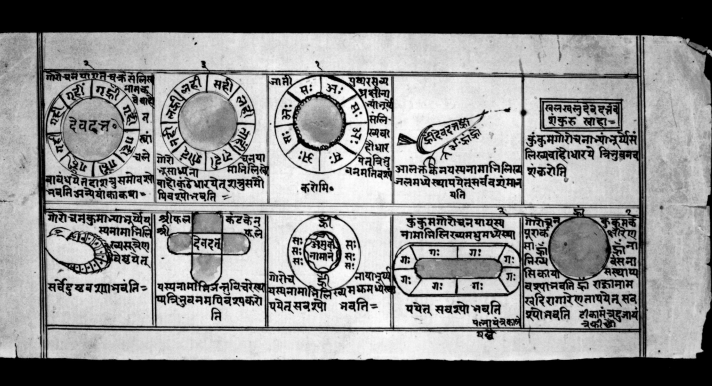

87, 88 Esoteric yantras intended (top) to bring luck, appease anger and nullify the effects of curses; and (above) to subjugate one's enemy or an evil-doer, and to bring under one's control the forces of the three spheres – earth, atmosphere and sky. Pages from the *Kāmaratna Tantra*, Rajasthan, *c*. 18th century. Ink and colour on paper

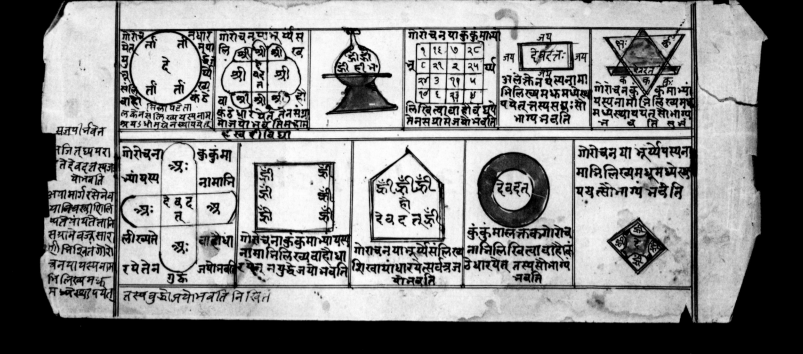

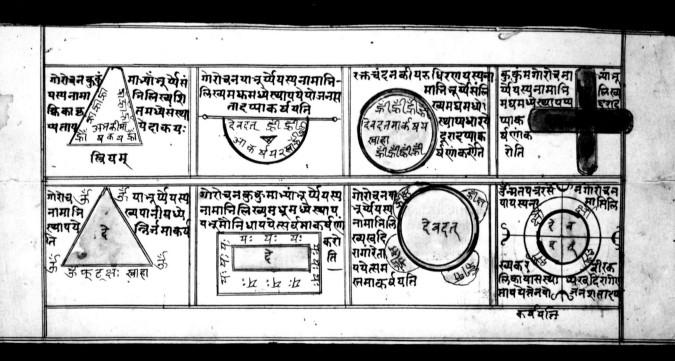

89, 90 Esoteric yantras intended (top) to conquer the evil forces of nature, when drawn on level ground or paper in yellow or red while chanting appropriate mantras, or, when worn as a talisman, to safeguard against hazards and evil spirits; and (above) to attract, entice and infatuate the opposite sex from far away. Pages from the *Kāmaratna Tantra*. Rajasthan, c. 18th century. Ink and colour on paper

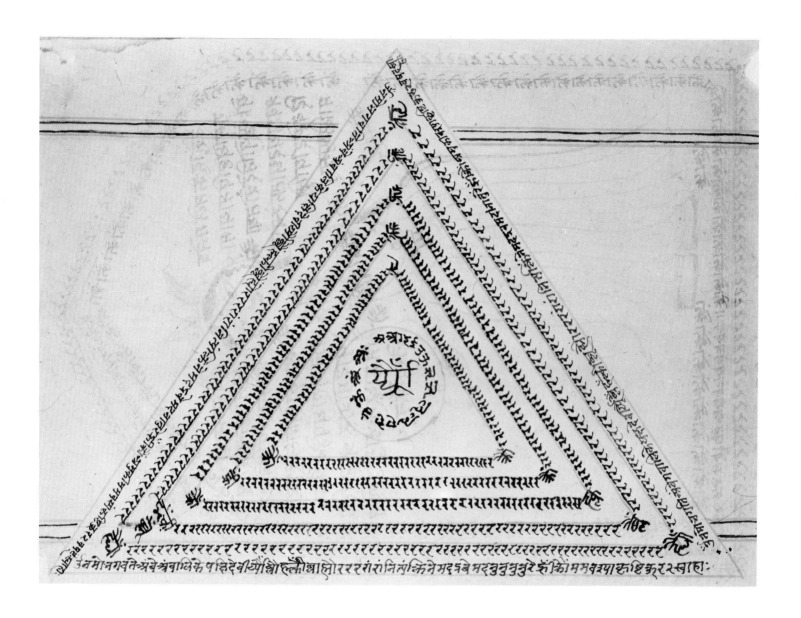

91 Yantra to subjugate, formed of cryptic mantra syllables in order to conceal its significance from the uninitiated. Rajasthan, c. 18th century. Ink and colour on paper

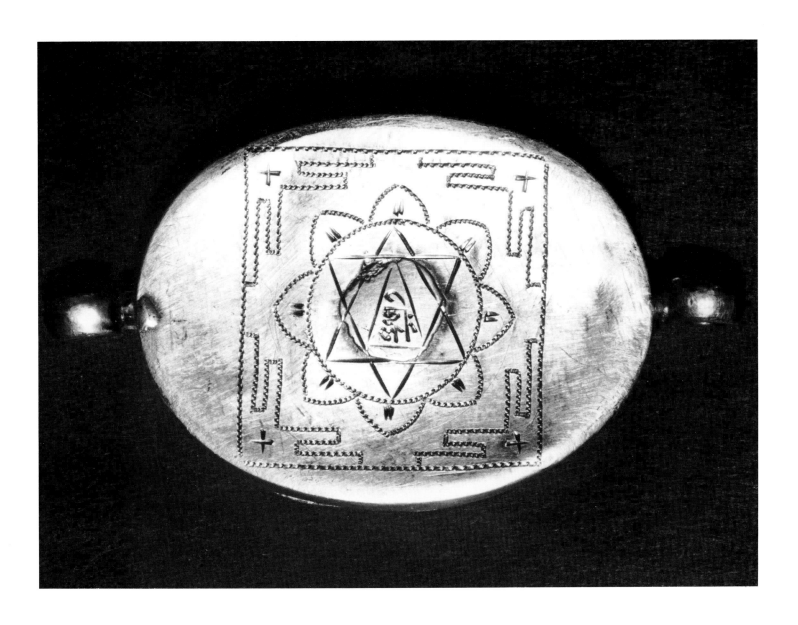

92 Yantra of Mahāvidyā Bagalā-mukhī on silver, considered to be a 'fragment of the moon'; an amulet to be worn on the neck or arm to protect and promote well-being. Kalighat, Calcutta. Contemporary image based on traditional forms

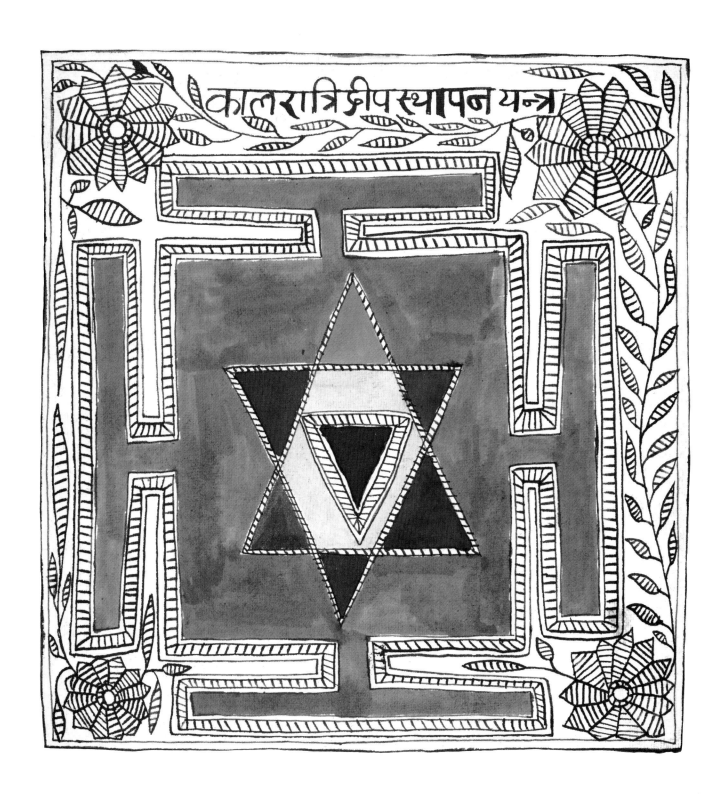

काल रात्रि दीप स्थापन यन्त्र

93 Yantra of the Goddess, to be worshipped at night for occult proficiency. Madhubani (Mithila),
North Bihar state, contemporary image based on traditional forms. Ink and colour on paper

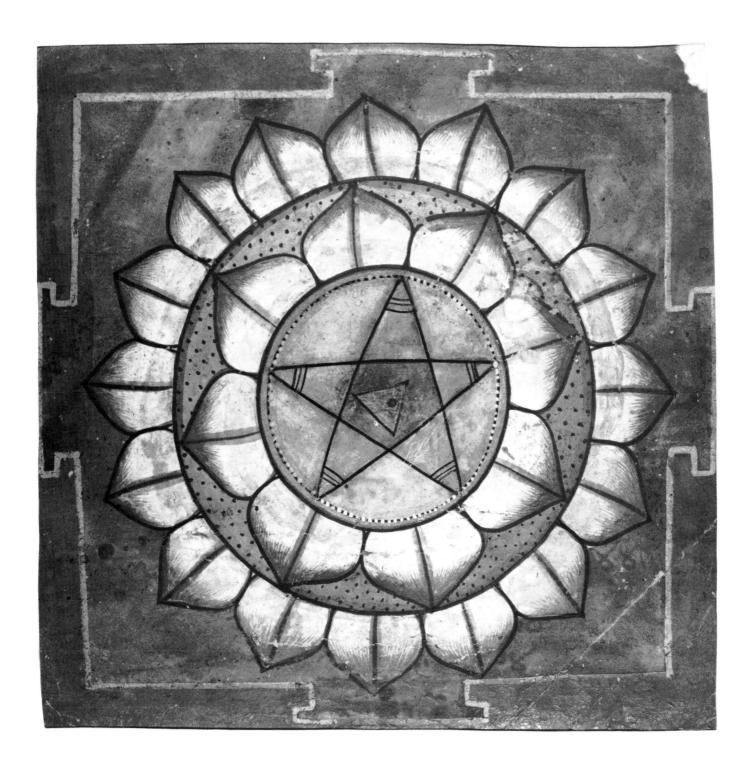

94 Shyām-Kālī Yantra with magic pentagon symbolizing the five elements – earth, water, fire, air, ether – which may be vitalized as a safeguard against destruction, evil and sin, and for good fortune. Rajasthan, *c.* 18th century. Gouache on paper

95 The bindu, sacred point of origin and return, with concentric circles symbolizing the eternal cycles of cosmic evolution and involution. The goal of the adept is his own involution to the centre, the ultimate point of psycho-cosmic integration, where he discovers his link with the Whole. Andhra Pradesh, c. 19th century. Wood

Notes on the Text

1 Introduction

1 For instance, *Kulārṇava Tantra* (10, 109) says: 'If worship is performed without a yantra the devatā is not pleased.' Or *Śilpa-Prākaśa* (II, v. 504): 'Without offering pūjā to the Kāmakalā, the Śakti pūjā and sādhana becomes useless.' Or *Gandharva Tantra*, Chap. V, v. 1.
2 See *Tantric Sāhitya* (Gopinath Kaviraj), pp. 40–1.
3 Ibid., pp. 532–5, lists several unpublished manuscripts on yantras.
4 M. Monier Williams, *A Sanskrit-English Dictionary*, p. 845.
5 Vāstuśastrā (D. N. Sukla), p. 372 ff. See Bibliography.
6 Saraswati Pratyagatmananda, *Japa Sūtram*, p. 110.
7 *Saundaryalaharī*, v. 11; and *Lalitāsahasranāma*, 996.
8 Wendell Charles Beane, *Myth, Cult and Symbols in Śākta Hinduism*, p. 206.
9 Mircea Eliade, *The Two and the One*, p. 204.
10 Calculations based on *Tantrarāja*, Chap. XIX.
11 For Vedic maṇḍalas, see *Rigveda-Brahmakarmasamuccya* (Nirṇayasāgar Press, Bombay, 6th edition, 1936), cited in P. V. Kane, *History of Dharmaśāstra*, Vol. V, Part II, p. 1184.
12 Buddhist maṇḍalas form a separate study on account of their complex symbolism; see G. Tucci, *The Theory and Practice of the Maṇḍala*; also the *Guhyasamāja Tantra* and *Niṣpannayogāvalī*; and for the Buddhist meditation on the Śrī Yantra, see *Śrīchakrasaṃbhara Tantra*.
13 For Jain types of yantras, see 'Bhairava Padmāvatikalpa' in M. B. Jhavery, *Comparative and Critical Study of Mantraśāstra*, and *Ṛishi Maṇḍala Yantra Pūjā*.
14 One of the sources of the astrological type of yantra is the *Bhṛigu-Saṃhitā*.
15 Abhinavagupta, *Tantrasāra*, text cited by G. Tucci in *The Theory and Practice of the Maṇḍala*, p. 140.
16 Text cited and translated by S. R. Dasgupta in *Obscure Religious Cults*, p. 104.
17 *Gandharva Tantra*. Text cited and translated in *Karpurādistotra*, p. 64.
18 Quoted in Edward F. Edinger, *Ego and Archetype*, p. 109.

2 Archetypal Space and Sacred Sound

1 *Kāmakalāvilāsa*, v. 21.
2 For mathematical enumeration of zero, see Ajit Mookerjee, *Yoga Art*, pp. 19–20, and also S. Radhakrishnan (ed.), *History of Philosophy, Eastern and Western*, Vol. I, pp. 441–4.
3 Agehananda Bharati, *The Tantric Tradition*, p. 102.
4 *Śaradātilaka Tantra*, Chap. VII, 9–14.
5 *Tantrasāra*, Vol. I, Chap. I, v. 10–24.
6 *Tārārahsya*, Chap. III, v. 137.
7 *Vākyapadiyam*, v. 120.
8 Swami Prabhavananda's translation in *The Spiritual Heritage of India*, p. 38.
9 For instance, see S. Śrīkaṇtha Śāstri, 'The Iconography of the Śrīvidyārṇava Tantra', in *The Quarterly Journal of the Mithic Society*.
10 Quoted L. Blair, *Rhythms of Vision*, p. 115.

3 Metaphysics of Yantra

1 *Mahākāla Saṃhitā*, quoted by Arhtur Avalon in *Śakti and Śākta*, pp. 28–9.
2 Tantrism seems to have developed its own branch of feminine divinities. See S. Śrīkaṇtha Śāstri, 'The Iconography of the Śrīvidyārṇava Tantra' in *The Quarterly Journal of the Mithic Society*.
3 See *Devībhāgavata Purāṇa*, Part II, Chap. VIII, Book V, pp. 376–8, on the origin and form of the Devī; also *Mārkaṇḍeya Purāṇa*, 83, 10–34.
4 Such as *Tantrarāja Tantra*, *Śaktisaṅgama-Tantra*, *Śāradātilaka Tantra*, etc.
5 For instance, texts and unpublished manuscripts on the ten Māhavidyās cited in *Tantric Sāhitya*, pp. 26–39; and also *Śaktisaṅgama-Tantra* and *Tantrarāja Tantra*.
6 'Śākta Philosophy' by Gopinath Kaviraj in Radhakrishnan (ed.), *History of Philosophy, Eastern and Western*, Vol. I, p. 403. Ibid., 'Śaiva and Śākta School', p. 403.
7 David R. Kinsley, *The Sword and the Flute*, Chap. III.
8 *Mārkaṇḍeya Purāṇa*, 87, 5–23.
9 *Karpurādistotra*, p. 26.
10 M. Monier-Williams, *Brahmanism and Hinduism*, p. 186.
11 *Tantric Sāhitya*, pp. 26–39.
12 Another group of Nityā Śaktis, with their dhyānas, mantras, and descriptions of their respective yantras, occurs in the *Śaktisaṅgama-Tantra* (Chap. 12, 14–18), probably belonging to Kālī-kula.
13 Calculations based on the *Tantrarāja Tantra*, Chap. XXV.
14 According to *Sūksmāgama*, VI, 8, The liṅga is a unifying principle of Śiva, whereas Śakti is the Cit or Consciousness aspect of reality. See, for instance, 'Vīra Śaivism' by Kumaraswamiji in Radhakrishan (ed.), *History of Philosophy, Eastern and Western*, Vol. I, p. 394.
15 *Mahābhārata*, XXII, 14, 233, quoted in W. D. O'Flaherty, *Ascetism and Eroticism in the Mythology of Śiva*, p. 257.
16 Agehananda Bharati, *The Tantric Tradition*, p. 202.
17 *Kālīkā Purāṇa*, 66; 60–1. (See Bibliography under *Worship* . . .)
18 Text quoted in S. Shankaranarayanan, *Śrī Chakra*, p. 63.
19 *Mālinīvijayottara Tantra* (*Śrī*), Chap. III, v. 10–12.
20 *Atharva Veda*, X, v. 31–4, translated by R. Shamasastry in *The Origin of the Devanāgarī Alphabets*, p. 16: 'The impregnable city of the gods consists of eight circles and nine triangles (dvāra). Within it is a golden cell celestial and invested with light. In the triangle (tryara) and three dots (tri-pratishṭhita) within that cell, resides the One Eye. Those who know Brahman think that this Eye is Ātman. For into that impregnable city, which is resplendent, bright and invested with renown, Brahman has entered.'
21 For different worshippers of Śrī Vidyā, see *Tantric Sāhitya*, p. 29, and *Saundaryalaharī*, pp. 21–2.
22 Some major Tantras in which the descriptions of the Śrī Yantra occur are *Kāmakālavilāsa*, v. 1–50; *Tantrarāja Tantra*, Chap. IV; *Bhāvanopaniṣad*, v. 1–30; *Gandharva Tantra*, Chap. V; *Nityaśoḍaśikā*, Chaps. I–IV; *Yoginī Hṛdaya*, Chap. I; *Tripurātāpini Upanishad*, Book II, v. 15–23 and Book III, v. 13, in *The Śākta Upaniṣad-s*.
23 *Varivasyā-Rahasyam*, translated R. Shamasastry in *The Origin of the Devanāgarī Alphabets*, p. 39.
24 *Bhairava-Yāmala*, 1–47, translated by Arthur Avalon in *The Serpent Power*, p. 145.

4 Dynamics of Yantra: Ritual

1 Arthur Avalon, *Śakti and Śākta*, p. 250.
2 *Jayadratha-Yāmala*, for instance; text cited by J. Gonda in *Change and Continuity in Indian Religion*, p. 443.
3 *Kālikā Purāṇa*, 59, 135 ff. (See Bibliography under *Worship* . . .)
4 *Yantra Saṁskārapaddhiti*.
5 See *Tripurātāpini Upanishad*, III, v. 13, in *The Śākta Upaniṣad-s*, p. 23, for the colours and materials of the Śrī Yantra in relation to specific merits.

5 Dynamics of Yantra: Meditation

1 *Yoga-Sūtra*, Chap. I, 39–40.
2 Arthur Avalon, *Hymns to the Goddess*, pp. 94–6.
3 For detailed symbolism see *Bhāvanopaniṣad*, p. 46, note 22.
4 The Mudrā Śaktis are ten in number. Nine represent the nine psychic centres of the subtle body (p. 123), and the tenth, the one who presides over them all. They are: the agitator of all (Sarvasankshobhiṇī), the chaser of all (Sarvavidraviṇī), the attractor of all (Sarvākarṣiṇī), the subjugator of all (Sarvavaśankarī), the intoxicator of all (Sarvomādinī), the great restrainer of all (Sarvamahānkuśa), the all-mover in space (Sarvakhecarī), the seed of all (Sarvabīja), the creative genetrix of all (Sarvayoni), and last, the one who presides over the threefoldness of all (Sarvatrikhaṇḍā). Ibid., p. 47.
5 *The Thirteen Principal Upanishads*, p. 23.
6 Ibid., p. 24.
7 *Śiva Saṁhitā*, 2, 1–5, texts cited and translated by Jean Varenne in *Yoga and the Hindu Tradition*, p. 155.
8 For instance, see *Ṣaṭ-Chakra-nirūpaṇa*.
9 Practising Śāktas relate the nine circuits of the Śrī Yantra to the nine psychic centres as exemplified in the *Saubhāgya-Lakshmī Upanishad*, III, 1–9. See Bibliography under *Śākta Upaniṣad-s*.
10 According to Brahmachāri Laksmana Joo, a living practitioner of Śaivism in Kashmir.
11 See, for instance, *Dhyānabindūpaniṣad*, 33–7, in *The Yoga Upaniṣads*.
12 *Triśikhibrāhmaṇopanishad*, 135–42, in *The Yoga Upaniṣads*.
13 *Kālikā Purāṇa*, 59, 132 (See Bibliography under *Worship* . . .); *Bhāvanopa-niṣad*, v. 31.
14 See, for instance, *Kālikā Purāṇa* (op. cit.), 59, 113–14, in which a similar rite is called yoga-pīṭha meditation. *Devībhāgavata Purāṇa*, Book III, 39, mentions it as manasic yajña, or mental oblation.
15 *Kaulāvalīnirṇaya*, Chap. 3, v. 103.
16 *Dhyānabindu Upanishad*, quoted by Paul Deussen in *The Philosopy of the Upanishads*, p. 392.
17 *Bṛhadāraṇyaka Upanishad*, 4, 5, 15.
18 *Hathayogapradīpikā*, 4, 115, in George W. Briggs, *Gorakhnāth and the Kānphaṭa Yogīs*, p. 346.

6 Aesthetics of Yantra

1 *Bhāvanopaniṣad*, v. 6–8.
2 *Tantrarāja Tantra*, Chap. V, v. 14.

3 Ibid., Chap. V, v. 23–5.
4 See *Mahānirvāṇa Tantra*, Chap. V, v. 97–104; and *Ṣaṭ-Chakra-nirūpaṇa*.
5 *Mahānirvāṇa Tantra*, Chap. XIII, v. 5.
6 Saraswati Pratyagatmananda, *Sādhanā for Self-Realization*, p. 53.
7 N. J. Bolton and D. Nicol G. Macleod, 'The geometry of the Śrī Yantra', in *Religion. A Journal of Religion and Religions*, pp. 66–85.
8 For instance, see Ananda K. Coomaraswamy, *Figures of Speech or Figures of Thought*, Chap. X.
9 *Agni Purāṇa*, Chap. XI, III, text cited by Ananda K. Coomaraswamy in *Dance of Śiva*, p. 27.
10 'Devī-Māhātmaya', II, 14–18, tr. Shankaranarayanam. (See Bibliography under *Glory* . . .)
11 *Tantrasāra (Brihat)*, Vol. II, pp. 397–8.
12 *Yajur Veda*, XIV, 5.

7 Architectural Yantras

1 See, for instance, *Mānasāra (Architecture of)*, a treatise on Hindu architecture by P. K. Acharya which gives site-plans of thirty-two varieties.
2 For the complex symbolism of the Vāstu-Purusha Maṇḍala, see S. Kramrisch, *The Hindu Temple*, Vol. I, Part II, p. 29 ff.
3 Ibid., p. 57.
4 Compare, for instance, the method of constructing the Śrī Yantra in the evolution mode outlined by Lakṣmīdhara in the *Saundaryalaharī* (1972 edn.), p. 5, with the mode of preparing the site-plan of a Śakti temple as discussed in the *Śilpa-Prakāśa*, II, v. 61–85.
5 *Śilpa-Prakāśa*, II, v. 499.
6 Compositional yantras are discussed by Alice Boner in *Śilpa-Prakāśa* and in her *Principles of Composition in Hindu Sculpture*.
7 See Alice Boner and S. R. Sarma, *New Light on the Sun Temple of Konārka*.
8 Ibid., translation of *Maṇḍala Sarvasva*, pp. 209–10.
9 See Paul Mus, *Barabudur*.

8 Occult Yantras

1 The method of ascertaining the correct 'yantra-bīja mantra' for an individual appears to be the same as for the mantra; see *Yantracintāmaṇi*, II, v. 36 ff.
2 *Tantrasāra (Brihat)*, Vol. I, pp. 575–84.
3 See, for instance, S. Cammann, 'Islamic and Indian Magic Squares' in *History of Religion*, Parts I and II, Vol. 8, No. 2, pp. 275–86.
4 *Tārā-Bhakti-Sudhārṇava*, Chap. X, p. 354.
5 *Yantracintāmaṇi*, II, v. 26–32.
6 *Tantrarāja Tantra*, Chap. V, v. 81.
7 *Uḍḍiśi Tantra*, v. 44–60.
8 *Maheśvara Tantra*, p. 9.

Note on Sanskrit pronunciation

VOWELS transliterated from Sanskrit as ā, ī, ū are long ('ā' as in 'father', 'ī' as in 'see', 'ū' as in 'loot'); ṛ is a vowel, and is pronounced with a sound between 'ri' and 'er'; a is short, as in 'apple'; e is pronounced 'ai' as in 'gait'; o is long as in 'open'; u is pronounced as in 'full'; ai is pronounced as in 'aisle', au as 'ow' in 'how'.
CONSONANT c is pronounced 'ch' as in 'church'; ḍ is pronounced 'd' as in

'dog'; ṃ and ṁ are pronounced 'mn', nasalized, as in 'somnolent'; ṇ and ṅ are pronounced 'ng', nasalized, as in 'gong'; ṣ is pronounced 'sh' as in 'shun'; ś is pronounced with a sound between 'sh' and 's'; ṭ is pronounced as 't' but with the tongue turned back on to the roof of the mouth.

The symbol known as the 'visarga', ḥ, is aspirated from deep in the throat. Apart from the Sanskrit vowel transliterations 'ai' and 'au', each letter of a word is to be individually sounded.

Glossary

ākāśa: etherial space, the subtlest of the five cosmic elements.

antaryajña: 'inward oblation', a form of meditation in which all the tattvas or constituents of the cosmos are dissolved psychologically in internal yantras visualized by the adept.

Ardhanārīśwara: the androgynous form of Śiva.

Ātman: Pure Self, identified with the ultimate principle of the universe.

Āvaraṇa Devatā: deities surrounding the principal deity and presiding over the linear framework of the yantra.

Āvaraṇa pūjā: ritual worship of the surrounding deities of the yantra.

avidyā: ignorance of the reality of the cosmos.

bhūgraha: region of materiality associated with the outer, square enclosures of the yantra.

bhūpura: the square and T-shaped portals of the yantra, identified with the earthly sphere.

bīja-mantra: seed-syllable, a monosyllabic sacred sound representing a deity or cosmic force.

bindu: extensionless point, sacred symbol of the cosmos in its unmanifested state.

Brahmā: the first god of the Hindu trinity, the Creator.

Brahman: the Absolute Principle of the universe, Cosmic Consciousness. In the Tantras, Brahman may be equated with the unity of Śiva/Śakti, the male and female principles.

chakra: (lit. wheel, or circle) a yantra, especially the internal yantras or energy centres in the subtle body, represented as lotuses.

Cit: Pure Consciousness, the highest principle, manifesting everywhere.

Daśa-Mahāvidyā: cluster of ten goddesses who represent the knowledge aspects of the great goddess Kālī.

devatā: a divinity.

Devī: female divinity, goddess.

dīkshā: ritual initiation by a guru of a pupil.

Garbhagṛiha: womb-chamber, an inner cell of a temple where an icon or emblem of the divinity is installed.

Gāyatrī Mantra: a well known Vedic mantra representing cosmic categories.

guṇas: the attributes or qualities which make up the universe. They are three: sattva, rajas, and tamas, collectively the constituents of Prakriti, or material nature.

Icchā-śakti: energy of will, one of the triad of energies of Śakti, the female principle; the other two energies are knowledge and action.

Iḍā: the 'female', left-hand channel of the subtle body, coiling around the Sushumṇā and terminating at the left nostril.

Ishṭa-devatā: a person's chosen deity, generally assigned by the guru.

Jñāna-śakti: energy of knowledge, one of the triad of energies of Śakti, the female principle; the other two energies are will-power and action.

Jñāendriyas: the five organs by which we apprehend the world – hearing (ears), touching (skin), seeing (eyes), tasting (tongue), and smelling (nose).

kañchukas: limiting factors imposed on creation during evolution, which veil the Absolute Principle.

Karmendriyas: the five agents of action – walking (feet), handling (hands), speaking (mouth), procreation (genitals), and evacuation (bowels).

Kaulas: 'left-hand' sect of tantrism.

Kriyā-śakti: energy of action, one of the triad of energies of Śakti, the female principle, the other two are will-power and knowledge.

Kuṇḍalinī: latent psychic energy lying coiled in the root chakra, the Mūlādhāra, the psychic centre at the base of the spine.

laya-krama: the order of dissolution; way of viewing the yantra as a symbol of involution, moving inwards from the periphery to the centre.

liṅga: abstract symbol of Śiva.

Lokapālas: deities of the eight regents of space, who guard the sacred spaces of the yantra.

Mahāvidyās: the ten 'Great Wisdoms', the ten goddesses representing the 'knowledge' aspect of Kālī, the supreme goddess.

maṇḍala: (lit. circle) sacred diagram composed of primal shapes, sometimes identified with yantras.

mantra: sacred sound representing cosmic form at its most subtle, as vibration, incantation.

mātṛikā: letter of the Sanskrit alphabet representing the eternal aspect of cosmic sound.

Mātṛikā-nyāsa: ritual projection of sacred seed mantras on the body.

Māyā Śakti: creative power of the cosmos.

mudrā: sacred finger-gesture.

mūla-trikoṇa: root triangle, symbolizing the female principle.

mūrti: icon, anthropomorphic deity image.

Nāda: cosmic sound, manifesting as subtle vibration.

nādātmikā śakti; principal energy of Cosmic Sound.

Nityā Śaktis: cluster of sixteen goddesses known as the 'eternal' ones, each representing a phase of the moon.

nyāsa: ritual projection of divinities into various parts of the body.

Padma: lotus, symbol of unfolding energies: term for a chakra.

Pañcarātra: tantric Vaishṇava philosophy.

Pañchabhūtas (or bhūtas): five gross elements of the physical world: earth, water, fire, air and ether.

Pañchopacāra: ceremonial worship with five ritual offerings – flowers, incense, lighted oil-lamp, food and sandal paste.

Piṅgalā: the 'male', right-hand channel of the subtle body.

pīṭha: sacred seat of a deity; pilgrimage centre.

pīṭha-sthāna: sacred place of the divinity.

Prakṛiti: material nature; creative energy of the universe made up of three guṇas, and identified with the female principle.

prāṇa: the vital energy of the cosmos, carried by breath.

prāṇapratiṣṭhā: rite of infusing vital energy into the yantra in order that it may become an active symbol.

pūjā: ceremonial worship with ritual offerings.

Purusha: male principle, essence of Śiva.

rajas: kinetic power of the universe, one of the three guṇas, the constituents of material nature, or Prakriti.

Ṣaḍaṅga: Indian theory of the science of image-making; forms based on six principles.

sādhaka: spiritual aspirant.

sādhanā: spiritual discipline.

Śaivites: followers of Śiva.

Śāktas: followers and worshippers of cosmic energy as the female principle (Śakti).

Śakti: kinetic principle of the universe; power, energy permeating creation, seen as female.

samādhi: the final aim of yoga, when man and cosmos attain unity; a state of yogic ecstasy.

Samayacāra: tantrikas who practise abstract worship of the body cosmos.

Sāmkhya: one of the major systems of Indian philosophy, founded by the sage Kapila (c. 500 BC) which influenced tantrism. This system identifies 25 tattvas, or cosmic principles, and formed the basis of the Śaiva-Śākta theory of the evolution of the cosmos, which recognizes 36 tattvas.

Samvit: consciousness; Śiva and his potential energy as the Ultimate Principle.

Ṣaṭkarma: six magical rites used by tantrikas for occult proficiency, and for mundane ends.

sattva: truth, purity, principle of equilibrium, the first of the three guṇas, the constituents of Prakṛti, or material nature.

siddhi: personal power acquired by yogic practices.

Siddhāis: yogis who have attained supernatural powers.

Śiva: the third god of Hindu trinity, the Destroyer; Absolute Principle or Cosmic Consciousness; the male principle in union with Śakti, the female principle.

sṛṣṭi-krama: order of creation; a way of viewing the yantra as a symbol of evolution, unfolding from the bindu outwards.

Śrī Vidyā: the Supreme Goddess in her 'knowledge' aspect, cognized in her fifteen-syllabled mantra.

Sūrya: Sun God.

Sushumṇā: the central channel in the subtle body, up which rises the female energy, or Kuṇḍalinī.

tamas: the power of inertia, the lowest of the three guṇas, the constituents of Prakṛti, or material nature.

tanmātras: subtle elements, or energy-potentials.

Tantra: a class of scripture; an ancient spiritual discipline relating to the power of Śakti.

Tantrika: follower of tantric disciplines.

tattvas: cosmic categories of which the entire universe is composed; see also Sāmkhya, above.

Upanishad: spiritual doctrine of ancient Indian philosophy; texts composed in their present form between c. 1000 and 800 BC.

Vāstu: site, plan of the house; dwelling or building place.

Vedas: the revealed scriptures of Hinduism.

visarjana: ritual of dispersing the divinity from the yantra after worship.

Vishṇu: the second god of the Hindu trinity; the Preserver.

yantra: mystical diagram used as a tool for meditation and worship; an abstract symbol of divinity; a figure to harness cosmic forces, synonymous with maṇḍala.

yogi: seeker; one who aims to achieve union with the reality of the cosmos.

yoginī: female aspirant.

yoni-maṇḍala: inverted triangle symbolizing the creative genetrix of the cosmos; emblem of Śakti, the female principle.

yuga: an aeon, or cosmic age.

Bibliography

The Sanskrit sources: texts and translations

Ahirbudhnya Samhitā, ed. F. Otto Schrader, Madras 1916. English introduction.

Atharva Veda, tr. M. Bloomfield, Oxford 1897.

Atharva Veda Samhitā, Vols. I–II, tr W. D. Whitney, revised, ed. C. R. Lanman, Cambridge, Mass. 1905.

Bhagavad-Gita, tr. Swami Prabhavananda and Christopher Isherwood, New York 1972.

Bhāvanopaniṣad, tr. S. Mitra, Madras 1976.

Bhṛigu-Samhitā. Edition in the collection of Pandit Vishṇu Narāyaṇa London. N.d.

Devībhāgavata Purāṇa, tr. Swami Vijnanda, Allahabad 1921–3.

Gandharva Tantra, ed. R. C. Kak and H. Shastri, Srinagar 1934. Short English introduction.

Gaṇita Kaumudi of Narayana Pandita, Part II, ed. M. D. Shastri, Banaras 1942.

Glory of the Divine Mother (Devīmahātmyam), S. Shankaranarayanam, Pondicherry 1968.

Guhyasamāja Tantra, S. Bagchi, Darbhanga 1965.

Hymns of the Rig Veda, Vols, I and II, tr. R. T. H. Griffith, Banaras 1862.

Kālīkā Purāṇa, see below, under Worship . . .

Kalī-Tantram, ed. with Hindi tr. R. Sukla, Prayag 1972–3.

Kāma-Kalā-Vilāsa, ed., tr. Sir John Woodroffe (Arthur Avalon), Madras 1953.

Kāmaratna Tantra, ed. T. Goswami, Shillong 1928. Short English introduction.

Kāmaratna Tantra. MS. in the collection of Ajit Mookerjee.

Karpurādistotra, ed., tr. Arthur Avalon, Calcutta 1922.

Kaulāvalīnirṇayah of Jñānanda Paramahaṃsa. English introduction by Arthur Avalon, Calcutta 1928.

Kulārṇava Tantra, ed. with short English introduction Arthur Avalon, Madras 1965.

Lakṣmī Tantra, tr. S. Gupta, Leiden 1972.

Lalitāsahasranāman with Bhāskarāya's commentary, tr. R. Ananthakrishna Sastry, Madras 1970.

Mahānirvāṇa Tantra. Tantra of the Great Liberation, tr. Arthur Avalon, New York 1972.

Maheśvara Tantra, ed. with Hindi tr. N. M. Misra, Bombay 1902.

Mālinīvijayottara Tantra (Śrī), III, ed. M. Shastri, Bombay 1922.

Mānasāra (Architecture of), P. K. Acharya, London 1933–4.

Mārkaṇḍeya Purāṇa, The, tr. F. Eden Pargiter, Calcutta 1904.

Niṣpannayogāvalī, ed. B. Bhattacharyya, Baroda 1949.

Nityaśoḍasikarṇava with commentaries by Sivananda and Artharatnavali Vidyananda, Banaras 1968.

Ṛishi Maṇḍala Yantra Pūjā with Hindi tr. M. Shastri, Bombay 1915.

Śākta Upaniṣad-s, tr. A. G. Krishna Warrier, Madras 1967.

Śākta-Darśana of Hayagriva, ed. with introduction by K. V. Abhyankar, Poona 1966.

Śāktapramodaḥ, Bombay 1931.

Śaktisaṅgama-Tantra (Sundarikhand), Vol. III, ed. B. Bhattacharyya, Baroda 1947. Short English introduction.

Śāradātilaka Tantra, ed. Arthur Avalon, Calcutta 1933. With English introduction.

Ṣaṭ-Chakra-nirūpaṇa, see Sir John Woodroffe, *The Serpent Power*.

Saundaryalaharī, The, or *Flood of Beauty*, ed., tr. W. Norman Brown, Cambridge, Mass. 1958.

Saundarya-Laharī, tr. S. S. Sastri and T. R. S. Ayyangar, Madras 1972. With full commentary.

Silpa-Prakāśa by Ramachandra Kaulacara, tr. A. Boner and S. R. Sarma, Leiden 1966.

Śiva Saṃhita, tr. S. Chandra Vasu, Allahabad 1905.

Śrīchakrasaṃbhara Tantra, ed. K. D. Samdeep, Calcutta 1919.

Tantrabhidhāna with *Vija-Nighaṇṭu* and *Mudrā-Nighaṇṭu*, ed. Arthur Avalon and T. Vidyāratna, Calcutta 1913.

Tantrarāja Tantra, ed. Sir John Woodroffe, Madras 1954.

Tantrasāra, ed. Sri Krisnananda Vagisa, Banaras 1938.

Tantrasāra (*Brihat*) of Krishnananda Agamvagish, Vols. I and II, ed. U. and S. Mukhopadhyay, Calcutta, n.d. With Bengali translation.

Tantra-tattva (*Principles of Tantra*),Vols. I and II, ed. Sir John Woodroffe, Madras 1953.

Tantric Sāhitya (in Hindi) with commentary by Gopinath Kaviraj, Banaras 1972.

Tārā-Bhakti-Sudhārṇava, ed. Arthur Avalon, Calcutta 1940. Short English introduction.

Tārā-Rahasyam, ed. with Hindi commentary S. Shastri, Banaras 1970.

Thirteen Principal Upanishads, The, tr. R. E. Hume, Oxford 1975.

Uḍḍiśi Tantra ascribed to either Ravana or Mahadeva, Hindi tr. R. Diksita, Delhi, n.d.

Vākyapadiyam (*Brahmakanda*) of Bhartrhari, tr. S. Varma, New Delhi 1970.

Varivasyā-Rahasyam, ed. S. Sastri, Madras 1968.

Vāstuśāstra, Vol. I, with special reference to Bhoja's *Samaraṅganasūtradhāra*, D. N. Sukla, Chandigarh 1960. In English.

Worship of the Goddess according to the Kālikā Purāṇa, Part I, tr. with introduction and notes of Chapters 54–69 by K. R. van Kooij, Leiden 1972.

Yajur Veda, tr. R. T. H. Griffiths, London 1899.

Yantra Saṃskārapaddhiti (in Hindi), Tract No. 11 by Kanhailal in *Miscellaneous Tracts* (Laxmi Narayan Press), Moradabad 1899.

Yantracintāmaṇi,with Hindi tr. B. P. Misra, Bombay 1967.

Yantrasāra Tantram in *Tantrasāra*, ed. R. Chattopadhyaya, Calcutta 1292 BS.

Yoga Upaniṣads, The, tr. T. R. Srinivasa Ayyangar, ed. B. Srinivasa Murti, (Adyar Library) Madras 1952.

Yoga-Sūtra of Patañjala, tr. Bengali Baba, Poona 1949.

Yoginī Hṛdaya with commentaries by Dipikā of Amṛtānanda and Setubandha of Bhāskara Rāya, Banaras 1963.

Other sources

Abbott, J., *The Keys of Power. A Study of Indian Ritual and Belief*, London 1932.

Avalon, Arthur (pen name of Sir John Woodroffe, q.v.), *Hymns to the Goddess*, Madras 1973.

———, *Śakti and Śākta*, Madras 1969.

———, *The Serpent Power*, Madras 1953, New York 1974.

Beane, Wendell Charles, *Myth, Cult and Symbols in Śākta Hinduism*, Leiden 1977.

Bharati, Agehananda, *The Tantric Tradition*, London 1965.

Blair, L., *Rhythms of Vision*, London 1975.

Bolton, N. J., and D. Nicol G. Macleod, 'The geometry of the Śrī Yantra' in *Religion. A Journal of Religion and Religions*, Vol 7, Spring 1977, pp. 66–85.

Boner, Alice, *Principles of Composition in Hindu Sculpture*, Leiden 1962.

———, 'The Symbolic Aspect of Form' in *Journal of the Indian Society of Oriental Art*, Vol. XVII, 1949, p. 40.

———, and S. R. Sarma with R. P. Das, *New Light on the Sun Temple of Konārka*, Varanasi 1972.

Briggs, George W., *Gorakhnāth and the Kānphaṭā Yogīs*, Delhi, 1973.

Cammann, Schuyler, 'Islamic and Indian Magic Squares', in *History of Religion*, Parts I and II, Vol. 8, No. 2, pp. 275–86.

Coomaraswamy, Ananda K., *Dance of Śiva*, New Delhi 1976.

———, *Figures of Speech or Figures of Thought*, London 1946.

———, *The Transformation of Nature in Art*, New York 1956.

Daniélou, Alain, *Hindu Polytheism*, London 1964.

Das, S., *Śakti and Divine Power*, Calcutta 1934.

Dasgupta, S. R., *Obscure Religious Cults*, Calcutta 1946.

Deussen, Paul, *The Philosophy of the Upanishads*. New York 1966.

Dikshitar, V. R. Ramachandra, *The Lalita Cult*, Madras 1942.

Edinger, Edward F., *Ego and Archetype*, Baltimore 1974.

Eliade, Mircea, *Comparative Religion*, London 1976.

———, *The Myth of the Eternal Return*, London 1965.

———, *The Two and the One*, London 1962.

———, *Yoga, Immortality and Freedom*, London 1958.

Gonda, J., *Change and Continuity in Indian Religion*, The Hague 1965.

Jhavery, M. B., *Comparitive and Critical Study of Mantraśāstra*, Ahmedabad 1944.

Kane, P. V., *History of Dharmaśāstra* (*Ancient and Medieval Religions and Civil Law*), Vol. V, Part II, Poona 1962.

Kinsley, David R., *The Sword and the Flute: Kālī and Kṛṣṇa*, Berkeley 1975.

Kramrisch, Stella, *Art of India*, London 1955.

———, *The Hindu Temple*, Vols. I and II, Calcutta 1946.

Misra, K. C., *The Cult of Jagannatha*, Calcutta 1971.

Monier-Williams, M., *Brahmanism and Hinduism or Religious Thought and Life in India*, London 1891.

———, *A Sanskrit-English Dictionary*, New edn. Delhi 1974.

Mookerjee, Ajit, *Tantra Art*, Paris, New York 1967.

———, *Yoga Art*, London, New York 1975

———, and Madhu Khanna, *The Tantric Way*, London, New York 1977.

Mus, Paul, *Barabudur*, Hanoi 1935.

O'Flaherty, Wendy Doniger, *Asceticism and Eroticism in the Mythology of Śiva*, London 1973.

Pott, P. H., *Yoga and Yantra*, The Hague 1966.

Prabhavananda, Swami, *The Spiritual Heritage of India*, London 1962.

Pratyagatmananda, Saraswati, *Japa Sūtram*, Madras 1971.

———, and John Woodroffe, *Sādhanā for Self-Realization*, Madras 1963.

Radhakrishnan, S., ed., *History of Philosophy, Eastern and Western*, Vol. I, London 1952.

Rawson, Philip, *The Art of Tantra*, London, New York, 1973; rev. edn. 1978.

Shamasastry, R., *The Origin of the Devanāgarī Alphabets*, Varanasi 1973.

Shankaranarayanan, S., *Śrī Chakra*, Pondicherry 1970.

Śrīkaṇṭha Śāstri, S., 'The Iconography of the Śrīvidyaraṇava Tantra', in *The Quarterly Journal of the Mithic Society*, Vol. XXIV; No. 1, July 1943, pp. 1–18; Nos 2 and 3, Oct. 1943 and Jan. 1944, pp. 186–204; No. 4, April-July 1944, pp. 4–12.

Tucci, Giuseppe, *The Theory and Practice of the Maṇḍala*, tr. A. H. Brodrick, London 1961.

Varenne, Jean, *Yoga and the Hindu Tradition*, Chicago 1976.

Williams, M. Monier, see Monier-Williams, M.

Woodroffe, Sir John (pen name Arthur Avalon, q.v.), *The Garland of Letters, Studies in the mantra-śāstra*, Madras 1952.

Zimmer, H., *Myths and Symbols in Indian Art and Civilization*, ed. Joseph Campbell, Washington 1946.

———, *Kunst Form und Yoga im Indischen Kultbild*, Berlin 1926.

Index

ACKNOWLEDGMENTS

Works illustrated are drawn from the following collections:
Archaeological Survey of India, New Delhi 4 below; p.10; Achim Bedrich, Munich 16; Bharat Kala Bhavan, Banares 9–12, 26–7, 67–8, 77–81; British Museum, London 8; J. C.

Ciancimino, London 3, 91; Robert Fraser, London 4, 15, 66, 69; Madhu Khanna 48, 50–3, 82–6, 93; Ajit Mookerjee 2, 5, 7, 13, 14, 17–21, 28, 29, 31–47, 56–63, 70, 72–4, 76, 87–90, 92, 94, 95; pp. 2, 8, 39, 41; Museum für Indische Kunst, Berlin 6; Priya Mookerjee (photographs) 24, 25, 75; private collection 22, 23;

Ronald Nameth 65; Jan Wichers, Hamburg 64.
Illustrations on pp. 143, 144 centre and 145 below are reproduced from *Living Architecture: India* (Volwahasen); p. 144 top is after *The Hindu Temple* (Kramrisch); drawings pp. 146 below, 147, 148 top are after *New Light on the Sun Temple of*

Konārka (Boner, Sarma and Das); plate 49 is after *Hindu Polytheism* (Daniélou); p. 42 is after *Varivasyā-Rahasyam*; plates 54, 55 are from the work *Lakṣmī Tantra* (Gupta).

Diagrams are drawn by Peter Bridgewater; Sanskrit lettering is by Stephen Thompson.